ANDY WARHOL'S
BRAIN

ANDY WARHOL'S BRAIN

Creative Intelligence for Survival
PHILLIP ROMERO, MD

Foreword
CHRISTOPHER MAKOS

First published in 2023 by

G Editions
New York, NY 10018
geditions.com

Copyright © 2023 **Phillip Romero**

All rights reserved. No part of this book may be reproduced or transmitted in any form or by any means, including information storage and retrieval systems, without permission in writing from the publisher, except by a reviewer who wishes to quote brief passages in a review.

First Printing, 2023

Library of Congress Cataloging-in-Publication data is available from the publisher.

Creative Director **Christopher Makos**
Art Director **Pau Garcia**
Associate Art Director **Jonay Cogollos**

Hardcover
ISBN : 978-1-943876-39-6

Printed and Bound in the United States of America
10 9 8 7 6 5 4 3 2 1

Andy Warhol Artworks, pages 34, 48, 81, 118, 132, 148, 158, 168/169, © 2023 The Andy Warhol Foundation for the Visual Arts, Inc. / Licensed by Artists Rights Society (ARS), New York.

Dedicated to my daughter, Sayume Ann
and to the inspiring memory of my friend, Andy Warhol

CONTENTS

FOREWORD
11 Science Fact, Not Fiction // Christopher Makos

PREFACE
15 Andy: Creative and Intelligent

INTRODUCTION
29 Andy Warhol's Brain: *Science Reveals the Complexity in Art*

PART ONE **ORIGINS**
35 Andy's Creative Intelligence
49 Andy's ACE
61 Andy's Phantom Stress
73 Andy's Autopoiesis
87 Andy's "As If" Personality

PART TWO **EMERGENCE**
97 Andy's Body
107 Andy's Brain-Mind
119 Andy's Identity

PART THREE **CREATIVITY**
133 Andy's Art I
149 Andy's Art II
167 Andy's Art III

PART FOUR **LEGACY**
179 Andy and Halston
189 Andy's Global Mind
197 After Andy
205 Andy's Paradox

EPILOGUE
215 My First Conversation with Andy Warhol
219 In Memoriam

220 WORKS CITED

226 INDEX

FOREWORD

Science Fact, Not Fiction
Christopher Makos

As I have seen, read, looked at, and experienced so many versions of who Andy Warhol was, is, when I heard that Phillip Romero was writing this book about the brain of Andy Warhol, I was more than curious: I wanted *in*.

Being part of the art scene that has been talked about, analyzed, and examined for cultural importance for years, the idea that a significant scientist was going into the brain of Warhol seemed right. I always talk about how photographing a portrait is similar to functioning as a psychiatrist: Subjects always ask me, "How do I look?" This is a question I am very hesitant to answer, as it is such a big question. If you're a good photographer, one needs to, actually *has* to, become that director; someone who is able to bring the subject to a place that makes them feel comfortable enough for you to capture the authentic essence of who they are. Phillip Romero—both friend and psychiatrist to Andy—is more than able to answer the question through his written analysis: "How did Andy look?"

I remember when I was shooting a portrait commissioned by Malcom Forbes of Elizabeth Taylor, I was a bit intimidated by the notion, until I realized that she was always married, and directed by strong men. That wakened me to the idea: Just direct in the way you want, and it will all be ok. As it turned out, when she came on-set, I was firm/strong, and she responded, and the resulting portrait was fantastic.

This is what Dr. Romero accomplishes with his written portrait in this book: Directs the reader to understand the best way to approach and comprehend one of the most visible human beings of the ages, unlike anyone before him has. Humans need direction, focus, and love. Therefore, in this book, the intriguing exploration of what makes Andy Warhol, "Andy," was very appealing to me. Phillip takes a deep dive, not just into Andy's brain, but into the psychology of the artist in general and how those two work in tandem in this individual. His approach is unique and novel, as was the reality/myth of Andy himself.

Romero's take on Warhol is more than surprising, it's illuminating not just regarding Warhol, but how the artist's brain works, and what differences effect how the artist makes decisions, and how that in the end affects us all when we are looking at art. The way art effects our lives—by way of Romero's words and his carefully chosen illustrations—we can see here how the artist ultimately encourages viewers to think, which in the final result might encourage us all to think in a new way about art, artists, and ourselves, as well.

Warhol and Makos rowing at the Bois de Boulogne, Paris, France 1982

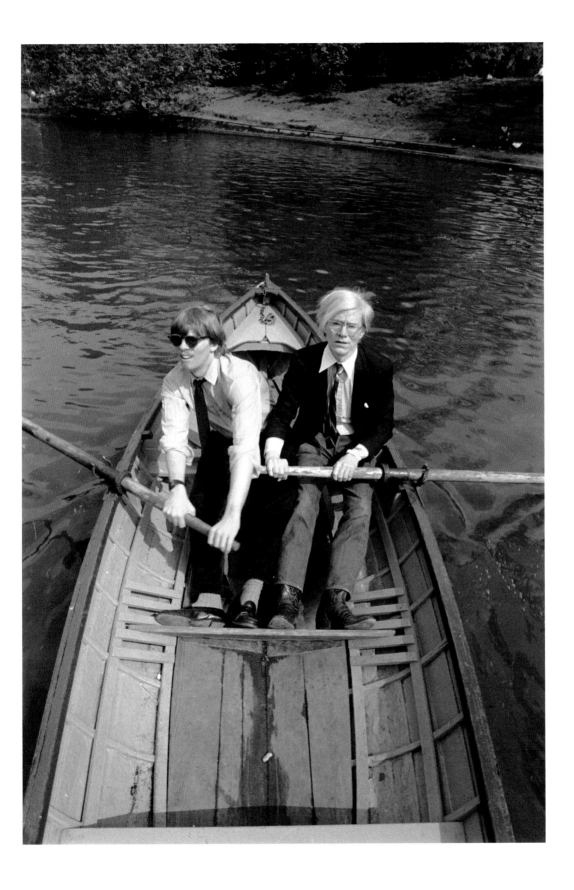

PREFACE

Andy: Creative and Intelligent

Creative Intelligence is the subject of this book. Andy Warhol's life, his mind, his art, and his influence on culture provide a rich example of how human beings use creativity to overcome individual adversity and to promote cultural evolution. With two inborn traits—resilience to adversity and creative problem solving—both hardwired in the brain, *Creative Intelligence* is defined as the effortful attention of the "mind" to recruit both these attributes to change oneself, to evolve social systems, and sustain the environment to improve the quality and duration of human life. Resilience + Creativity = Creative Intelligence for Survival.

> *I'll be your mirror*
>
> *Reflect what you are, in case you don't know*
>
> Lou Reed, The Velvet Underground (1966)

My last conversation with Andy Warhol

My last conversation with Andy Warhol was at a Christmas party in December 1986 two months before he died on February 22, 1987. We were watching Keith Haring play pool in the game room. I had asked Andy if we could do an interview for my book project, *The Art Imperative: The Secret Power of Art.* We had been talking about art, creativity, and culture for a decade. He always reflected some insight on my research into the healing power of art and how art shapes culture. Andy embodied my thesis more than any living artist; my view is that both artists and art viewers get stress relief and inspiration for creativity in beholding art. I believe that art inspires us to change ourselves. I think artmaking is as instinctual as eating or breathing. When I told Andy the book title, *The Art Imperative*, he had quickly answered, "Oh sure. I like the title. I have that 'art imperative' thing. I don't know what I'd do if I didn't make art."

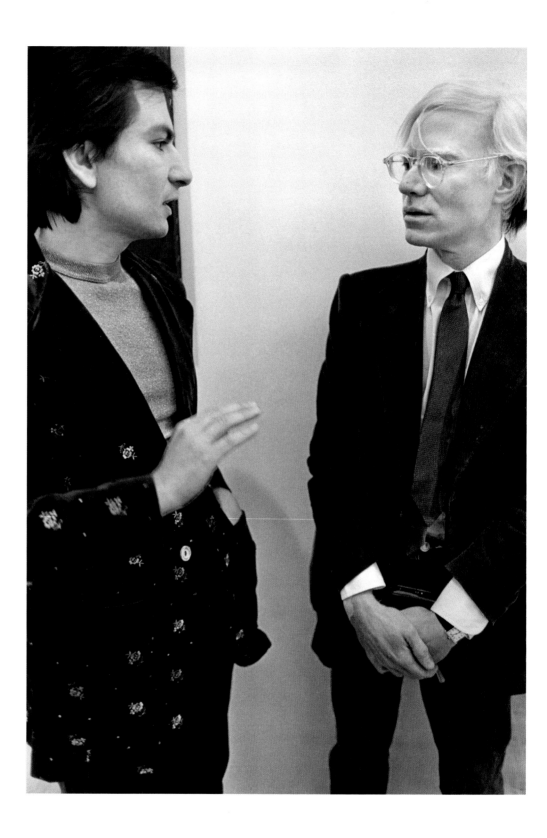

The author's first meeting
with Andy Warhol,
David Richmond, 1976

Knowing Andy's competitive nature, I told him, strategically, that I had already taped conversations with Audrey Flack, Isamu Noguchi, and Louise Bourgeois.

Andy jumped in, "We can do it at the Factory. We can put it in *Interview*."

I was overjoyed. I had been speaking about the idea with Abrams, the art publisher, and they felt that having Andy would make the book a success.

Two months later, I was traumatized when Andy died.

The Lost Conversation with Andy Warhol: *The Day Andy Died*

On February 21, 1987, I received a call from one of Andy's doctors.

> Dr. B: Phil, Andy is going into New York Hospital for emergency surgery. Andy is afraid he's going to die. Would you visit him as a friend after his surgery?
>
> Me: Of course, I'll go first thing in the morning.

As I prepared to visit him the next day at the New York Hospital, where I was assistant professor of child psychiatry, the morning news blared: "Andy Warhol is dead."

I was dumbfounded, frozen in disbelief, shocked beyond words. I dropped onto the couch as a cascade of stress hormones triggered an acute reaction. I sat there for what seemed like a very long time. I felt pain in the loss of a friend in my gut. Grief for a great artist hit me like a tidal wave. I was crushed by disappointment in the lost conversation I had hoped to have.

A few days later, I received a letter from the hospital that the faculty was given a gag order not to discuss the case with anyone. I put my book, *The Art Imperative,* on hold for twenty-three years before publishing it in 2010, but I have not published any of my thoughts about Andy Warhol until now. I feel that this book, *Andy Warhol's Brain: Creative Intelligence = Survival,* is a virtual return to the interview with Andy that never happened. It is both an homage to Andy for his inspiring friendship and a platform for me to explore my thesis, "Art = Survival."

My aim in *Andy Warhol's Brain* is to demonstrate that Andy's life story reveals how human beings use art to face everyday stress and overwhelming adversities of life, as well as how a single artist can be a tipping point in cultural evolution toward a more humane society by mirroring the best and worst of human nature.

For anyone who knew Andy, in whatever capacity, I believe that we all would say, "There is no one like Andy." Far beyond the glitz and glam associated with Andy Warhol, there is much to learn from the genius of his life story that can inspire everyone to activate their own creativity in the face of the challenging stresses of this time.

Andy Warhol: *Inspiration/Obsession*

Andy Warhol is an iconic figure who inspired me and countless people. I first became aware of Warhol after Valerie Solanas shot him on June 3, 1968, around the time of my high school graduation. I had just started my first job as a firefighter at the Port Arthur Fire Department. Three days later, Robert Kennedy was assassinated, scaring me and the nation forever.

A few months later, I started my premedical courses, and as an active artist, I took a modern art appreciation class in which Warhol played a vital role. I also discovered our hometown art star, Robert Rauschenberg, who inspired my art. Warhol and Rauschenberg kindled my desire to go to New York to become an artist.

In December 1968, I saw the film *Monterrey Pop*. Janis Joplin, another hometown popstar, burst onto the scene. This film kindled the motivation to go to the Woodstock Festival in 1969. Somewhere in my teen gut, I formed an obsessive wish to meet my heroes. My "inner groupie" would drive this curiosity that became research into the brain-mind/art-culture continuum of Creative Intelligence. How could such damaged people—alcoholics and drug users with self-destructive behaviors—become such creative people?

With perseverance, I had the good fortune to develop a friendship with Andy in the final decade of his life. He was fascinated by my research into creativity, child development, and cultural evolution. He encouraged my book project, *The Art Imperative:*

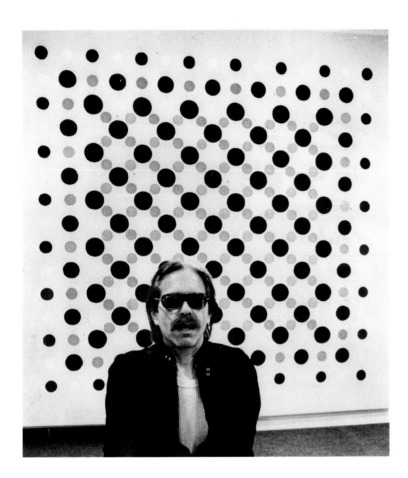

Thomas Downing with his painting "Pepper", James M. Thresher, 1979

The Secret Power of Art. As a sequel to that book, I have chosen to focus on Andy's life, his Creative Intelligence, and how he overcame immense adversities and contributed to changing the world.

As I reconstruct Andy's history, my own memories, thoughts, and feelings emerge. In authoring this book, Andy's life is proving to be a mirror for my own self-understanding. Over thirty years after his death, Andy continues to inspire my exploration of Creative Intelligence.

Galveston, Michael Tracy, and Thomas Downing: *Friends and Mentors*

I met Michael Tracy in Galveston, Texas, at his art-bar, Stella Maris, while I was an artist/medical student at UTMB (University of Texas Medical Branch). He had lived in huge lofts on The Strand, at the port for the fishing boats and oil tankers. The port of "Old Galveston" was colonized by a few artists who commanded the loft buildings for studios.

Michael was amazing. His color field abstract paintings exuded emotional power. The mega-scale of his art filled several museums in Texas. He also was a filmmaker, photographer, and performance artist. He inspired my exploration of the links between art and medicine with a performance piece that became a traveling exhibition. *Terminal Privileges*, 1987, was organized by Alanna Heiss, founder of P.S.1, The Institute for Art and Urban Resources, Inc. in Long Island City, New York. Curated by Edward Leffingwell, it was cosponsored by Everson Museum of Art, Syracuse, New York; Center of Contemporary Art, Seattle; Fisher Gallery, University of Southern California, Los Angeles; Wexner Center for the Visual Arts, Ohio State University; and The Menil Collection, Houston.

I participated in Tracy's performance art project with Dr. Burke Evans, chief of orthopedic surgery at UTMD, for *Terminal Privileges*. Michael filmed the process of being encased in a total body cast by Dr. Evans. Michael's ideas kindled my interest in the links between art, creativity, mind, and medicine.

Michael introduced me to Tom Downing, Washington Color School painter. Tom had been the visiting artist-in-residence at the Contemporary Arts Museum in Houston and had moved into a loft in Tracy's building. Tom and I began long conversations about the *brain-mind/art-culture* system that powered cultural evolution. He inspired me to interview artists about their creative experiences. Tom's brilliant vision produced profound minimalist "dot painting" that functioned as triggers for mindful reflection. Keenly aware of the brain-mind/art-culture links, Tom and I laughingly coined the term *Pop Zen* to describe his art. Tom became a dear friend and mentor for the next decade, up until his premature passing in 1985.

Tom began his career in Washington and showed in New York, where he met Andy Warhol. He introduced me to Andy in 1976. They knew each other from Eleanor Ward's legendary Stable Gallery (home to abstract expressionist painters in the 1950s). Andy had his first one-man show in New York there in 1962, and Tom exhibited his Dot paintings in 1965. Tom and I remained close friends after I moved to New York and he returned to Washington, DC.

Artists and the Brain-Mind/Art-Culture System

Tom inspired me to tape conversations with artists. I interviewed Audrey Flack, Louise Bourgeois, and Isamu Noguchi. Audrey embraced a psychoanalytic approach in her photorealism paintings. She was the first living female artist to be collected by the Museum of Modern Art. Her portraits of Marilyn Monroe probe her feminine mystique with meticulous magic, revealing the human side of the Hollywood facade. Louise also embraced a psychoanalytic framework in her otherworldly creations that reinvented sculpture. Her power to startle and seduce the beholder transcends any preconceptions in the viewer's expectations. Isamu represented a very personal passion of mine: bridging East-West/Ancient-Modern art and culture. Like Michelangelo, Isamu's ability to reveal the "voice of the stone" into human comprehension transcends the time-space continuum. Isamu represents what I have come to call *quantum art*, art that taps into the core of the cosmic creativity apparatus that permeates the universe.

I saw Andy as the perfect example of a single artist who mastered the brain-mind/art-culture system. He restructured the definition of art and promoted POPism that altered cultural evolution in the last half of the twentieth century. POPism is a cultural wave that continues to shape the global village.

The Birth of My Daughter and the Art Imperative: *Art = Survival*

My daughter was born during my child psychiatry training. The art imperative idea emerged in an epiphany while I watched her birth. I was in a state of awe, wonder, excitement, fear, and envy.

I have been an artist since childhood. I kept a studio during my entire medical training. Now, I was witnessing the birth of my daughter, the most creative act possible. As my wife struggled to push our baby into this world, making art seemed so insignificant when compared to making a human being. I felt deeply connected to the creativity of life, from the "me" of my puny identity to the "we" of coparenting with my wife, to the expansive "We" of humanity and life on this planet. My mind was soaring, my imagination radiant, and the connections between everything seemed so clear.

Time was bending, allowing me to see across the eons back to the origins of art.

As I photographed the arrival of my daughter as a work of art and wonderment, I had a primordial emotional fantasy:

> *I imagined myself a cave artist, secretly watching the birth of my daughter from a discreet vantage point. Men cannot participate in the sacred ritual of giving birth. I had a powerful urge to protect and nurture my new family. I was not a hunter, but I had talent to draw the animals of our world. By creating images of these creatures on the cave walls, I could magically empower the hunters in the quest for food to sustain the clan.*

This fantasy mirrored the idea of genetic memory, and I believed being an artist was inborn. It sparked my urge to find out all I could about the cave paintings of prehistory.

Art-Mind-Medicine

My identity was artist-doctor not doctor-artist. I had my own studio on Union Square across from the Factory. A whole new series of paintings—the *Noh Time Series*—was born from watching the birth of my daughter. Her multicultural reality—her mother is Japanese, and I had Anglo and Mexican parents—inspired the works. I called my studio Noh Time Studio, named after the Japanese Noh Theater of Zeami Motokiyo (c. 1363–c. 1443). He describes Noh Theater as "the perfection of time." When my daughter was twelve, she identified herself as a Japexican.

This marvelous experience of witnessing the birth of my daughter inspired my research into the paleolithic cave paintings at Lascaux, discovered in 1940. During my fellowship in child psychiatry at New York Hospital-Payne Whitney Clinic, I wrote a theoretical developmental psychoanalytic essay, "Men, Their Painting, and Their Fear and Envy of Women," a critical reflection of my thoughts and feelings as an artist. It laid the foundation for my lifelong study of creativity. It seemed clear that when Cro Magnon created art (Chauvet Cave, discovered in 1994, dates about 40,000 years ago), art was a tipping point in human cultural evolution. Art played a significant role in all domains of human creativity, from science to religion to government. Art con-

ferred greater social connectedness through symbolic imagery. The paintings are charged with magical interpretations and animistic mirroring of human life that kindled narratives of shared meaning—*art = survival.* We are still interpreting the meanings that these beautiful paintings may have held for their creators.

My Creative Intelligence: *Art as Medicine*

As an artist and child psychiatrist, I knew the "healing power of art" and the "art of healing" reflected one another. Healing from injury in living systems is a creative process. Creativity is imprinted at the genetic level to make new tissues to replace damaged cells. Resilience to adversity in mammals is a social phenomenon—groups survive better than individuals. The strands of my knowledge and experience would take decades before I became aware of my own Creative Intelligence.

During medical school, I took a course in Tibetan meditation in Houston. I met Dundel Tsarong, a former official in the exiled Tibetan government. He introduced me to his son, Jigme, who was the director of the Tibetan Medical Center in Dharamsala, India. This led to spending three months there for my externship sponsored by Drs. William Bean and Tristram Engelhardt of the Department of History and Philosophy of Medicine. I dedicated myself to studying Tibetan medicine, Buddhist philosophy, and meditation where the essence is promoting wisdom and compassion for all humanity—*mind is the physician of the body*. I accepted initiations from H.H. Dalai Lama, and he provided me letters of introduction for further training. I traveled to Kathmandu, Nepal, to receive initiations in the Medicine Buddha and the Boddhisatva path by Thrangu Rinpoche of Boudhanath and Tenga Rinpoche of Swayambhu. Buddha's Four Noble Truths are presented like a physician's approach to diagnosing, assessing, and treating illness:

1. The Problem: Life is Suffering.

2. The Cause: Attachment is the root of all suffering.

3. The Solution: Cessation of suffering arises with deep experiential acceptance of Emptiness and Impermanence.

4. The Plan: The Eightfold Path prescribes a mindful way of living that changes one's attitudes, behaviors, and values beyond the personal goal of liberation to the enlightenment of all human beings.

Our survival as a species depends on cooperation and connectivity. But sustaining a creative social system is an experiment that remains the primary obstacle for humanity. Greed, anger, fear, confusion, and lust remain sources of chronic, toxic stress that triggers patterns of self-sabotaging behavior and attitudes.

Our creative nature allows us to reinvent ourselves, our society, and our circumstances. We evolve as a culture with our science, technology, and social system's experiments. It is our own, self-centered, competitive nature that poses the greatest threat to our species more than anything else.

My personal experience with Buddhism, creating art, and practicing psychiatry inspired me to specialize in developmental psychobiology. It was clear that creativity played a vital role in attachment in family systems. And likewise, family systems formed the core of culture. As families used creativity to adapt to the challenges in life, culture used art to identify the values, beliefs, and patterns of behaviors that defined it.

My core sense of self, my authenticity as a person, emerged early in childhood. I emerged as the "class artist" by third grade, thanks to my talented father who taught me to draw in perspective—perspective drawing is a technique used to depict spatial depth, or perspective. Florentine architect Filippo Brunelleschi (1377–1446) created art with linear perspective, laying the foundations for Renaissance painting. I identified with his name and felt a connection beyond time through art. Perspective drawing felt like a superpower. I was able to accurately draw a three-dimensional object onto a two-dimensional plane. With shading, chiaroscuro, I could make a flat image pop off the page! With my imagination and my talent in art, I began my cultivating my Creative Intelligence.

As a physician, I became aware that healing was a natural phenomenon, a mind-body process, and it is empowered by the patient-physician alliance. Listening plays a critical role in cultivating empathy and applying science to recruit healing. After starting my private practice, I integrated all my experiences into a clinical method

Medicine Buddha

I called *Logosoma Brain Training: Ways of Listening toward an End of Suffering*. After twenty-five years of clinical application, I published the methodology in *Phantom Stress: Brain Training to Master Relationship Stress* (2010).

What is this book about?

Andy Warhol's Brain: Creative Intelligence = Survival is a sequel to *The Art Imperative: The Secret Power of Art* (2010), which explored the role of art in human evolution and individual development. A biopsychosocial approach reveals how Andy Warhol's life exemplifies human creativity as critical to overcoming individual adversity and how his unique talents and Creative Intelligence changed culture.

Understanding human Creative Intelligence has been the driving narrative of my life. Recent science points to the concept of Creative Intelligence as a complex mind-body system that involves two inborn traits in human beings: resilience and creativity.

Resilience, the ability to quickly recover from adversity, is genetically hardwired into our stress response. Mediated by the allostatic system, our cellular immunity and social survival depend on the ability to regulate the emotional, psychological, and behavioral encounter with stress. *Creativity*, the ability to reproduce and evolve, drives all self-organizing systems. With mindful attention, we can empower the entanglement of resilience and creativity in wish-driven narratives and action. Resilience + Creativity defines *Creative Intelligence (CI)*. Although no metric for measuring Creative Intelligence exists, Andy would set a standard for high CIQ with such a metric.

Mirroring Andy Warhol: *The Beholder's Share*

Andy once said:

> People are always calling me a mirror, and if a mirror looks into a mirror, what is there to see?

Andy was a philosophical artist with words, images, films, and actions. Commercial art was a job. Cultural impresario became his career. Everything he created was ambiguous, filled with ambivalence, wit, irony, and reflected his own enigmatic identity. His Creative Intelligence invited interpretation, igniting creativity in the beholders of "the Warhol." Two quotes reflect his own self-awareness of impermanence:

> The idea is not to live forever, it is to create something that will.

> I always thought I'd like my own tombstone to be blank. No epitaph, and no name. Well, actually, I'd like it to say "figment."

Using the "case study method" to explore Andy Warhol's story, we can track the complex, biopsychosocial processes that shaped the transformation of Andrej Warhola into Andy Warhol. We can also examine how this extraordinary artist shaped cultural evolution.

A consilient approach (consilience = the unity of knowledge) helps make sense of the ambiguity he presented. Integrating multiple domains of knowledge provides for a deeper understanding of his and our creative nature. Complex systems theory, new theories about mind and consciousness, and the social neuroscience of emotional attachment offer new insights into the Creative Intelligence of Andy Warhol.

This book is a looking glass into human Creative Intelligence, Andy Warhol, and us. The struggle between Creative Intelligence and adversity exists within each human being. We can use his life as a mirror to inspire our own Creative Intelligence in reinventing ourselves through the complex and challenging times we live in.

INTRODUCTION

Andy Warhol's Brain: *Science Reveals the Complexity in Art*

Social neuroscience is revealing how the complexity of the brain contributes to the role art plays in individual development. Linking the social functions of art to individual artists contributes to new ways of understanding how art functions to promote cohesive, resilient human civilization.

Andy Warhol's life story reveals how an individual artist mustered extraordinary Creative Intelligence to survive personal adversity, to thrive as an artist and businessman, and to shape the course of global culture toward humanistic, egalitarian values.

Brain science is advancing at an incredible pace. The Society for Neuroscience (SfN), founded in 1969, boasts 36,000 members in 95 countries and is committed to educating the public about the critical role brain science plays in helping us understand ourselves. As a member of the Society for Social Neuroscience (S4SN), I am part of the quest for linking brain mechanisms with social behavior.

As a child and family psychiatrist and assistant professor of psychiatry at New York-Presbyterian Hospital, Weill Medical College-Cornell University (now retired after twenty-five years), I have devoted my professional career to training child psychiatry fellows in family systems theory and helping families overcome relationship stresses that contribute to the dysfunction and collapse of family systems. I developed Logosoma Brain Training (LBT) for my patients in 1986, a mindful method for stress mitigation. I wrote *Phantom Stress: Brain Training to Master Relationship Stress* (2010) to introduce LBT.

Models of Consciousness

Models of consciousness and the brain are also advancing. In *The Consciousness Instinct: Unraveling the Mystery of How the Brain Makes the Mind* (2018), Michael S. Gazzaniga distinguishes two theories of consciousness: emergentism and panpsychism. The former concept proposes that consciousness emerges from complex self-organizing systems of unconscious matter that have attained a high level of complexity. The latter proposes that consciousness is somehow embedded in the self-organizing systems that permeate the universe from the quantum realm to the cosmos.

The idea that consciousness is an abstract realm that permeates the universe is an ancient philosophy found in Taoism, Buddhism, and Plato. Neuroscience continues to struggle with identifying the relationship between abstract consciousness and the concrete brain.

Nobel Prize–winning physicist Roger Penrose and anesthesiologist Stuart Hameroff propose a controversial hypothesis that bridges the abstract philosophy and the concrete mechanisms of anatomy-physiology. Their theory, Orchestrated objective reduction (Orch OR), postulates that consciousness originates at the quantum level inside neurons, rather than the conventional view that it is an emergent phenomenon from connections between neurons. The Orch OR mechanism is held to be a quantum process called objective reduction that is orchestrated by cellular structures called microtubules. It is proposed that the theory may answer the hard problem of consciousness and provide a mechanism for free will.

The Universe is a Creativity Machine

The concept of autopoiesis can be applied for a deep understanding of nature. Roger Penrose proposes conformal cyclic cosmology (CCC), a cosmological model in the framework of general relativity. In CCC, the universe iterates through infinite cycles, from a Big Bang to entropic expansion to collapsing back to a singularity that eventually reiterates another Big Bang. Penrose popularized this theory in his 2010 book *Cycles of Time: An Extraordinary New View of the Universe*. This model sees the universe as an autopoietic system of self-creativity. During the expansion, nonliving matter moves toward greater complexity from atoms to molecules to self-organizing living systems. Human civilization is the best evidence of this process evolving consciousness and eventually manifesting as Creative Intelligence.

Creative Intelligence invented art in paleolithic times to play a critical role in individual development and cultural evolution. The inborn *art imperative* empowers human beings to perpetuate their survival.

Creative Intelligence: *How Mindfulness Harnesses Resilience and Creativity*

As an artist, a lifelong practitioner of Buddhist mindfulness meditation, and student of philosophy, I have experienced and studied the mental and emotional patterns of my own creative process. I developed the concept of Creative Intelligence Training, a mindfulness method of integrating the inborn traits of resilience and creativity toward empowering *autopoiesis*, the self-making attribute found in all self-organizing systems. I use this method clinically to help individuals and family systems recruit their resilience and creativity to overcome adverse experiences and reinvent themselves.

Andy Warhol's Creative Intelligence

My life as an artist, my friendship with Andy Warhol, and my relationships with other artists inspired the mission to link Andy's complex life and art with current understanding of the brain-mind/art-culture system. I wrote *The Art Imperative: The Secret Power of Art* (2010) to explore the role of art in human evolution and individual development. In 1986, I had a conversation with Andy at a Christmas party about the project, and he said,

> I love the idea. Let's tape a conversation at the Factory. We can put it in *Interview*. I have that "art imperative" thing. I don't know what I'd do if I didn't make art.

Sadly, Andy died two months later before we could have our conversation.

I have contemplated the brain-mind of Andy Warhol, researched the art-culture links of his art, and written essays about this book for thirty years.

This project is a consilient effort to integrate the life and art of my friend, Andy Warhol, with the brain-mind/art-culture system that informs the evolution of human civilization.

PART ONE

ORIGINS

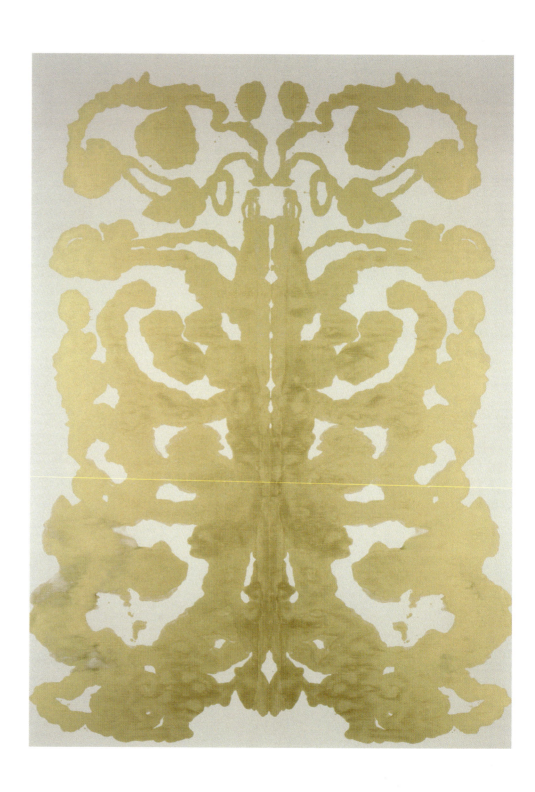

Rorschach
Andy Warhol, 1984
Synthetic polymer
paint on canvas
167 x 115 inches
424.2 x 292.1 cm

1 ANDY'S CREATIVE INTELLIGENCE

> *The view of the brain as a creativity machine that constantly uses inferences and guesses to reconstruct the external world . . . was a dramatic shift . . .*
>
> Eric R. Kandel in
>
> *The Age of Insight: The Quest to Understand the Unconscious in Art, Mind, and Brain*

Andy's Creative Intelligence: *Make Something Out of Nothing*

Andy Warhol was one of a kind. The unique complexity of his life kindles questions about his personal identity, his mind, his art, and how he influenced culture. We know that Andy's development was fraught with extraordinary adversity. We also know that his mother, Julia, enriched his development with creative stimulation during convalescence from illness. Their complex bond was a lifelong relationship.

Focusing on Andy's *Creative Intelligence,* defined as "the guided integration of resilience and creativity," reveals how his resilience to extraordinary adversity and his creative talents are intricately entwined.

Human beings have inborn *resilience* to adversity—the greater the adversity, the greater the need for creative problem-solving. *Creative* problem-solving is a genetically endowed aptitude that can be experientially enhanced. During childhood, when protective and nurturing parenting are critical, children use creative problem-solving to meet the developmental challenges of walking, climbing, manipulating objects, social interaction, and mastering language. The entanglement of these innate traits, Resilience + Creativity, defines Creative Intelligence. Creative intelligence is a mindful practice of effortful attention that integrates linear thinking with nonlinear, imaginative thinking to adapt to the ever-widening world of experience.

I developed Creative Intelligence Training based on developmental neuroscience, my own mindful reflections on my creative processes, and extensive clinical experience with creativity. Creative Intelligence involves six fundamental steps, the 6Rs of Creative Intelligence Training:

1. *Remembering* past negative emotions
2. *Reflecting* mindfully on these memories from the present
3. *Reframing* the feelings of victimhood, resentment, self-pity, and helplessness with the self-making declaration "I am not a victim"
4. *Reimagining* oneself in the present and the future
5. *Reinventing* new attitude and behaviors
6. *Reconnecting* with the world in the newly formed, adaptive sense of self

Make Something Out of Nothing

Andy Warhol reflected this process with a fundamental philosophical position. In 1975's *The Philosophy of Andy Warhol (From A to B and Back Again)*, he reveals his solution to existential nihilism in a conversation:

B: If you know life is nothing, then what are you living for?

A: For Nothing…

B. Then why do you keep making paintings? They're going to hang around after you die.

A: That's nothing.

B: It's an idea that goes on.

A: Ideas are nothing.

B: If ideas are nothing, and objects are nothing, then as soon as you get some money you should just spend it having as good a time as possible.

> A: Well, it doesn't mean if you believe in nothing that it's nothing. You have to treat the nothing as if it were something. *Make something out of nothing.*

Warhol arrived at this a simple, and yet profound, approach to life, to art, and to meaning. "Make something out of nothing" reflects his deep existential experiences about life, about how self-organizing systems survive, adapt, and thrive. Warhol's complex development, his creative output, and his ability to reinvent himself and the world reflect his prodigious Creative Intelligence.

Andy Warhol's Brain-Mind/Art-Culture System

Exploring Andy Warhol's Creative Intelligence (CI) with a biopsychosocial approach reveals how Warhol was able to create new links in the complex brain-mind/art-culture system. Like a spider and its web, Warhol spun an intricate network of meaningful connections that reinvented the definition of art with POPism. The Pop movement dissolved hierarchical boundaries, challenged traditional values, and altered the way of thinking in culture. Pop art kindled society toward an egalitarian concept of art-culture. Andy said,

> Once you "got" Pop, you could never see a sign again the same way again. And once you thought Pop, you could never see America the same way again.

Andy understood how artmaking mitigated his enormous personal stress. Using Andy Warhol's life as an example, we can learn to empower our Creative Intelligence as a lifelong practice that helps us overcome adversity and enhance our joy of living.

The long shadow of Andy Warhol continues to shape culture as a narrative of creative possibilities against insurmountable odds. Andy Warhol reflects the deep American value of self-making. Illuminating the structure of his web of influence, we can mirror our own personal experience with his creativity to adapt to the chronic stressors that we face individually each day and that threaten the stability of our global village.

My personal relationship with Andy began in 1976. We met while I was a medical student.

Creativity versus Stress: *A Developmental View*

From childhood, Andy's creativity entwined with his mother, Julia, and his convalescence from illness. Art helped him deal with physical pain, emotional stress, and social anxiety. Andy viscerally experienced the power of art to help him overcome adversity. As a young adult, he achieved enormous success in advertising art. Andy became acutely aware of how art shapes public opinions, promotes merchandise sales, and affects the zeitgeist. In my decade of conversations with Andy, I saw the essence of his artistic mission as an advocate for cultural progress toward a more humane, egalitarian society. His mind observed the world as a system of connections. He understood and linked multiple realities at once. His fascination with human relationships, celebrity, fame, and power were rooted in his personal experience of how painful love can be. Warhol poignantly reflects:

> Human beings are born solitary, but everywhere they are in chains—daisy chains—of interactivity. Social actions are makeshift forms, often courageous, sometimes ridiculous, always strange.

Personal relationships challenged Andy. In *The Philosophy of Andy Warhol*, he wrote:

> At the times in my life when I was feeling the most gregarious and looking for bosom friendships, I couldn't find any takers, so that exactly when I was alone was when I felt the most like not being alone.

His social disappointments activated his Creative Intelligence to create "the Warhol," an emotionally aloof, objective, adaptive persona. Like a psychoanalyst, he paid attention to others in a non-emotional, almost clinical style. The Warhol persona embodied feigned ignorance, witty intelligence, and a bewigged ingenue style. The Warhol became one of his greatest works of art, a kind of perpetual performance artist. He recalls:

> The moment I decided I'd rather be alone and not have anyone telling me their problems, everybody I'd never even seen before in my life started telling me their problems… As soon as I became a loner in my own mind, that's when I got what you might call a "following."

> As soon as you stop wanting something you get it. I've found that to be absolutely axiomatic.

Warhol's shy temperament harnessed a powerful survival drive to achieve extraordinary success. In *Holy Terror: Andy Warhol Close Up* (1990), author Bob Colacello described Andy's ambition: "He wanted to be, you know, a god. Someone who completely changed the ... he wanted to be Zeus with the lightning bolt, and nothing less would have satisfied him."

Andy, Advertising, and Art: *Shaping Social Consciousness*

Andy knew that art had the power to activate Creative Intelligence in the public. He was aware that when the viewer sees an image, the first reaction is emotional, invoking a feeling about it. Then, a thought or reflection may emerge. Finally, a behavior may take place. In advertising, the goal is to short-circuit the process to "see it-feel it-buy it!" Andy won awards for his advertising. As a super successful advertising artist on Madison Avenue in the 1950s, he plugged into the styles, the fashion, and the art that was transforming New York into the center of America's explosive economy. He loved it all, but he was unsatisfied with the boring, redundant, formulaic art of advertising.

In becoming a fine artist, he added his own spin to creating art history. Inspired by Marcel Duchamp's talents for ambiguity, Andy's new formula was "see it-feel confused about it-think about it-talk about it-buy it." He used this formula with his business knowledge to empower Pop art for changes in human values, relationships, and culture. He embodied the self-styled anti-hero that promotes changes in gender identity, socioeconomic strata, and psychosocial bias toward a more egalitarian society. He saw celebrity and fame as potential vehicles to transform society toward a more humanistic system. His most famous prophecy predicted the worldwide web, reality television, and social media:

> In the future, everyone will be world-famous for 15 minutes.

Andy's Creativity Machine

Every human brain is what Eric Kandel, Nobel Prize–winning neuroscientist, calls a "creativity machine." Andy attuned with the mental, emotional, physical, and social processes involved in creating art—he was intuitively aware of how his brain-mind system linked with the art-culture system. He reflected,

> The reason I'm painting this way is that I want to be a machine, and I feel that whatever I do and do machine-like is what I want to do.

Using a brain-mind/art-culture system to approach Andy Warhol, we begin tracking the process when the artist's brain enters the creative brain state—*divergent thinking*. When the brain "stops doing" and dwells in "just being," the daydreaming "resting state" of the brain transforms consciousness. Conscious and nonconscious memories, emotions, and thoughts comingle in nonlinear, timeless patterns of synchronized associations. Multiple centers of consciousness in the brain communicate with each other, sharing information. The neuropsychology of imagination reframes adversities into possibilities. Once a new idea emerges, the brain-mind is ready to experiment with it.

Using *convergent thinking*, the 'doing' brain state evaluates the new idea and takes action to produce it in the world. Andy's business brain-mind executes the new idea and creates a work of art—the *Soup Cans*, for example. All of Andy's knowledge of line and color, art history, marketing strategies, and trend-setting patterns converge to inform the final product. Like Marcel Duchamp's infamous *Fountain*, 1917, Andy took what he knew to be "not art" and reframed it as art. This simple creative act had global reverberations.

Andy was a professional commercial artist before transforming into a fine artist. He was a natural collaborator, and he knew the value of shared Creative Intelligence in arriving at innovative ideas. He approached art in a businesslike manner, using his divergent, inventive mind for inspiration, style, and trendspotting. He had great skill in toggling back to his convergent, linear thinking for production and marketing. In *POPism* (1980), Warhol recalls conversations with Henry Geldzahler, a young scholar-curator at the Metropolitan Museum of Art.

> Henry was a scholar who understood the past, but he also understood how to use the past to look at the future… Henry liked all the rock and roll I kept playing while I painted. He told me once, "I picked up a new attitude toward the media from you—not being selective, just letting everything in at once."… He like to compare our relationship to ones between the Renaissance painters and the scholars of mythology or antiquity or Christian history who doled out the ideas for subjects… It was Henry who gave me the idea to start the Death and Disaster series.

Andy's Talent for Shared Creative Intelligence

Andy and Henry cocreated a dynamic duo of Creative Intelligence. Andy had a natural gift for bonding with people who reciprocated his own creativity, expanding the possibilities for future projects. Together, their conjoint brain-mind systems marshaled their individual expertise in strategies for success in the art-culture system of New York. They were powerful collaborators in shaping the emerging brain-mind/art-culture transformations of POPism. Andy wrote in *POPism*:

> Right away we became five-hours-a-day-on-the-phone-see-you-for-lunch-be-quick-turn-on-the- "Tonight-Show" friends… In the last half of the '60s Henry and I were both, in our very different ways, coming fresh into and up against the intrigues and strategies of the New York art scene, so that was good for at least four hours a day on the phone right there.

Andy and Henry entered their conversational space with shared Creative Intelligence, daydreaming together, and imagining the next steps as they approached "taking the artworld of Manhattan." Andy's art production at The Factory depended on collaborating with other creative people: Paul Morrissey, John Giorno, Lou Reed, Gerard Malanga, Christopher Makos, Rupert Jasen Smith, Jean-Michel Basquiat, Francesco Clemente, and others.

Warhol and Marisol: *Kindling Creative Intelligence*

In a recent exhibition, *Marisol and Warhol Take New York,* curated by Jessica Beck at the Andy Warhol Museum in Pittsburgh, we discover their friendship and their pro-

found shared Creative Intelligence that helped ignite Pop art. Marisol matched Warhol for Creative Intelligence, and in many ways, had success before Warhol. They inspired each other, perhaps challenged each other, and certainly had fun together. Their Sphynx-like defiance to become media puppets was formidable. Marisol frequently created art that probably inspired Andy to do his version of her idea. Her giant portrait of *John Wayne* (1963) preceded Warhol's eight-foot-tall *Silver Elvis* (1963), and her self-portrait *Looking at the Last Supper* (1982–84), may have inspired Warhol's mega-series of *The Last Supper* (1986).

Where Warhol needed to become a business success to finance his art, Marisol had family money that allowed her to nourish her natural talents with the serious fun in daydreaming. The divergent brain state accomplished during daydreaming allows the brain to "free associate," to imagine. The artist's reflective mind can "play with possibilities," invent new ways to see things, and create abstractions in their virtual world that are rendered into material art objects. Marisol was a genius at daydreaming. Beck wrote:

> Relaxation and daydreaming were activities that Marisol spoke about frequently in interviews: "When I relax," she said in a 1964 interview in *Cosmopolitan,* "most of the time I daydream." That's when the best ideas come. I have to spend three-four hours daily daydreaming—otherwise I would lose touch with myself."

Marisol resonated with Albert Einstein's reflection.

> I am enough of an artist to draw freely upon my imagination. Imagination is more important than knowledge. Knowledge is limited. Imagination encircles the world... *The true sign of intelligence is not knowledge but imagination.*

Andy Warhol and Marisol exemplify shared Creative Intelligence. Their different life stories, emotional realities, and motivations for making art reciprocated with each other, and they followed their own pursuits. Warhol was driven toward wealth, power, and fame, the things he did not have as a child. Marisol, born into wealth and culture, sought truth.

POPism's Social Influence

Warhol knew that he could influence attitudes and behaviors in the people who looked at his Pop art. In the psychedelic 1960s, Timothy Leary, the LSD guru, chanted, "Tune in, turn on, drop out." As drug induced "mind manifesting" experiences of cosmic consciousness swept the culture of ambition and greed, Warhol embraced business as art and knew that art could be a medium of mind-manifesting experiences. Art could be a vehicle for changing perceptions of reality and promote opening culture to greater diversity.

Warhol was the quintessential "cool" anti-hero outsider and the ice-cool center of his own business world. He embodied a new view of everything. Sphinx-like, he consolidated many forms into a single new identity, the Warhol, in his lair, the Factory.

The Beholder's Share

In 1900, Austrian art historian Alois Riegl first discussed how past experiences shape our perceptions of art. Whether we enjoy, hold contempt for, or find ourselves bored with a work of art is informed by personal history. He introduced the idea of the beholder's share—that a viewer brings personal meanings to a work—and this interplay makes all art a collaboration between artist and audience.

When the viewer's brain-mind perceives a *Soup Can*, it initiates a complex process of deconstructing the image through the brain's visual system. While gazing at art, the brain attunes to the same contemplative state of consciousness as the artist, like a musical instrument. While the viewer is in the divergent cognitive state, multiple brain centers associate the viewer's own subjective experiences. The beholder's memories, emotions, and knowledge comingle to re-create the art as a meaningful image of his or her own in the brain-mind's eye. The beholder's share of the art completes the social meaning of the art. Marcel Duchamp explicitly cites the process:

> All in all, the creative act is not performed by the artist alone. The spectator brings the work in contact with the external world by deciphering and interpreting its inner qualifications and thus adds his contribution to the creative act.

The brain-mind/art-culture system is complete when the viewer creates conversations about his interpretation of Andy's art. These conversations inspire art magazines, research dissertations, art sales, art criticism, philosophy, fashion, movies, and beyond. The artist creates art that the viewer "completes" by perceiving it. Art is a socially charged, meaningful object with ambiguous, even mysterious, meanings and intentions designed by the artist to connect with the viewer.

Warhol was an expert impresario of the brain-mind/art-culture system.

The Factory: *Reinventing Art and Artist—an Art-Culture Laboratory*

In the 1950s, American artist Allan Kaprow coined the term *Happening* to describe an event that combined elements of painting, poetry, music, dance, and theater. Attending one of his staged Happenings was a must in the 1950s. Warhol was acutely aware of the transformations occurring in the New York art scene, and when he was ready to reinvent himself as a "fine" artist in the 1960s, he showed up at the forefront of culture. Like Warhol's childhood ideal superhero, Superman, whose Fortress of Solitude he built for himself, Warhol's Factory was his personal domain for experimentation, socialization, and kindling creativity. He was the master of his own reality, at last. Nothing like it had ever existed before.

As Warhol reinvented himself from graphic designer to Pop artist, he reinvented everything about being an artist. Rather than calling his workplace an artist studio or atelier, Warhol reflected pride in his working-class background and called it the Factory—by day, he focused on the business of art production and marketing, and by night, he became host to a perpetual Happening, a must-see-and-feel experience. Massive amounts of art, films, recordings, and photography emerged with the help of Warhol's workaholic patterns and a generous dose of stimulant medication. The night world Factory was a full immersion art experience—sex, drugs, and rock'n'roll. Warhol used the nightlife to kindle his own creativity as well as that of anyone who attended. His anti-elitist attitude reflected pride in his working-class background. Reframing art as something for everyone became the core philosophy of POPism.

> What's great about this country is that America started the tradition where the richest consumers buy essentially the same things as the poorest. You can be watching TV and see Coca-Cola, and you can know that the President drinks Coke. Liz Taylor drinks Coke, and just think, you can drink Coke, too.

Warhol created his own laboratory to study people, culture, and personality. The Factory was a time-space-art experience for people to enter. He would take photos, record conversations, and film people as if he were an anthropologist studying the celebrities, drug dealers, and artists that showed up in his lab. Andy created a persona, the Warhol, to function as ringmaster, social curator, documentary filmmaker, and transcriber. As an artist-anthropologist, he took inspiration and material from his nights of research to ignite his daytime creativity. The Factory functioned as an art–social science incubator for Warhol's Creative Intelligence that would transform him—and the world.

Andy completely understood the systemic links that connected his own brain-mind with the art-culture networks of New York. Art functions as a social communication system that activates mass Creative Intelligence, and Andy used his own vision to pilot cultural evolution.

Andy's Ordinary and Extraordinary Creativity

Nancy Andreasen MD, PhD, is a psychiatrist, professor of literature, neuroscientist, winner of the 2000 National Medal of Science award, and author of *The Creating Brain: The Neuroscience of Genius.* She has revealed the links between current brain science and what we have known about genius since classical times. The creative genius brain has an extraordinary capacity for making observations and connecting them in new ways. Art emerges from the divergent brain state—the free associations and internal communication between centers of consciousness in the brain. Walking into the Factory in the 1960s was like walking into a projection of Andy Warhol's brain.

Andy had the ability to toggle back and forth from divergent cognition to convergent thinking. He could talk business in a linear, profit-driven manner and move seamlessly to the nonlinear inventive mind.

At the Gala dinner for Pina Bausch in 1985 at BAM, the Brooklyn Academy of Music, I sat with Andy at Hedy Klineman's table for ten. We discussed one of our favorite topics, children's creativity. He shared his curiosity:

> Sometimes I have my driver take me to Harlem. I love watching the kids on the street. I photograph them with their new hairdos, their dances, and their clothing. They inspire me for my own work. This is where the next wave of culture comes from. Children are the future.

On the one hand, Andy had an anthropologist's mind, tracking culture, people, style, and possibilities. He was always researching the world, documenting it with photography, and activating his own creativity. His favorite topic was America, the people, the places, the things that made it a unique culture. The Gagosian Gallery mounted an exhibition of work from the 1980s, *London, 2002,* that highlighted Andy's constant themes of consumer culture, death, and religion that are powerfully represented in these late works.

Andy knew that fame allowed him to introduce many people to his art. He wanted to stimulate creativity in society and contribute to reshaping cultural attitudes and patterns of behavior. Andy's art is a shared laboratory for Creative Intelligence. Because it is pleasurable to be playful, experimental, and inventive, creativity is its own reward.

Andy's Creative Brain Map

Dr. Andreasen's groundbreaking research maps the creative brain using PET scans. She identifies the neural networks involved and how they function during the "ordinary creativity" of the human brain (which is quite extraordinary when compared to chimps or dolphins). Her neural network model distinguishes extraordinary human creativity from the everyday creativity that we all experience.

With our new "brain scanning" technologies, we can watch the brain think, feel, dream, do math, play chess, compose music, and even create. We can map the brain during stress, emotion, memory, love, motivation, belief systems, economics, and music. Dr. Andreasen's research looks at the brain during free association, a technique developed by nineteenth-century association researcher Wilhelm Wundt and popularized by Sigmund Freud to access the unconscious.

Andreasen discovered the randomly wandering unconscious free associations are rooted in the association cortices of the brain. She identified the contribution of unconscious processes that link social awareness, value systems, guilt, memory, personal identity, and past experiences. These interactions activate mindful awareness, allowing us to focus on self-awareness and disengagement, censorship and freedom, or consciousness and the unconscious.

Andreasen endorses the case-study method and the "introspective descriptions of the creative process" to reflect what's happening in the creative brain-mind.

Andy Warhol's backstory of Childhood Adverse Experience (ACE) offers new insight into his brain-mind system and how his Creative Intelligence became a Factory for making art and changing culture.

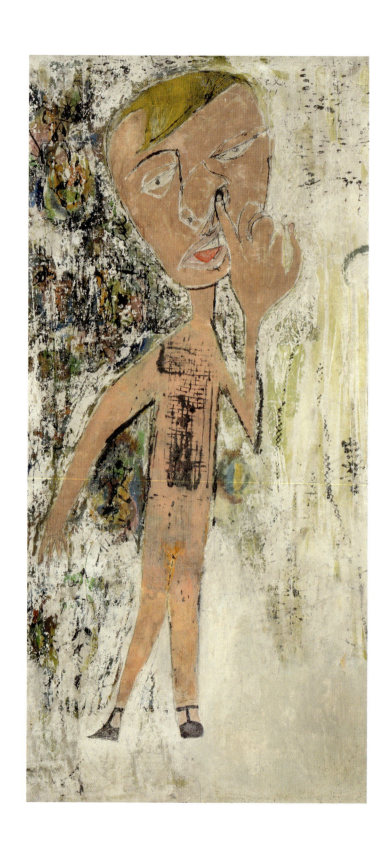

Nosepicker II
Andy Warhol, 1948
Tempera on Masonite
37 x 18 inches
94 x 45.7 cm

2 ANDY'S ACE

Adverse Childhood Experience

Andy Warhol's life story is a saga of grave adversity against human creativity—a life of mythopoesis. Andy's challenges began long before he was born. Julia Warhola suffered extraordinary traumatic events early in her adult life. And yet, with her genetic talents and social support of village life, she, too, was able to survive catastrophe and become a stable, loving mother for three boys. Andy's Adverse Childhood Experiences (ACE) included physical trauma, life-threatening infectious disease, neurological damage to his brain, loss of his father, gender identity confusion, and family stress. The family's genetic endowment for resilience and creativity proved to be a critical attribute that spanned generations.

Andy's Creative Brain: *What Science Tells Us*

New science reveals the inborn traits of resilience and creativity can be enhanced through learning and practice. By integrating our natural resilience with creativity, we cultivate Creative Intelligence. The development of robust Creative Intelligence begins in the patterns of emotional and behavioral mother-child attachment. The relationship between Julia Warhola and Andy exemplifies the idea that *human creativity is the antidote to toxic stress—vis medicatrix naturae,* the healing force of nature. Creative Intelligence is rooted in childhood play, cultivated with education, and expanded with exploration, experimentation, and innovation.

Andy's childhood presented extraordinary adversity to his brain-mind-body development. With an attentive mother, a supportive family, a secure cultural context of religious belief, and an immigrant cultural community, his talents blossomed throughout his life of extraordinary creativity.

Andy's ACE: *Poverty, Pittsburgh, Psychobiology, and PTS*

Andy experienced many ACE. Vincent J. Felitti, MD, describes how ACE negatively affects the life-course, often predicting self-sabotaging behaviors that increase morbidity and diminish longevity. In *The Relation Between Adverse Childhood Experiences and Adult Health: Turning Gold into Lead* (2002), he reports groundbreaking research that compares current adult health status to childhood experiences decades earlier. This detailed biopsychosocial evaluated more than fifty thousand adult Kaiser Foundation Health Plan members per year. A powerful relation exists between our emotional experiences as children and our adult emotional health, physical health, and major causes of mortality in the United States. Moreover, time does *not* heal some of the adverse experiences we found so common in the childhoods of a large population of middle-aged, middle-class Americans. One doesn't "just get over" some things. The ten ACEs of trauma are forms of physical/emotional abuse, neglect, and household dysfunction. The real damage from ACE unfolds over the life cycle with chronic, *toxic stress*.

Andy Warhol began his extraordinary life in poverty. Suffering life threatening illness, immersed in the filth of a toxic environment of an industrial city, the early death of his father, gender identity stress, and socioeconomic stigmatization, his chances for survival were low. With a background of poverty, low socioeconomic status, and immigrant stigmatization, the possibility of becoming a business success were statistically at 1 percent.

Andy Warhol scored 6/10 ACE. People with an ACE score of 6 or higher are *at risk of their lifespan being shortened by 20 years.* This contributes to explaining his early death at age 58. Andy's mother, Julia, despite severe stress as a young adult, lived to be 81.

Andy's Stress and Bruce McEwen's Hostage Brain: *Art Against Phantom Stress*

In *The Hostage Brain* (1994), Bruce McEwen, PhD, presents a framework on how the brain-mind-body-environment can be hijacked by toxic stress. As the Alfred E. Mirsky professor and head of the Harold and Margaret Milliken Hatch Laboratory of Neu-

roendocrinology, at the Rockefeller University, his research focused on the stress regulatory system—*the allostatic system.* In 1999, as assistant professor of child psychiatry at New York Hospital, I approached Bruce with my book project, *Phantom Stress, Brain Training to Master Relationship Stress: An Introduction to Logosoma Brain Training (LBT),* 2010. LBT integrated developmental neurobiology, Buddhist mindfulness practices, and linguistics into a clinical method for learning "ways of listening toward the end of suffering." Bruce invited me for lunch at Rockefeller University to discuss the project. He said, "I think you're onto something here. Do you want to put some science in it? I'm trained as a neuroscientist, but I consider myself a molecular sociologist. You might find the science behind your ideas compelling."

That was the beginning of a long friendship, mentorship, and an endless series of attending neuroscience conferences around the world. Through Bruce, I attended private high-level conferences at Rockefeller University with some of the top researchers in the world, including Joe Ledoux, Michael Meaney, Antonio Damasio, E.O. Wilson, Robert Sapolsky, Eric Kandel, B.J. Casey, Elizabeth Gould, and others. In 2012, Bruce helped organize the twenty-fifth Mind and Life Institute's dialogue with His Holiness the Dalai Lama at Caspary Auditorium of the Rockefeller University, a world-renowned center for research and graduate education in the biomedical and physical sciences. The theme was Contemplative Practice and Health: Laboratory Findings and Real-World Challenges. Bruce sat next to me before the conference started and said, "I bet you never thought you'd see this day when you were a med student in India!" He knew that day was one of the most important days of my career. Receiving initiations from H.H. Dalai Lama in 1976 and then greeting him in 2012 with countless Nobel Prize winners and great scientists profoundly gratified my life mission.

McEwen's critical research reveals how stress builds up over time causing an elevated *allostatic load* that results in *burnout*—a breakdown in the biopsychosocial functions of the individual. He explained the difference between episodic stress and toxic stress. Episodic stress triggers the beneficial transient release of stress hormones, adrenaline, and cortisol, and activates the immune system to prepare for defense against injury. When stress is chronic and unrelenting, it can be toxic for the brain and body, especially for the developing brains of children. Toxic stress impairs the

immune response, and excess cortisol kills brain cells in the hippocampus. The toxic effects of high levels of cortisol damage many other tissues and hormonal regulatory systems. Chronic, toxic stress includes environmental toxins, poverty, physical illness, family stress, perceived vulnerability, violence witnessed or experienced, loss of a loved one, and many others. Andy suffered all of these at one time or another over many years.

Michael Meaney trained in McEwen's lab (1980–81). As director of the Sackler Program for Epigenetics & Psychobiology, Douglas Research Centre at McGill University, Meaney explores the quality of attachment in the mother-infant bond. "We have come to understand how infant-mother bonding has a genetic effect on the developing brain, its reactions to stress, and its resilience to stress."

Sadly, the world lost a great pioneer and mentor when Bruce passed in 2020. In an obituary written by Michael Meaney, Meaney remembers, "Bruce's training provided a vision for the integration of cell and molecular biology with the social sciences and, ultimately, the study of health across the lifespan… Bruce… forged the path by which he became a 'molecular sociologist.'"

In my private conversations with Bruce, it was clear that he was a contemplative philosopher at heart. His curiosity about mind, consciousness, and humanness always made for a great rapport with my clinical work and his science. When I finally published *Phantom Stress*, Bruce wrote the jacket endorsement:

> Modern neuroscience tells us that the brain is a dynamic and resilient organ. Dr. Romero presents an appealing strategy based upon current scientific information and his own extensive clinical experience for using this capacity for resilience to overcome the ravages of toxic stress.

A few years earlier, I had the privilege to review the personal writings of psychoanalyst D.W. Winnicott in the Payne Whitney Historical Archive. He introduced critical concepts on the nurturing of creativity, the infant-mother "holding environment," the "good enough" mother, and the origins of the True Self and the False Self. His work laid a foundation for my own clinical theories.

Winnicott's "good enough" mothering describes the development of a secure bond in the "holding environment" of the mother-child attachment. Meaney's research reveals the biopsychosocial mechanism of how "good enough" mothering confers genetic changes that boost the allostatic system's resilience to stress in adulthood. Good mothering confers longevity and resilience. Meaney provided fact-based mechanisms of how early experience permanently alters behavior and physiology. Changes are mediated through sustained alteration in gene expression. He observed that high level mother-infant grooming in the first week of life alters DNA structure at the glucocorticoid receptor gene promoter in the hippocampus of the offspring. His experiments in cross-fostering between high- and low-grooming mothers revealed that the effects are reversible and last a lifetime. Meaney notes that the damaging effects of stress in early development can be overcome with improved mothering and an enriched environment that recruits the natural creativity and resilience.

Andy Warhol and Julia exemplify this process. Andy's ACE, toxic stressors of childhood, were mitigated by his creative interactions with Julia.

Julia's "Good Enough" Mothering for Andy

Despite Julia's posttraumatic stress and Andy's adverse childhood experiences, their shared experiences in making art empowered creativity and resilience between Julia and Andy. Their creative bond conferred considerable resilience and enhanced creative problem-solving for both throughout their lives together. They remained a codependent duo for the rest of her life. This was the foundation for Andy's complex conflicts. He struggled with a need to split his world into two distinct realms: public and private. Their attachment played an important role in his prodigious Creative Intelligence.

Andy emerged with enormous resilience, creativity, and success in his lifetime. Although he struggled against posttraumatic stress and obsessive-compulsive symptoms, his resilience to adversity was kindled with positive emotional connections, an enriched environment, exercise, and stimulation of creativity. Exploring the development of Andy's brain-mind-family system, we will see how he learned to use creativity and art to mitigate life-threatening illness, family adversity, poverty, a toxic environment, and gender confusion.

Julia's Tragic Saga: *Infant Death, War, and Pandemic*

In *The Life and Death of Andy Warhol* (1989), author Victor Bockris reveals a detailed account of the families, the village culture, and the courtship between Andrej Warhola and Julia Zavacky. Julia was a talented, beautiful, vivacious person, desired by many men. She had talents from art to music. They married in 1909 in Mikova, Czechoslovakia—a tiny village known once as a center for taxidermy. After three years, they got pregnant before Andrej left for America. Andrej had hoped to bring Julia to Pittsburgh and improve their life, but Julia endured nine years of severe toxic stress before making her way to America. Her most traumatic stresses may have been the loss of her infant daughter, Maria.

Elaine Rusinko, associate professor emerita at University of Maryland, Baltimore County, discovered that Julia's first child was named Maria, and she died one month after birth in 1912.

Additional chronic stressors to Julia's traumatic stress include:

- Death of her father
- Separation from Andrej before the birth of their daughter, Maria
- Lives with Warhola family
- Brother Yurko leaves for war and is mistakenly reported dead
- Forced to work in the fields for 12-hour days after childbirth
- Julia's mother, Josephine, dies after hearing of Yurko's death
- Famine hits Mikova, results in near starvation for Julia and her two younger sisters
- World War I begins and Mikova is devasted
- Julia's house burns, loss of all her possessions
- Mass execution of men from 36 families in nearby village
- From 1914 to 1918, she and her sisters live in chronic fear of soldiers, so they take a horse-drawn cart into the forest and stay for days until the soldiers leave
- Spanish influenza pandemic is severe in Carpathia
- With a loan from a priest of $160, she travels by cart, train, and ship for months to arrive in America in 1921

Julia escaped the war and disease that ravaged her homeland only to arrive in the immigrant ghettos of Pittsburgh. Urban filth, poverty, malnutrition, and overcrowded housing became the new environment in the lowest socioeconomic community in town—no forest, no farmland, no fresh air, no village community to support her. But there was St. John Chrysostom Byzantine Catholic Church, a historic Eastern Catholic church. Andrej was a strict Catholic, and Julia thrived on the social connections. Andrej worked hard in Pittsburgh and tried to save money. Both Andrej and Julia had suffered extreme hardship and separation from each other before reuniting in Pittsburgh to start their own family.

Julia's severe stress load would overwhelm anyone's allostatic system. Her post-traumatic stress would cast a long shadow and affect her attachment to her third son, baby Andek. When Andy was born, Julia was blessed with a pale-skinned infant with blonde hair. She may have had conscious and nonconscious associations to her daughter Justina, and possibly wished for a girl, after having two robust sons, Paul and John. As Andy grew, the "holding environment" between Julia and Andy would prove to be a complex crucible for nurturing Andy's prolific Creative Intelligence.

Andy's Brain: *Ravages from Sydenham Chorea*

Andy suffered numerous illnesses, the worst being rheumatic fever at age eight. A few months later, he developed Sydenham Chorea (SC), commonly called St. Vitus Dance. SC is a neurological disorder of childhood resulting from infection via Group A beta-hemolytic streptococcus, the bacterium that causes rheumatic fever. SC is characterized by rapid, irregular, and aimless involuntary movements of the arms and legs, trunk, and facial muscles. Symptoms include muscular weakness, stumbling and falling, slurred speech, difficulty concentrating and writing, emotional instability, a halting gait, slight grimacing, and involuntary movements. Symptoms can be frequent and severe enough to be incapacitating. The random, writhing movements of chorea are caused by an autoimmune reaction to the bacterium that interferes with the normal function of a part of the brain that controls motor movements.

Andy's PANDAS

It is likely that Andy developed Pediatric Autoimmune Neuropsychiatric Disorders Associated with Streptococcus (PANDAS) infection. For unknown reasons, these antibodies also target certain cells in the brain, specifically cells of the basal ganglia, the part of the brain that controls motor movements. The toxic effects of PANDAS triggers brain changes that cause lifelong effects such as obsessive-compulsive disorder (OCD), attention deficit/hyperactivity disorder (ADHD), tic disorders, and autism.

Andy struggled with these sequelae, especially OCD, and autistic-spectrum type traits that made socializing problematic. To meet the physical challenges to his brain, body, and social identity, Andy marshalled his Creative Intelligence to adapt and thrive with his creation of his artist persona the Warhol.

Andy's Hostage Brain: *OCD and Brain Lock*

Andy struggled with OCD, the "doubting disease," throughout his life. His Creative Intelligence had a formidable obstacle in his brain. OCD is regarded as the archetypal disorder of compulsivity, a tendency toward repetitive habitual actions that a person feels a need to perform. These tendencies detract from overall life goals, or quality of life—*brain lock*. OCD and related disorders include hoarding disorder, body dysmorphic disorder, trichotillomania, skin picking disorder, and Tourette's. Structural and functional changes occur within the brain. Cortical and subcortical brain regions comprise a series of circuits that may play different roles in thoughts and behaviors. Malfunction in these circuits produces a disorder of habit formation and loss of top-down (mindful) control by cortically mediated inhibitory mechanisms (referred to as *disinhibition*).

Andy's Time Capsules: *Artist-Mind Against OCD*

Andy's Creative Intelligence, nurtured across his life by Julia, his family, his friends, art teachers, and colleagues in New York, sublimated his OCD symptoms into art. For example, his compulsive hoarding was transformed into an art project, *Time Capsules.* The Warhol Museum writes:

During the latter part of his life, Warhol created over 600 *Time Capsules* by collecting and storing various items in cardboard boxes and other common storage containers. Warhol would simply fill a cardboard box with a variety of objects that represented a period of time. Each *Time Capsule* became an archival treasure trove, teaching us about the life, art, and career of Andy Warhol. The items contained in his *Time Capsules* range from everyday ephemera to valuable artworks and everything in between (including autographed underwear)!

Andy Warhol developed a variety of behavioral and emotional patterns that may have been a direct consequence of Sydenham chorea—obsessive-compulsive checking and collecting, chronic self-doubting and insecurity, flattened affect, and minimal verbal expressiveness with social anxiety. What is extraordinary about Andy Warhol, the artist, is that his creative mind transformed obsessive-compulsive *disorder* symptoms into obsessive compulsive *traits* (OCT). OCT is highly adaptive. It requires mindful effort for self-regulation of stress, emotions, and behaviors to override compulsive behaviors. Andy discharged his obsessive-compulsive impulses into producing art and mitigating the paralyzing symptoms of brain lock, doubt, and indecision. He was able to extend his creative will socially, turning the executive functions of "making art" to assistants. Paul Morrissey, who directed many of Andy's films, observed:

> Andy was a nonverbal person; you couldn't get directions out of him. All he knew was what was modern in art was what wasn't art: The telephone was art, the pizza was art, but what was hanging on walls in museums wasn't art.

> Andy wasn't capable of any complicated thoughts or ideas. Ideas need a verb and a noun, a subject. Andy spoke in a kind of stumbling staccato. You had to finish sentences for him. So, Andy operated through people who could do things for him. He wished things into happening, things he himself couldn't do.

Andy had the magic touch, influencing people to do his bidding. This empowered his skill of transforming symptoms into art. His assistants helped him with making repetition of images, multiples, time-capsule boxes in which he kept everyday things, his personal art collection, and more. Warhol's *Time Capsules* continue to inspire re-

search and displays at the Warhol Museum, providing ongoing examples of Warhol's alchemy to transform everyday objects into precious *objet d'art*. Beyond his lifetime, like the contents of a pharaoh's tomb, Warhol's *Time Capsules* exemplify his idea:

> The idea is not to live forever, it is to create something that will.

Andy's Brain-Mind Factory: *The Healing Power of Art*

Warhol transformed childhood trauma, faulty brain circuits, obsessive-compulsive disorder, and developmental adversity, into art. His Creative Intelligence was always at work. The creativity machine in his brain was the real Factory. He felt like a hostage to his body and symptoms. But rather than crumbling under the weight of his damaged brain, his artist-mind reinvented itself as a creativity factory. As the CIO (Creative Intelligence Officer) of his brain-mind machine, he recruited an army of assistants to execute his ideas. He eloquently reflects:

> Being born is like being kidnapped. And then sold into slavery. People are working every minute. The machinery is always going. Even when you sleep.

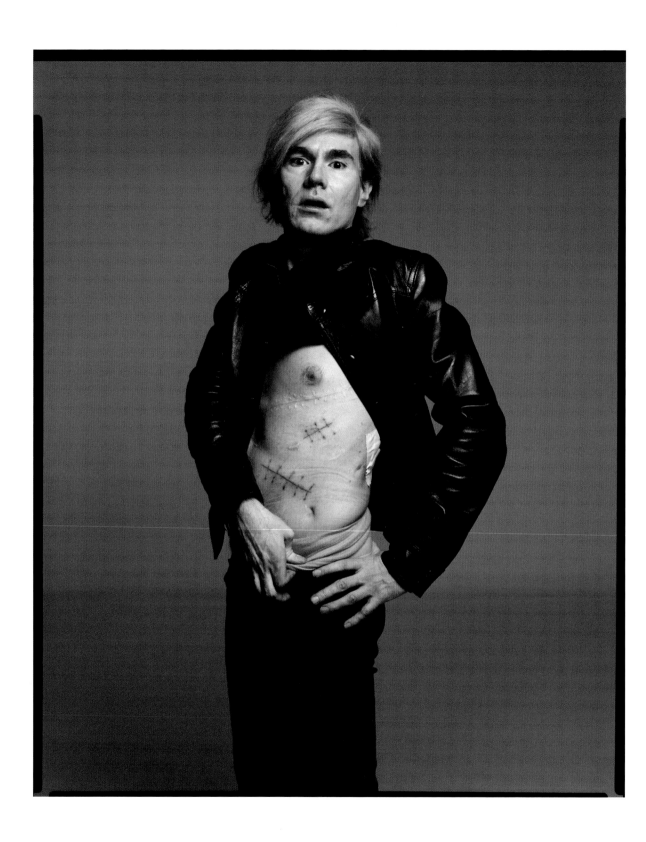

Andy Warhol Artist, New York City,
Richard Avedon, 1969

3 ANDY'S PHANTOM STRESS
Shadows, Mirrors, and Death

Sanctuary in the Shadows of the Silver Screen Mirror

Andy Warhol was obsessed with shadows, mirrors, and death throughout his life. Like every child in the Great Depression, he sought sanctuary from the agony of his damaged body and harsh life of poverty in the silver-screen movie theaters. There, in the safety of shadows, he could identify with and idealize his favorite star, Shirley Temple. Andy reflected, "I never wanted to be a painter; I wanted to be a tap dancer." He adored her and wrote to her as a fan, receiving a treasured photo, signed "To Andrew Worhola from Shirley Temple," and dated 1941 on the back.

Daydreams about his future let his imagination ricochet from the mirror of the shimmering silver screen. His visual-emotional memory was imprinted with flickering images that were reactivated with his Creative Intelligence and projected in his art, his films, and his philosophy.

Phantom Stress: *Andrej Warhola's Death*

The shadows of the movie theaters could not protect Andy from the traumas of his life. In 1942, at age fourteen, he suffered another traumatic stress—his father, Andrej Warhola, died at age fifty-five from complications of hepatitis, chronic stress, and inadequate medical care. As his adolescent metamorphosis began, the imprint of his father's death would cast a lifelong shadow on Andy.

The entire Warhola family plunged into grief—the breadwinner was gone; Julia had lost her chief support; brothers took over as the "men of the house"; and teen Andy was frozen in fear under his bed in his room for three days during his father's wake, which took place in the family drawing room. Whatever anxieties Andy had about illness or death were amplified, possibly triggering posttraumatic stress (PTS) symptoms.

Traumatic stress can have lifelong effects on brain function. When the individual cannot control their reaction to stress, symptoms emerge. Panic attacks, phobia, avoidant behavior, generalized anxiety, social anxiety, depression, flashbacks, emotional numbness, and dissociation can occur.

Andy's traumatized pubertal brain added a new layer of stress to his already overloaded mental-emotional-physical system. Andy would avoid funerals for the rest of his life, even his mother's. Andy's brain had been tattooed with traumatic stress, imprinting phantom stress patterns of avoidance and experiences of dissociation. The term *phantom stress* borrows from the physiology of the phantom limb, the cognitive perception of pain in a severed hand. Pain is perceived by the brain region devoted to sensation in the hand even after the hand has been amputated. Like the amputated hand, stress from the past is etched in the brain, haunting the neural networks of emotional memory that can be reperceived by circumstances in the present—hence the term *phantom stress*.

Logosoma Brain Training: *Rewiring the Script for the Mind-Body Link*

In 1985, I developed Logosoma Brain Training (LBT)—*logos = word, soma = body*—to master relationship stress for my clinical practice in family psychiatry. LBT empowers mindful self-regulation for relationship stress by integrating clinical neuroscience with mindfulness. The brain's neuroplasticity can be recruited to unlearn old stress-driven reactions and relearn mindful patterns of cognition, emotion, and behavior. LBT activates Creative Intelligence to prevent burnout and reverse damage from toxic stress.

I had personal experience as an artist mitigating my own stress and detoxifying negative memories by making art. Mindfulness is activated in making and beholding art. I learned the *healing power of art* as I practiced the *art of medicine.* Exploring the links between art, mind, and medicine would be my life's mission—the science of the brain-mind/art-culture system. As a child psychiatrist, I researched the role art plays in individual development and cultural evolution.

One of Andy's doctors recommended that he speak with me about his PTS. When I spoke with Andy as a friend, he acknowledged having many of these debilitating experiences, but he was not interested in talking to a doctor about the symptoms, recalling, "I saw a psychiatrist in the 1950s, but he wasn't helpful." When I invited him to do an interview for my book project, *The Art Imperative: The Secret Power of Art*, he said:

> I have that Art Imperative thing. I just keep making art and going out, keeping busy. I don't know what I'd do if I didn't make art. Working and TV helps keep my mind on doing positive things.

Andy's wit reflected his solution to PTS. He became a compulsive socialite, challenging his fear of socializing and cultivating an endless hunger for external validation—fame. He was able to sublimate anxiety and stress into many aspects of his artist life. He wrote:

> I have Social Disease. I have to go out every night. If I stay home one night, I start spreading rumors to my dogs.

Art against Stress: *Andy's Creative Resilience*

With Julia's guidance, Andy intuitively embraced creative resilience from childhood onward. Growing up with chronic, traumatic stress, and life-threatening illness, he was fortunate to have a support system that empowered his resilience. Andy developed the five critical mechanisms for mitigating PTS over many years of adversity. They include:

- *physiologic steeling* to the negative experience (he had spent a lifetime toughening to pain and fear with acceptance and gratitude)

- *coping mechanisms* (television, compulsive artmaking schedule)

- *psychological understanding* (his Creative Intelligence helped him use art to make sense of the things that plagued him: social anxiety, identity doubts, death. He developed a complex personal philosophy—*The Philosophy of Andy Warhol*)

- *social connectivity* (family, work, and socializing recruited his attention to positive experiences and emotional connectivity)

- a story of *personal meaning* (Catholic faith, POPism, fame, gender identity, and business drove Andy through the pain beyond fear and doubt).

Andy's extraordinary creative output emerged from a complex integration of compulsive brain circuitry, positive social connectivity, a loving family, a private, devoted

faith to Catholicism, close friends, his pets, and attention from strangers. All these factors mitigated his chronic, toxic stress. However, the long shadow of phantom stress took a toll on his lifespan due to adult traumatic stress.

Andy's Quest for Love: *In Search of Empathy, Validation, and Security*

Andy, armed with the American drive for hard work, inborn artistic talent, and a devoted mother, set out for New York to create a life and career in advertising. He was wildly successful. Wealth and fame were established. But the hunger for love was unrequited. Writing in The Philosophy of Andy Warhol (1975), he recalled:

> At the times in my life when I was feeling the most gregarious and looking for bosom friendships, I couldn't find any takers, so that exactly when I was alone was when I felt the most like not being alone... I became a loner in my own mind... I decided I'd rather be alone.

Psychoanalysis was booming among the stressed-out executive class in New York in the 1950s. Alfred Hitchcock's psychological thrillers—*I Confess* (1953), *Vertigo* (1958), *Psycho* (1960)—gave piercing insight of how depth psychology reveals the unconscious roots of human suffering that ignite self-sabotaging behaviors. Andy was starving for love. His workaholic lifestyle could not protect him from the burgeoning unconscious warehouse of phantom stress from childhood. Julia had moved in with him, so "mother issues" were a daily source of stress. They created art books together. His awkward personality, social shyness, and pushy temperament were not scoring points for partnership. He earned the nickname in his profession of Raggedy Andy due to his frumpy suits and paint-spattered shoes.

In *The Philosophy of Andy Warhol,* Andy recalled:

> Because I felt I was picking up the problems of friends, I went to a psychiatrist in Greenwich Village and told him about myself. I told him my life story and how I didn't have any problems of my own and how I was picking up my friends' problems and he said he would call me to make another appointment so we could talk some more, and then he never called. As I'm thinking about it

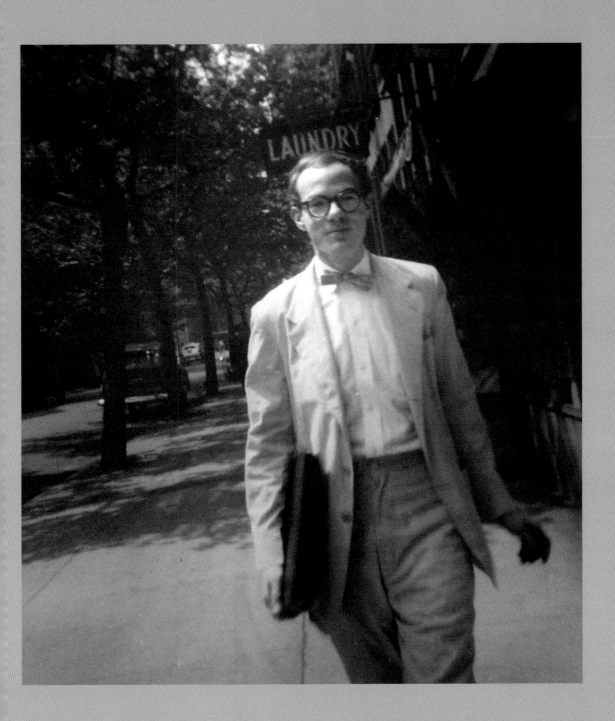

Raggedy Andy,
Leila Davies Singelis,
1950

> now, I realize it was unprofessional of him to say he was going to call and then not call. On my way back from the psychiatrist's office I stopped in Macy's and out of the blue I bought my first television set, an RCA 10-inch black and white. I brought it home to my apartment where I was living alone...and right away I forgot all about the psychiatrist. I kept the TV on all the time, especially while people were telling me their problems, and the television I found to be just diverting enough so the problems people told me didn't affect me anymore. It was like some kind of magic.

During childhood, movie theaters provided sanctuary for Andy. The darkness and the flickering screen-mirror kindled his robust imagination. The storyline and the soundtrack held him in a virtual world, free of pain, fear, and shame. He could be the king of his own kingdom in the shadow world between the film and his mind.

Andy found magic in his first television; it was therapeutic for him. Television was literally a movie theater in a box. His frail sense of self had trouble processing interpersonal social emotions—"I felt I was picking up the problems of friends." He was unconscious of many of his own problems, and by projecting them on others, they became more manageable. He could escape the real world of emotional entanglements with television and mitigate loneliness. Television was a portal to safety, the in-between zone that protected him from the stresses of the external world and the phantom stresses of his adverse childhood experiences.

Andy's Unrequited Love: *From Love to Fame*

Ironically, Andy's hope for love in the 1950s was Charles Lisanby, a television production designer. Lisanby tells the poignant story of his first meeting with Andy in an interview for EmmyTVLegends.org. The two met at a New York cocktail party, where Andy had been sitting alone in a corner, avoiding any socialization. Charles, feeling empathetic, chatted with him, and they left the party together. Andy offered to drop him at his apartment by taxi. As they waited for a cab, Lisanby noticed a stuffed peacock in the window of a taxidermy shop, and he told Andy a story about peacocks on his father's farm. Within a couple of days, Lisanby arrived home to find a package at his door—the stuffed peacock! The gesture kindled a "bosom friendship" Andy craved. They spent time together drawing, taking photos, and inspiring each other's work. Charles came up with the title to Warhol's book *25 Cats Name Sam and One*

Young Charles Lisanby in garden, Private Collection

Blue Pussy, and both artists frequently exchanged art and ideas into the early 1960s. In 1956, Charles and Andy took a month-long trip around the world that directly inspired Warhol's *Golden Shoes* series.

In WarholStars.org, Gary Comenas documents the life, times, and legacy of Andy Warhol. In *Andy Warhol: From Nowhere to Up There,* he quotes Victor Bockris and Charles Lisanby describing a confrontation between Charles and Andy on the second night of their trip in a hotel room in Honolulu.

> **Victor Bockris:** Charles and Andy had a confrontation on the second night of the trip in a hotel room in Honolulu. Andy had suggested they have separate rooms in San Francisco but when they got to Honolulu Charles said, "This is ridiculous," and got them a double with twin beds overlooking the beach. It was around three o'clock in the afternoon.

Charles wanted to go out and cruise the beach immediately but Andy, appearing jet-lagged, hung back. As soon as Charles hit the beach, he ran into a particularly beautiful young guy with a great story about how he had to pick up one soldier every day in order to support his family, and after talking to him for a while Charles suggested they go up to the room to take some pictures. As Charles walked down the corridor of the hotel to their room with the kid, he hoped that Andy had gone out but figured he could handle the situation if he hadn't. Finding that he had forgotten his key, Lisanby knocked on the door. There was a long pause and then, furtively, with the chain on, Andy peeked out. "Andy, open the door," Charles said, "we..."

Andy took the chain off the door and stepped back half a foot, still blocking the entrance, and said, "Who's tha- what are you doing?" Suddenly he went berserk, screaming, "How dare you bring someone back here?" and lifting both his hands up over his head to bring them crashing down on Charles.

"Andy, stop it! Calm down!" Charles cried and grabbed hold of his wrists. "Stop it!"

Andy screamed, "How dare you? Get out of here and don't come back!" stepped back and slammed the door.

Charles Lisanby: I still didn't have the key and he wouldn't open the door. I shouted, "Andy I know you're in there and you might as well open up because I can go and get another key!" and finally he opened the door. He walked back across the room and slouched on the bed droop-shouldered and said, "I want to go home. There's no use in going on."

He wasn't behaving angrily anymore. He was very aloof, trying to ignore that anything at all had happened and ignore me and shake the whole thing off. I was feeling very guilty. I wanted very much to stay his friend and I didn't want him to be angry with me and I didn't want him to hate me. I didn't want to lose Andy. I said, 'Yes we are going on.

> You've come this far, and I won't let you go back.' I was very concerned because here was somebody who was obviously in torment, and I realized this was a confrontation. He wanted to be persuaded to go on, and he wanted me to give in and decide that now was the time that something was going to happen, and I had to get out of that one.
>
> I remember the windows and the ocean outside. It was still not sunset, but it was getting close to it. I remember sitting beside him. I put my arms around him, and I was trying to calm him down, and he really did totally break down crying and then it got worse, and he couldn't stop. He really couldn't stop sobbing hysterically and crying on the bed. It was that he didn't want to be alone. Andy always wanted to be in his own center, but he wanted somebody to share it with. I knew that he loved me, but he said, in a soft, trembling voice, "I love you." I said, "Andy, I know, and I love you too." And he said, "It's not the same thing." And I said, "I know it's not the same thing, you just have to understand that, but I do love you."

When Warhol bought a house, he urged Charles to move in with him. Andy even tried to give Charles one of his famous Marilyn Monroe prints that he made specifically for him. Lisanby refused Marilyn and their friendship faded. Andy's unrequited love fueled his creative talent and obsession with becoming a great artist.

Andy's insecure attachment, emotional dysregulation, and need for external validation made a long-term relationship problematic. His insatiable hunger for validation could not be satiated by any single love relationship. He needed more. Fame and wealth became his obsessive goals.

Assassination Attempt: *Andy's Phantom Stress*

After Andy was shot, he was recorded by the *New York Times* saying:

> I was shot, and everything is such a dream to me. I don't know what anything is about. Like I don't even know whether or not I'm really alive or—whether I died. It's sad.

The magnitude of the traumatic stress compounded the high load of chronic posttraumatic stress that shaped Warhol's brain, his personality, his social patterns, and his art.

Steven Watson begins his monumental work, *Factory Made: Warhol and The Sixties* (2003), stating:

> What is usually regarded as Andy Warhol's golden age started in the 1960s, when he began his earliest Pop paintings. It ended on June 3, 1968; the day Valerie Solanas shot him. He was declared officially dead for one and a half minutes.

Valerie Solanas retraumatized Andy in her assassination attempt at the Factory. Solanas fired two gunshots, severely damaging Warhol's stomach, liver, spleen, esophagus, and both lungs. He flatlined on the operating table, requiring open chest cardiac massage that resuscitated him. Warhol was permanently impaired. He spent two months in the hospital undergoing multiple repair surgeries and recuperating. Chronic pain, physical disability, and expanded phantom stress would be lifelong companions. Due to his frail state, he would have to wear a surgical corset for the rest of his life to hold his organs in place. PTS symptoms of dissociation and numbness hijacked Andy's mind-body relationship.

> Before I was shot, I always thought that I was more half-there than all-there—I always suspected that I was watching TV instead of living life. ... Right when I was being shot and ever since, I knew that I was watching television. The channels switch, but it's all television.

In 2018, Sarah Pruitt wrote an article for History.com titled "Andy Warhol Was Shot by Valerie Solanas: It Killed him 19 Years Later," implicitly focusing on the toxic effects of phantom stress that eroded his health.

Andy's posttraumatic stress amplified nonconscious body memories of past physical pain, helplessness, and fear (Sydenham chorea). It is likely that the chronic pain and inflammation from the gunshot wounds contributed to the production of toxic levels of the stress hormone, cortisol, over time. Chronic elevated cortisol is toxic to the brain, the gut, the immune system, and the cardiovascular system. Andy's phantom stress cast a very long shadow from his ACE to the assassination attempt and shortened his lifespan.

The Day Andy Died

Andy's dermatologist, Dr. Karen Burke, a close friend, called me the day Andy was hospitalized for emergency gall bladder surgery. Warhol had been terrified of hospitals. He hda refused surgery once before after being diagnosed with a gallstone. She said, "Andy is convinced he will die if he is hospitalized." He was admitted to New York Hospital, where I was assistant professor of child psychiatry. She implored, "Please visit Andy after surgery as his friend. He's afraid he's going to die in a hospital."

"Of course," I replied.

The next morning, as I prepared to visit Andy, the news broadcast declared "Andy Warhol is dead." I was stunned, shocked, saddened, and dropped onto the couch. It would trigger a lifelong quest to understand what happened to my inspirational friend.

Blake Gopnik reported in the *New York Times* (2017):

> For at least a month before his death, Warhol had been ill, but had done his best to keep up his usual exhausting pace. His terror of hospitals had prevented him from getting any serious treatment. Even once Warhol had finally ended up in the office of Bjorn Thorbjarnarson, a leading surgeon — he was known for treating the Shah of Iran — Warhol had begged for stay-at-home treatment. "I will make you a rich man if you don't operate on me," the artist had said, Dr. Thorbjarnarson recalled during my visit to his New Jersey home in 2014. (He is now 95 and lives in Florida.)

Andy dealt with health issues using alternative methods, nutrition, exercise, and crystals. He had regular visits with his dermatologist for facials. He suffered abdominal pain for weeks until his gallbladder became acutely infected. After undergoing surgery, he died the next day from postoperative complications.

Andy Warhol's estate settled a wrongful-death suit against the hospital for an undisclosed sum. James McCarthy, an attorney for Warhol's estate, said both parties agreed not to reveal the amount of the settlement. Warhol's family was reported to be "very happy" with the settlement, and a spokeswoman for New York Hospital called it "fair and equitable."

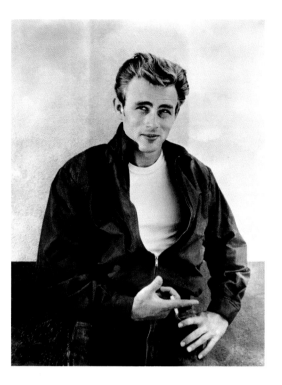
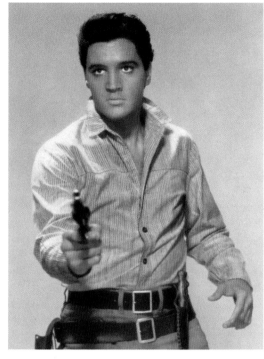
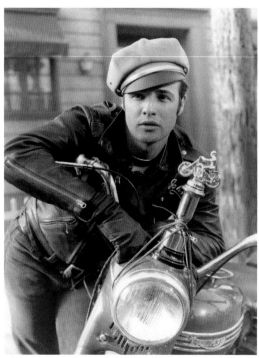
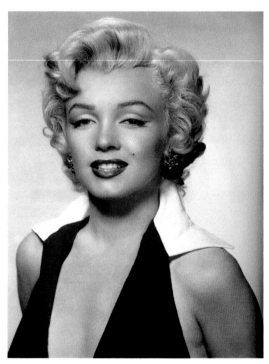

James Dean, *Rebel Without a Cause*, 1955.
Elvis Presley, *Flaming Star*, 1960.
Marlon Brando, *The Wild One*, 1953.
Marilyn Monroe, *Niagara*, 1953.

4 ANDY'S AUTOPOIESIS
Reinventing Andy Warhol

Love or fame? That is the question Andy Warhol faced in the 1950s. The pain of unrequited love with Charles Lisanby amplified Andy's drive for fame as an artist. Love was stressful, messy, and charged with interpersonal disappointments and emotional complexities. Convinced that fame could replace his craving for love, Andy looked to the movies for a solution to his pain.

Movie stars had it all. Everybody loved them. And they only had minimal social obligations to their adoring fans. They just had to make movies. Andy was already successful in the ad world, so perhaps his lifelong dream to become a famous artist could bring him the fame that seemed to make Shirley Temple so happy.

Fame could soothe the injuries and disappointments of personal love. Fame could solve the dilemma of loneliness. Fame could assuage helplessness and rage at feeling powerless in love relationships. Andy decided to transform himself, moving away from the shy, emotionally needy, socially awkward, Raggedy Andy persona of the 1950s.

Andy Warhol's Autopoiesis

It was time for Andy Warhol to reinvent himself. His Creative Intelligence focused on the biopsychosocial process of *autopoiesis*. Autopoiesis (Greek, *(auto-)* "self" and *(poiesis)* "creation, production") is the property of a living system (such as a bacterial cell or a multicellular organism) that allows it to maintain and renew itself by regulating its composition and conserving its boundaries. In 1972, Humberto Maturana and Francisco Varela introduced the term in *Autopoiesis and Cognition: The Realization of the Living*. Varela wrote in *Self-Organizing Systems: An Interdisciplinary Approach* (1981), "The notion of *autopoiesis* is at the core of a shift in perspective about biological phenomena: it expresses that the mechanisms of self-production are the key to understand both the diversity and the uniqueness of the living." In *What is Life?* (2000), Lynn Margulis and Dorion Sagan wrote: "All living beings, from a bacterial speck to a congressional committee member, evolved from the ancient common ancestor which evolved *autopoiesis* and thus became the first living cell."

Human living systems, from the individual to the family to the culture, are self-organizing systems. Nature drives human self-making, a conscious and nonconscious process, for survival and adaptation toward greater complexity. In *The Art Imperative: The Secret Power of Art* (2010), I explore the role of art in individual development and cultural evolution.

With his mother's support, Andy Warhol's talent, Creative Intelligence, motivation, personality, and imagination empowered his autopoietic powers to overcome major developmental challenges. As an adult, he used his Creative Intelligence to pursue fame and influence to shape cultural evolution beyond any artist in America.

Hollywood: *The Ultimate Makeover Machine*

Hollywood held a plethora of makeover models to emulate. Movies had always been a sanctuary, a mirror, and a crucible for Andy's imagination. Using movie stars as ingredients, he could transform himself into a new identity.

During the Technicolor 1950s, four iconic characters emerged that provided Andy with mirrors to model himself. Three male actors inspired Andy Warhol to draw or paint their portraits: Marlon Brando in *The Wild One* (1953), James Dean in *Rebel Without a Cause* (1955), and Elvis Presley in *Flaming Star* (1960). They were sexy male anti-heroes. They were "bad boys" with good hearts, outsiders with empathy, and utterly gorgeous to behold.

Andy Warhol: *Superstar*

In the 1950s, Andy Warhol lived the life of a shy workaholic commercial artist who failed to find "bosom friendship." Television and Julia were his only companions. His personality needed a new costume, a makeover, if he was going to become famous. Fame seemed more achievable than love for Andy, and he was a master of marketing images.

Warhol chose to create an identity from his authentic experience. He'd felt like an outsider since childhood, and like so many bullied children, he wanted to be Superman. He spent enough time as Clark Kent via his 1950s persona Raggedy Andy. Now it was time to become a famous, lonely, alienated superhero.

Andy invented an "anti-hero" super-artist as a character to cultivate—he called it the Warhol. He swapped his frumpy suit and bowtie for a leather jacket, dark glasses, and horizontal striped sailor shirt, like Elvis in *Jailhouse Rock* (1957). The death of James Dean was a wake-up call, inspiring Andy's drive to evolve.

James Dean: *A Critical Element in Andy's Self-Making*

James Colavito wrote "It's Time We Let James Dean Be the Queer Icon He Is" in *Esquire*, September 30, 2021. On September 30, 1955, screenwriter William Bast planned to move in with James Dean as his best friend and lover. Bast revealed the story decades later about their long, confusing courtship, full of starts and stops, denials and doubts. Dean finally decided to live together as partners and lovers, not just as friends. Before he could leave, Bast got a phone call that James Dean, just twenty-four, was dead, killed when his Porsche collided with another car in the California desert.

James Dean's tragic death sparked a global mourning that amplified his fame exponentially. Dean was a symbolic martyr for the youth, their teen angst, their feelings of social alienation, their emerging sexual urges, and their often-challenging gender identity confusion. In 1957, Stewart Stern (d. 2015) wrote a brilliant script for a Robert Altman film, *The James Dean Story,* an American documentary.

Andy was at the height of his career in advertising. He was struggling with love and disappointment. It is highly likely that Warhol saw this film, and his Creative Intelligence may have been inspired to learn from Dean's story. Stern wrote:

> James Dean died today. He had lived with a great hunger. His last film was *Giant*. When it opened a year after his death, Hollywood celebrated with the biggest premier in a decade. The night belonged to him. Everyone came and gave him an ovation each time his face appeared. They had made James Dean, and they wouldn't let him go. To keep him close, they made a legend in his name. From Maine to Manila, from Tokyo to Rome, he seemed to express some of the things they couldn't find the words for. Rage, rebellion, hope. The lonely awareness that growing up is pain. They wore what he wore.

They walked as he walked. They played the parts they saw him play. And they searched for the answers they thought he was searching for. Some found a kinship they had never known before. Youth mourned itself in the passing of James Dean. Because he died young and belonged to no one, every girl could feel he belonged to her alone. Because he died violently every boy could use him as a warning to his parents, "If you don't start understanding me, I could go the same way." A hero made of their loneliness. A legend made of their restlessness, their energy, their despair.

Stern's script could have been a formula for Andy's new fame-hungry persona. The *James Dean Story* provided Warhol with insights into James Dean's background, his pain, his thoughts, his ideas, and his reflections. Quotes from James Dean sound eerily like the aphorisms Warhol would produce over his career. Dean's attitudes and sentiments, like Warhol, reflect a struggling identity in deep, contemplative conflict in search of personal meaning. Warhol mirrored James Dean's reflection in myriad ways.

Dream as if you will live forever; live as if you will die today.

Only the gentle are ever really strong.
The gratification comes in the doing, not in the results.
Take it easy driving– the life you save may be mine.
Live fast, die young, leave a good-looking corpse.

There is no way to be truly great in this world. We are impaled on the crook of conditioning. A fish that is in the water has no choice that he is. Genius would have it that we swim in sand. We are fish and we drown.

An actor must interpret life, and in order to do so must be willing to accept all the experiences life has to offer. In fact, he must seek out more of life than life puts at his feet.

Being an actor is the loneliest thing in the world. You are all alone with your concentration and imagination, and that's all you have.

You're tearing me apart!

When an actor plays a scene exactly the way a director orders, it isn't acting. It's following instructions. Anyone with the physical qualifications can do that. So, the director's task is just that—to direct, to point the way. Then the actor takes over. And he must be allowed the space, the freedom to express himself in the role. Without that space, an actor is no more than an unthinking robot with a chest-full of pushbuttons.

I can't let in the light. It will destroy my performance like light destroys film.

Racing is the only time I feel whole.

Whatever's inside making me what I am, it's like film. Film only works in the dark. Tear it all open and let in the light and you kill it.

The James Dean Story mirrors experiences intimately familiar to Warhol: the death of a parent; teen loneliness; feeling misunderstood; a shy, gentle character; a love of theater; oppositional defiance; a high reactive temperament; artistic talent; a philosophical predisposition; and a melancholic attitude toward life. The film chronicles his short life and career through black-and-white still photographs, interviews with the aunt and uncle who raised him, his paternal grandparents, a New York City cabdriver friend, and the owners of his favorite restaurants. The film reveals many images, from the police photos of the car crash that killed him to the marquee movie lights in Times Square. These images form an eerily reflecting image with Warhol's *Death and Disaster* paintings of the 1960s.

Dean and Warhol shared feelings about impermanence and fame:

> Dean: If a man can bridge the gap between life and death, if he can live after he's died, then maybe he was a great man. Immortality is the only true success.

> Warhol: You cannot live forever, but what you create and build in your lifetime can.

And Then There was Marilyn Monroe

Marilyn Monroe presented a more complex character than the brooding beefcake stars. As the comedy character Lorelei Lee from *Gentlemen Prefer Blondes* (1953), Marilyn made everyone laugh. She demonstrated perfect comedic timing long before Lucille Ball's "Lucy" (1957) became television's funniest female. But she was something Lucy never could be as a TV star: Marilyn was sizzling, "hot," sexy, naïve, voluptuous, and powerful—far beyond the classic "dumb blonde" persona presented by the media. And she had mastered every nuance of choreography for her identity with precision. As Rose Loomis in *Niagara* (1953), Monroe reveals the depth of her dramatic art as a murderous adulterer in a high-suspense, film-noir thriller filmed in Technicolor. She ends up strangled by her crazed husband, George, played by Joseph Cotton.

Decades passed before Monroe's complexity emerged. Through the CNN documentary *Reframed: Marilyn Monroe* (2022), her Creative Intelligence continues to inspire new exploration.

Marilyn brilliantly used her Creative Intelligence to weaponize her sexuality and cut through the stereotypes typical of Hollywood and American culture of the 1950s. She was the most famous person in America, and she empowered women before the women's rights movement of the 1960s. She walked away from Hollywood's studio system and was hounded by lawsuits.

Monroe shrugged off the threats and immersed herself in New York City, literature, art, the theater, and poetry readings. She studied with Constance Collier and the Lee Strasberg Theatre and Film Institute. Marilyn worked with a psychotherapist she trusted who encouraged her to journal. Marilyn's Creative Intelligence flourished. She proactively initiated her next phase of autopoiesis—the reinvention of an empowered artist-businessperson. This is what truly inspired Andy Warhol—if a woman can do it, why not a gay man?

On New Year's Eve 1955, Fox Studio dropped the lawsuits and boosted her salary to $100,000 ($1,500,000 in today's market) per film. Marilyn's personal transformation into an empowered artist derailed the misogynistic Hollywood system. She made

history in becoming the first woman to have her own production company with story approval, director approval, even cinematographer approval. At a time when the studios wielded absolute power, this was revolutionary. Monroe hadn't just won her autonomy—she'd revealed the corruption, misogyny, and greed of Hollywood.

Andy Warhol was inspired by her power, her fame, her wealth, her shrewd business acumen, and her beauty.

Marilyn Monroe would become his ultimate muse. Andy's life story mirrored many of her adverse childhood experiences. She survived great adversity during childhood, including a mentally ill mother, an unknown father, growing up in orphanages and foster homes from age eight. She would be an essential element in Warhol's autopoiesis.

Andy Warhol's Wigs: *Mirroring Marilyn*

If there was a single thing that identified Andy Warhol in a crowd, it was his hairpiece—the famous silver wig, usually accompanied by dark glasses. Although he started wearing hairpieces during the 1950s to cover a receding hairline, the silver wig became a critical element in the Warhol persona. As he reconstructed himself with acquisitions from Brando, Dean, and Elvis, he literally topped off the new self with Marilyn's platinum blonde symbol of beauty, sex, power, wealth, and fame.

Andy was influenced by Julia's deep religious faith and a high level of superstitious thinking. He was especially vulnerable due to his obsessive-compulsive traits. The wig provided a talisman-like disguise of his impoverished background—it camouflaged his humble origins. The silver wig was easily identified, like Superman's red cape, a brand-item that helped him become the underground artist-hero.

Andy Warhol's Ultimate Muse: *Marilyn's Traumatic Loss, Grief, and Creative Intelligence*

Marilyn Diptych was completed just weeks after Marilyn Monroe's death in August 1962. Warhol's *Marilyn Diptych* (1962, 80.8" x 114"), a monumental silkscreen painting with fifty images of Marilyn Monroe, rivals any abstract expressionist painting for emotional impact. The first time I visited the Warhol Museum and saw this in person,

I nearly fell over. I found myself feeling deep sadness about Marilyn, Andy, and the idea of grief.

Each image of Marilyn is taken from the single publicity photograph from the film *Niagara*. The left panel of Marilyn's twenty-five portraits is silkscreened in comic book colors, depicting the superficial, glamorous public persona of Marilyn. Andy gives her the *Soup Can* treatment—just another product off the assembly line. The right panel presents smudged black-and-white portraits, a dialectical image of Marilyn's private, emotionally troubled relationships and her tragic death. Andy always lived in a dialectic narrative, the public glitzy art-superstar, and the private, shy Catholic boy devoted to his mother. *Marilyn Diptych* is a massive mirror—a self-portrait.

Warhol reacted as a painter to the tragic overdose of sleeping medication by America's most famous, glamourous actor. The emotional power of this painting reflects Andy's deeply personal relationship to Marilyn as he identified and internalized aspects of her persona to create the Warhol. Warhol's homage to the icon of beauty, sex, and fame reflects his emotional symbiotic mirroring of his most potent muse. The production of the painting reveals, like Marilyn, his brilliant timing and marketing genius.

Hail Mary . . . (lyn), Full of Grace

Andy Warhol said, "The more you look at the same exact thing, the more the meaning goes away, and the better and emptier you feel."

For Andy, feeling empty was a defense against the pain of lost love. The physiologic shock of acute posttraumatic stress is emotionally mitigated by the symptom of numbness. To mitigate the traumatic pain, the brain derails the emotional memory system, leaving it open to the development of posttraumatic stress. I call these memories phantom stress due to the ease that they can be triggered by objects and experiences in the present.

Andy needed to achieve emptiness, rather than feel the pain of Marilyn's death. Making *Marilyn Diptych* was Andy's way of working through his traumatic grief with a loss of his greatest muse—a part of himself. With each image, he could love her, pay his respects, and say goodbye to her. This process of repetition is akin to the rosary prayers of his childhood. It is not hard to imagine how the action of silk-screening

Marilyn Diptych
Andy Warhol, 1962
Acrylic, silkscreen ink
and pencil on linen
81 x 57 inches each
(two panels)
205.7 x 144.8 cm

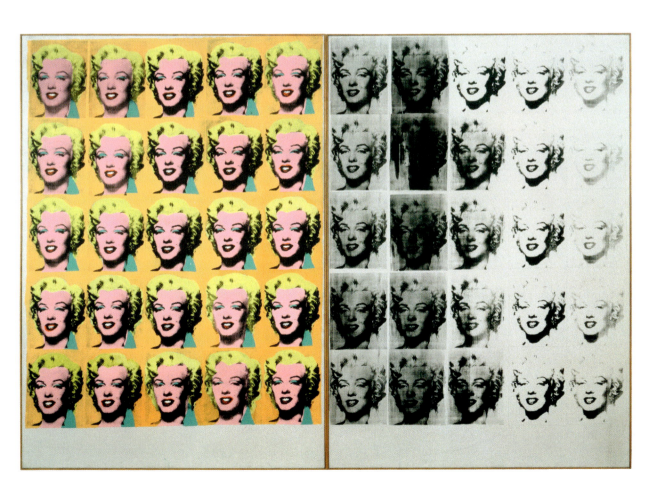

Marilyn Monroe fifty times triggered the association and memory centers of Andy's brain to this deeply felt prayer from childhood.

> Hail Mary, Full of Grace, The Lord is with thee. Blessed art thou among women, and blessed is the fruit of thy womb, Jesus. Holy Mary, Mother of God, pray for us sinners now, and at the hour of death. Glory Be to the Father, and to the Son, and to the Holy Spirit.

In 1967, Warhol established a print-publishing business, Factory Additions. His first published series was a screen print of Marilyn Monroe. He used the same publicity still of the actress that he had previously used for dozens of paintings. Each image here was printed from five screens: one that carried the photographic image and four for different areas of color, sometimes printed off-register. It is estimated that he printed 448 sets of prints, some containing 10 images. Andy sublimated his obsessive-compulsive anxiety by making series of images to relieve his anxiety, to fill his bank account, to extend his art at mass-market prices, and to soothe his private emptiness.

The Warhol: *Andy's Masterpiece*

The Warhol is a masterpiece. Wounded in sexual intimacy, the role of voyeur was the perfect position to take for an artist. Andy Warhol emerged as a mysterious, ambiguous personality designed to challenge, perplex, and entice the media. This was new. This was marketing genius. Fame was guaranteed.

The Warhol persona would need a private stage to present his meticulously crafted identity—the Factory.

Warhol painted all four of his iconic Hollywood heroes during the 1960s, the decade devoted to the quest for fame. During this prolific period, he mastered his persona. Andy knew that the artist and the subject fuse during the image-making process. The creative apparatus of the brain comingles emotions, psychology, memory, and imagination in the creation of the art object. From a brain perspective, all art is a kind of self-portrait.

Dean, Brando, Elvis, and Marilyn represented the pinnacle of fame. They inspired Andy during his period of autopoiesis. As emotionally vulnerable, misunderstood, loveable, sexy, social outsiders, they suffered from loneliness and irony. Warhol identified with them all and coveted their fame. They offered Andy a formula for his transformation. Like an alchemist, using the four base elements of earth, wind, fire, and water, Andy conjured a new sense of self from these iconic characters. Like Dr. Victor Frankenstein, he constructed a new, living creature—the Warhol—with his imagination. Andy's Creative Intelligence created his first artistic masterpiece—himself.

All the love he hoped to share in a personal love relationship could be sublimated in making art. His intuitive gratitude for surviving immense adversity kindled his devotion to making art. Art was Andy's gift to his mother, his family, and his fellow human beings. He reflected:

> As soon as I became a loner in my own mind, that's when I got what you might call a "following."

In his new independence, he found the power to influence others in paradox. He directed other people with non-direction. He activated other people to interpret his work by devaluing it. His passivity and feigned ignorance generated endless publicity. Having no secrets amplified curiosity about him. He invented himself as a pop icon, a thought leader, by not leading. He became a still point in the turning world. As the center of a wheel of influence, the spokes multiplied, connecting him to an endlessly expanding world of creative possibilities.

The Warhol brand, his style of painting, his techniques of image-making, could process anything and everything. People wanted him to sign their arms, legs, and underwear— "I want to become a Warhol."

Andy camouflaged his Christian values in his private life. The "good boy" advertising artist became the "bad boy" homosexual of the underground.

By sacrificing his search for romantic love, he refocused his Creative Intelligence to become a filmmaker. With Hollywood aspirations, he made films that were the opposite of everything Hollywood represented. He sublimated his anguish into creating art as an act of loving kindness for everyone. His quest to "spread the gospel of POPism" exploded.

The Warhol emerged with a leather jacket, sunglasses at night, and radical new ideas that redefined art and challenged the core of cultural reality of the 1950s. He surrounded himself with creative outsiders, refocusing on filmmaking with sexy outsider actors, those he dubbed *superstars*. Edie Sedgwick was his primary superstar. His films were prolific documentaries of the underground lifestyles. With Paul Morrissey, he produced hundreds of films that changed film history. His iconic films include *Sleep* (1963), *Empire* (1964), *Screen Tests* (1964–66), *Vinyl* (1965), *Poor Little Rich Girl* (1965), *Outer and Inner Space* (1965), *Chelsea Girls* (1966), *Lonesome Cowboys* (1968), and *Blue Movie (Fuck)* (1969).

In 1968, an assassin's bullets tore through Warhol's torso and brought the Warhol decade of the 1960s to a near-final end. Warhol was pronounced clinically dead at 4:15 p.m. Vascular surgeon Giuseppe Rossi (1928–2016), who had considerable experience in operating on victims of gunshot wounds, was on duty. Andy lived.

Speculations about Acute Posttraumatic Conversations with Julia

Andy was resurrected with open chest cardiac massage. It is not hard to imagine that Andy and Julia spent time in prayers of gratitude together. Thanking God for his survival, Julia may have pleaded for Andy to change his ways. Together, they may have once again activated Andy's Creative Intelligence to reinvent himself. His private story of redemption may have been kindled by his survival.

After a prolonged recovery, Andy Warhol returned, like Lazarus. He emerged less shrouded with cool mystique, more ordinary in his attire, and focused on growing his business. He established the Warhol brand as a trendsetter extraordinaire. In the 1970s, he focused on Factory production of fame, wealth, and power. With Rupert Jasen Smith, he produced a prolific print series business. Coming out of a decade underground in the night shadows of the Factory, he became a "day walker," handing out copies of his fame-focused tabloid *Interview* to strangers on the street. The new "business tycoon" Andy remained a camouflaged Catholic until 1980 when he went to Rome to greet the new Pope.

On December 7, 2021, Paul Elie wrote in *The New Yorker:*

> On April 2, 1980, Andy Warhol met Pope John Paul II in St. Peter's Square. John Paul was in the first bloom of his pontificate, and his image as a young, strong, independent-minded world citizen had been burnished by a visit to New York the previous fall. Warhol was hoping to cap a series of silk-screen celebrity portraits with the Polish pontiff. Warhol and his associate Fred Hughes arrived in Rome thinking they had a private audience, only to find that their tickets were for the weekly general audience. In his diary, Warhol recalled the event: "They finally took us in to our seats with the rest of the 5,000 people and a nun screamed out, 'You're Andy Warhol! Can I have your autograph?' . . . Then I had to sign five more autographs for other nuns. And I just get so nervous at church." He was in the front row, a V.I.P. after all. "And then the pope came out, he was on a gold car, he did the rounds, and then finally he got up and gave a speech against divorce in seven different languages. That took three hours."

Andy recreated the Factory as a center for multiple art businesses. The media christened Andy Warhol "the Pope of Pop."

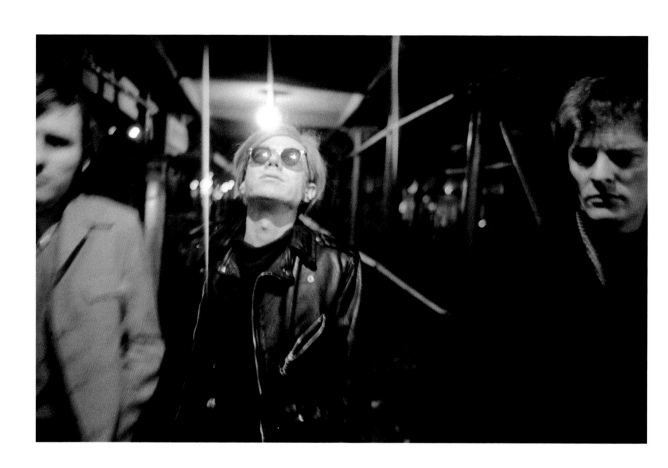

*Rod LaRod, Andy Warhol
and Paul Morrissey,*
Stephen Shore, 1965

5 ANDY'S "AS IF" PERSONALITY
Mirrors, Mirror Neurons, and Self-Creation

Andy Warhol seemed transfixed by silver: the silver Factory, the floating silver balloon sculpture, the silver wigs, silver Elvis, and silver mirrors. The silver screen of his favorite childhood movies kindled his imagination, tickled his wonderment, and activated his daydreams. Silver glitters. Silver and gold show wealth. Silver reflects the real world in and on a flat surface, "as if" it were real. Vampires do not reflect in mirrors. Silver bullets kill werewolves, and silver crosses repel vampires. Silver is endowed with mythical powers.

Andy Warhol's "As If" Personality: *The Cool Core of Warhol's Creativity*

Hester McFarland Solomon (d. 2021) published "Self-creation and the limitless void of dissociation: the 'as if' personality," in the *Journal of Analytic Psychology*, 2004. She wrote:

> The concept of the "as if" personality has been used variously in analytic literature without having formed part of a clinically based theoretical development over time… In this composite clinical picture, a grouping of elements that form a particular kind of defense of the self is identified in certain patients with an exceptional capacity for creative engagement in the world, surpassing expectations given their background. The picture includes the presence of physical breakdown and illness, as psychic suffering arising from early narcissistic wounding and from a physical, emotional and/or sexual abusive familial environment, was held for too long in bodily memory but not in mind. A distinction is made between the "as if" personality, the persona, and the false self. The "as if" personality concerns the action of defensive dissociation deriving from very early experiences of internalizing the presence of an absent object, creating the sense of an internal void at the core of the self. At the same time, the self is capable of acts of self-creation through a succession of

identifications and internalizations with other sources of environmental nourishment, which substitute for, and are constructed around, the original sense of internal emptiness. Thus, are restored, but only up to a point, the resources of the originally diminished self. Until these resources have been used up, the self is often able to excel in activities to an exceptional degree.

It's *as if* Solomon had Andy Warhol as a patient!

The Warhol, Andy's artist persona, embodied Solomon's "'as if' personality" with "the limitless void of dissociation."

Solomon's brilliant insights conform to the critical facts of Warhol's developmental experiences. Andy's primary attachment with Julia fits. His "very early experiences of internalizing the presence of an absent object, creating the sense of an internal void at the core of the self" fits.

Her observation that "the presence of physical breakdown and illness, as psychic suffering arising from early narcissistic wounding and from a physical, emotional and/or sexual abusive familial environment, was held for too long in bodily memory but not in mind" also parallels much of Warhol's developmental history.

Andy's Ambivalent Attachment: *Replacement Child Syndrome*

Julia suffered from chronic posttraumatic stress, losing her first-born child, Maria. She never stopped lamenting about her lost daughter to her sons. She brought this unresolved grief to baby Andek, whose frail body may have activated a rapprochement with her lost daughter. As she gazed at her baby Andek, it is likely that her emotional memory associated to Maria. Andy became a surrogate for the lost infant in her mind—the *replacement child syndrome*.

L.A. Grout and B.D. Romanoff published "The myth of the replacement child: parents' stories and practices after perinatal death" in *Death Studies*, 2000. They describe "replacement child syndrome," characterized by increased worry and doting on the replacement child, especially if it has ill health. Retelling memories of the lost child is common if the grief is unresolved.

Infant Andy may have been Julia's replacement child for Maria. She never stopped grieving her, according to family members. Andy would have internalized her loving eyes with confusion. Growing up feeling that he was loved for replacing Maria may have informed an ambivalent attachment pattern within his core self. Andy's frail health would have amplified Julia's clinging to Andy, keeping him home from school for months during his bouts with Sydenham chorea. Implicitly, his developing identity may have wondered, "Am I loved for being me, or for replacing Maria and pleasing Mother?" Andy would struggle with ambivalence in relationships rooted in the internalized absentee mother. Julia would live with Andy throughout her life. This symbiotic attachment was at the core of Andy's issues with intimacy. It also fueled the engine for a perpetual drive to recreate the Warhol in endless manifestations that shaped pop culture and inspired thousands of other creative people.

Julia's own Creative Intelligence helped her overcome extraordinary adversity. She survived intense traumatic experiences in Mikova; she immigrated to reconnect with Andrej in America; and she gave birth to three boys. She brought her own powerful, creative nature and resilience to the mother-child holding environment with baby Andek.

Julia's Face, Andy's First Mirror: *The Mirror Neuron System*

Giacomo Rizzolatti, director of neuroscience at the University of Parma, Italy, discovered the *mirror neuron system* in the early 1990s. His team of researchers found individual motor neurons in the brains of macaque monkeys that fired both when the monkeys grabbed an object and when the monkeys watched another primate grab the same object. The implication of this discovery is unparalleled in developmental neuroscience. In *Mirrors in the Brain: How Our Minds Share Actions and Emotions,* Rizzolatti reflects:

> In an interview … the great theatrical director, Peter Brook commented that with the discovery of mirror neurons, neuroscience had finally started to understand what has long been common knowledge in the theater: the actors efforts would be in vain if he were not able to surmount all cultural and linguistic barriers and share his bodily sounds and movements with the spectators, who thus actively contribute to the event and become one with the players on the stage.

For the newborn infant, mother's face is both the audience and the stage that holds the actions of the baby—D.W. Winnicott's idea of "the holding environment"—and is the baby's first mirror for emotional reality. Happy, secure, and peaceful mothers create secure emotional bonds with their babies. When past or present stress impairs the mother's emotional state, insecure mother-infant attachments are more likely. Poverty, posttraumatic stress, family conflict, and social status contribute to undermining the attachment. When insecure attachment occurs during early development, the adversities can shorten the lifespan by twenty years. Although Julia struggled with many traumatic episodes in her adult life, her secure childhood and Creative Intelligence empowered her to live to be eighty-one years old. Andy died at age fifty-eight, fifteen years after losing Julia.

Julia and Andy struggled with all these elements. It is Julia's innate and learned Creative Intelligence that provided a mother-son bond that would prove to be a lifelong codependency. Andy flourished by perpetual refueling with his mother across his life.

The Art-Mother-Self-System: *Art Against Stress*

During his childhood, Julia immersed Andy Warhol in shared creative experiences. Creativity would become a ritual for both Andy and Julia to feel secure. Their art-relationship would last Julia's entire life, and shape Andy's life, for better and for worse.

Artmaking nourished Andy's developing self, empowering his Creative Intelligence with acts of self-creation through a series of altered identifications and internalizations of idealized movie stars, especially Shirley Temple. He had unflinching family support for his talent. Art and creativity nourished his emotional hunger, and he learned to construct his own world in artmaking to mitigate the pain and anxiety of an original sense of internal emptiness. Art protected him from bullying and loneliness and helped form female friends.

Despite serious illness during childhood, Julia enriched his long, bed-ridden periods with drawing, coloring, paper cutting, and collecting movie magazines. She supported his developing mind-body navigate the physical dysfunction from Sydenham Chorea, a potentially fatal malady of the heart and the nervous system. Julia's talents

in art inspired Andy's love of drawing. Andy was an avid fan of the movies, so Julia attuned to his desire to take pictures. She bought him a camera at the age of nine, and the family helped him with photography so he could develop film in a makeshift darkroom they set up in their basement. Perhaps this became the emotional foundation for one of his greatest art projects, the Factory.

Warhol's talents in art were recognized by teachers who encouraged him to take the free art classes offered at the Carnegie Institute (now the Carnegie Museum of Art) in Pittsburgh. At age fourteen, Andy experienced further trauma when his father died. He was so upset that he could not attend his father's funeral, and he hid under his bed throughout the wake. Andrej Warhola had recognized his son's artistic talents, and in his will, he dictated that his life savings go toward Warhol's college education. Andy enrolled at the Carnegie Institute for Technology (now Carnegie Mellon University) to study pictorial design.

Andy intuitively explored experiences that inspired his imagination, especially the movies. He felt secure in the dark, anonymous world of the movie theater, with its shimmering silver screen, shadows, and idealized celebrities. Movie theaters provided him with a holding environment to reinvent himself. With Creative Intelligence, he fueled his self-esteem until he met with disappointments in real life.

The Silver Factory: *Andy Warhol's Creativity Machine*

Warhol's invention of the Factory was an ingenious solution that supplied him with financial stability, social connectivity, emotional nourishment, and continually inspired his creative production. Rich, famous, and talented people flocked to the scene at the Factory.

Dr. Solomon notes, "Until these resources have been used up, the self is often able to excel in activities to an exceptional degree."

Warhol was often heard, in doubtful reflection—"What should I paint?"

Pop art sprang from advertising. On the surface, it was all about the external, material world. The viewers share in re-creating the art in the mind's eye, activating their

private world of emotions. Unconscious memories and conscious associations triggered by pop art challenged the audience to decode the overly familiar images—Is it Art? Warhol's goals were clear: hijack the attention of the viewer instantly to recruit mass audiences that support mass production and make massive profits, mass gossip, and cultural influence. FAME.

By day, he was busy producing art with his staff. By night, he created a perpetual Happening scene. Allan Kaprow's concept from the 1950s to amalgamate many artforms together and just let things "happen" was translated into a disco-like party where film, music, painting, and acting could dissolve into a nourishing experience for the maestro of the scene. During the 1960s, in the Happening environment of the Factory, Andy absorbed the entire experience by tape-recording conversations, photographing the celebrities and ordinary visitors, and setting up film-portraits of anyone who wanted to sit silently in front of the camera. Andy nurtured his creative engine for making art during the day. Like a vampire in his castle, he floated through his Factory during the night, absorbing the life-giving energy, inspiring himself with creative ideas, and developing relationships with many people who were hopped up on amphetamines.

"As If": *The Virgin and the Vampire*

Andy Warhol was seen as a cold, indifferent, aloof persona. Was he real? Or was it an act? Warhol's "as if" vampire identity is revealed in his reflection:

> People are always calling me a mirror, and if a mirror looks into a mirror, what is there to see?

Andy would spend his life in pursuit of idealized people, places, and things. Attachment to and internalization of these experiences gave him temporary fulfilment for his emotional sense of loneliness. His insatiable hunger for security drove his compulsive socialization. Ondine, Factory superstar, coined a nickname for Andy—Drella, a portmanteau of Dracula and Cinderella. It reflects a poetic assessment of Warhol

as a vampire seeking virgin blood while being disguised as a Cinderella-like virgin himself. Edie Sedgwick was the perfect virgin for Andy's vampire. Warhol's proclivity for ambiguity, ambivalence, and paradox reflects his creative genius—he was both virgin and vampire. After Andy died, John Cale and Lou Reed, cofounders of the Velvet Underground, the Factory house band, dedicated an album to Warhol, *Songs for Drella* (1990).

The emotional emptiness and posttraumatic stress from childhood, and the unrequited love of the 1950s, left Warhol feeling numb, deadened, depersonalized, and dissociated. He also felt innocent, like a virgin. His mental life, his self-making, his core sense of feeling disconnected from his body, all inspired his Creative Intelligence. Making art became the most important way he generated emotional security for his body. He reflected:

> Fantasy love is much better than reality love. Never doing it is very exciting. The most exciting attractions are between two opposites that never meet.

Andy's connection with Julia contributed to his longevity, productiveness, and social connectivity. They lived together until she died.

PART TWO

EMERGENCE

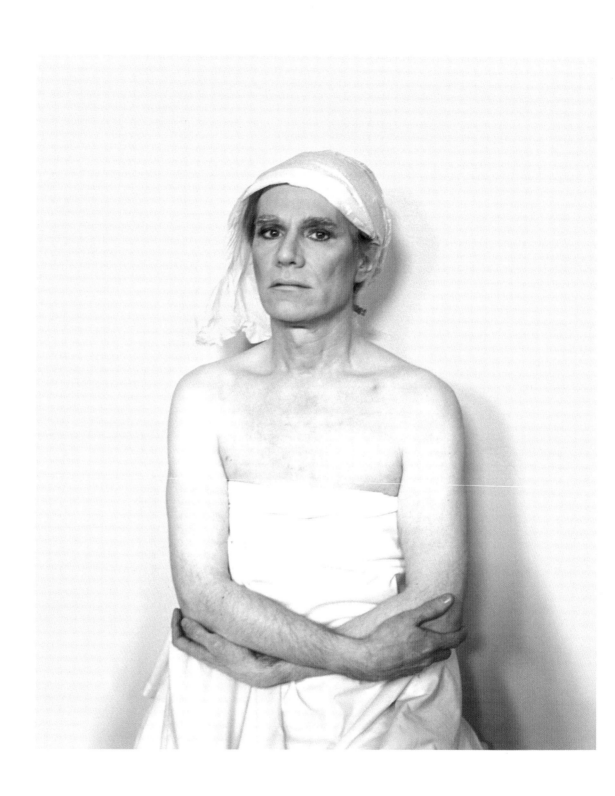

Altered Image,
Christopher Makos
and Andy Warhol, 1981

6 ANDY'S BODY
Agony, Angst, Anger, and Alchemy

Andy Warhol experienced severe traumatic stress beginning in childhood. Living in a damaged body was a lifelong reality. His physical agony in pain, his emotional angst about his future, and his visceral anger at his powerlessness shaped his mind-body relationship. Trauma plays a critical role in understanding the emotions, cognition, and Creative Intelligence that shaped the patterns of his life, the content of his artwork, and the extraordinary drive in his personal mission. Warhol's intuitive skills for transforming adversity into creativity reflect the ancient art of alchemy.

Alchemy can be viewed as a symbolic process, a consilient art-science, aimed at unifying domains of experience and knowledge.

Amalgamating positive and negative emotional and cognitive elements with Creative Intelligence can produce the sublime essence of Platonic values: truth, beauty, and goodness.

Andy's Childhood: *"In My Beginning is My End"* (T.S. Eliot)

During childhood, Andy suffered chronic pain, powerlessness, social isolation, and mental and emotional dysfunction. His body was no stranger to the *freeze-fight-flight* survival response. Julia, his devoted mother, provided him sanctuary, stimulation with shared creativity, and a secure bond. Together they cultivated the *calm-connect-create* antidote to the agony and anxiety of Andy's toxic stress of childhood.

Across the developmental stages of his life, his mind-body relationship was challenged over and over by marked adversity. Warhol suffered physical agony from rheumatic fever and Sydenham chorea during childhood that plagued him for life. His adolescent angst was traumatized by the death of his father, his mother's colon cancer, family dysfunction, and his confusion with sexual and gender identity. The teen years cast a long shadow on his body-self-perception. As his developing adolescent brain was exploding with growth of new neural networks, he used his

Creative Intelligence to adapt. As an adult, his miraculous recovery from his near-assassination kindled an outpouring of new art.

With each challenge, Warhol's extraordinary Creative Intelligence transformed his agony, angst, and anger into art. Warhol's creative abilities to transform pain into beauty, disaster into the sublime, and frustration into new realities defined him as an alchemist—a master of transformation.

The Mind-Body Link—*Emotions and Feelings*

The human body is the seat of emotions—the physiological reactions, sensations, perceptions, and orientations in the world. Children act out their emotions, and parents must contain the destructive potential of negative emotions.

When parents use language mindfully to model how to vent emotions with words called *feelings*, family stress is reduced, emotional communication improves, and children feel securely attached in a "family story of We." This is how *emotional intelligence* is learned during childhood.

Conversely, when parents use force or coercion to control negative emotions, children don't learn to put negative emotions into words. They act out their anger, fear, or confusion, the stress escalates, and conflict increases in the children. Oppositional-defiance patterns emerge in family patterns of *alexithymia*—no words for feelings. Alexithymia shapes relationship patterns in families that can last a lifetime, affecting the ability to form secure bonds with others. Passive-aggressive behavior, resentment, self-pity, and learned helplessness can develop.

A third avenue is open to manage stress in families that threatens development—creativity and the cultivation of Creative Intelligence. Warhol was fortunate that his mother, Julia, provided him with a rich, stimulating, creative childhood experience. She shared the creative experiences with him, forming a bond that would last a lifetime, for better or worse. Their shared creative experience mobilized Andy's resilience and empowered his genetically talented brain. The fact that his work had such far-reaching cultural influences is a testament to Andy's Creative Intelligence and how he learned to sublimate agony, angst, and anger into art.

Meet the Warholas: *Emotions and Feelings*

Andy grew up as the baby, Andek, in the world of Julia and Andrej Warhola with his brothers Paul and John. Their parenting styles dealt with emotions in drastically different ways. Andrej was very strict about religion: prayers before meals, church on Sundays, and a somber work ethic. Expressing negative emotions was not tolerated. Julia shared in the devotion to religion and faith and supported her husband's style of parenting in which religion provided rules for behavior. But her emotional expressivity produced massive amounts of art. Andy recalled:

> The tin flowers she made out of those fruit tins, that's the reason why I did my first tin-can paintings…My mother always had lots of cans around, including soup cans. She was…a real good and correct artist, like the primitives.

In *The Life and Death of Andy Warhol*, Victor Bockris explores the patterns in the Warhola family with stories from brothers Paul and John. Paul recalled the strict rules for Sundays:

> You weren't even allowed to pick up a pair of scissors on Sunday. It was going to church and then taking off your church clothes and then no playing around or nothing. My dad was very strict on that… Sometimes he'd yell at us if we were slapping at one another at the table or fighting in bed. Dad didn't like us starting a commotion because he was so exhausted, and he would get emotionally upset. Usually all he had to do was look at you. That was enough. Dad was so strict that when you were a kid, you'd think he was a mean father.

John recalled:

> Family church going was a joyous occasion—people really visited each other. My mother taught you she liked going to church better than material things. She never believed in being wealthy—she believed just being a real good person made you happy. We were brought up never to hurt anybody, to believe you're just here for a short time and you're going to leave the material things behind.

Julia never learned to speak English during the poverty-stressed childhood years. They spent evenings with Julia during which she reminisced about her traumatic past with her family.

> Closest to her when she told those stories about the war, the old church in Mikova, the ghost of their sister Maria, was the baby of the family, "Andek," as she called him. He was a pale, chubby boy, and precocious from the start ("aggressive" and "pushy" was how Andy remembered himself). You could see he was picking up things much better than we had, said Paul. But he was really mischievous between three and six…Swearing wasn't allowed in our house— you couldn't even say "hell!" … I'd sometimes smack him in the face. And the more you smacked him, the more he said it—the worse he got. He was real bad: Just because we *didn't* want him to say it.

Andy's ACE (Adverse Childhood Experiences) score was high and predicted a shortened lifespan—Andy died when he was fifty-eight years old. His stress load included poverty, nutritional imbalance, family stress, life-threatening illness, neuro-psychiatric damage, and social stigmatization. Consequences of chronic stress on his brain development, body image, and psychological organization contributed to the construction of his damaged sense of self. With Julia's help, Andy used his creativity to overcome the challenges of extraordinary stress. He would use art throughout his life to transform his agony, angst, and anger into culture, changing art and a robust social self with friends, businesses, and fame.

Portraits of the Body-Self: *The Alchemy of Transmuting Pain into Art*

In David Montgomery's intimate photo of Warhol's post-surgical scars, Andy leans back, clutching his chest near a window creating high-definition shadows like a Renaissance St. Sebastian portrait.

It is fair to say that all artists' productions are, to some degree, self-portraits from a brain-mind point of view. The perception of the external visual and internal visceral world, cognition, and emotion inform the artists' creativity from early childhood. Andy struggled with complex, toxic stress during childhood and used his innate creativity to overcome these issues with focused attention, diligence, and creative experimentation.

The Andy Warhol Museum presented a blockbuster exhibition in 2016: *Andy Warhol: My Perfect Body,* conceived by Associate Curator of Art Jessica Beck (now the Milton Fine curator). The exhibition tracks Warhol's mind-body-art, allowing for a deep understanding of how his Creative Intelligence sublimated the experience in his damaged body.

Highlighting The Warhol's permanent collection, and including rarely traveled loans, this exhibition broadly examines Warhol's work, from student drawings to late paintings of the 1980s. This exhibition reveals the parallels between Warhol's personal history—including his struggles with his own physical appearance, such as early signs of balding in 1950s and the gruesome scars following his shooting in 1968—and the treatment of the body as a subject in his work.

Physical flaws and the commercial products used to correct these vexing imperfections were central themes in the first hand-painted paintings of 1961 with *Wigs*, *Dr. Scholl's Corns*, and *Before and After* (a painting of a plastic surgery ad, which Warhol painted in four versions). Following this early period, Warhol's engagement with the body becomes complex with the emergence of trauma in the *Disaster* paintings, abstraction and abjection in the *Oxidations*, and transformation and humanity with *The Last Supper*, in black light, where Christ and the bodybuilder are aligned side-by-side.

From the early 1961 canvases to the late physiological diagram paintings, the interior of the body is put on display and its flaws either erased or highlighted. This discussion of inside and outside, and public and private, further establishes the body as a site for projection of outside pressures and interior desires and drives. This exhibition explores the tension between Warhol's personal narrative and the repetition of the fractured body found throughout his entire artistic output. Warhol spoke of Pop as democratic, an art form for everyone, a style that could be defined as a series of reversals. As he stated in a 1966 interview, Pop "is just taking the outside and putting it on the inside or taking the inside and putting it on the outside."

Beck reflects on how Warhol sublimated his "body dysmorphia" into art, a process that requires a robust effort of self-examination guided with Creative Intelligence. The Mayo Clinic describes body dysmorphic disorder:

> Body dysmorphic disorder is a mental health disorder in which you can't stop thinking about one or more perceived defects or flaws in your appearance — a flaw that appears minor or can't be seen by others. But you may feel so embarrassed, ashamed, and anxious that you may avoid many social situations.
>
> When you have body dysmorphic disorder, you intensely focus on your appearance and body image, repeatedly checking the mirror, grooming, or seeking reassurance, sometimes for many hours each day. Your perceived flaw and the repetitive behaviors cause you significant distress and impact your ability to function in your daily life.
>
> You may seek out numerous cosmetic procedures to try to "fix" your perceived flaw. Afterward, you may feel temporary satisfaction or a reduction in your distress, but often the anxiety returns, and you may resume searching for other ways to fix your perceived flaw.
>
> Treatment of body dysmorphic disorder may include cognitive behavioral therapy and medication.

Andy Warhol's "self-treatment" for his body dysmorphia was creativity. His experience of feeling ugly, defective, and worthless fueled his Creative Intelligence to transform himself from a damaged body into a great artist, a creator of beautiful images, an agent for cultural change. Warhol's obsession with the idea of beauty/ugliness led to a compulsive productivity amassing an estimated 85,311 works of art. Andy truly was a Factory for making art.

Alchemy and Irony: *Self-Transformation and Cultural Transmutation*

In 2019, the Reggia di Monza, Italy, mounted a major retrospective: *Andy Warhol: The Alchemist of the Sixties.* Curated by Maurizio Vanni, he identifies the critical distinction of Andy Warhol's genius—the ability to transform perceived "reality." He explains

Warhol's embrace of irony as a creative attitude:

> ... taking a distance and creating an alternative... setting a boundary between himself and the things and people around him... in harmony with the historic era that represented the current versus the recent past, vital versus institutional, truth versus reality, the critics versus the system, expressive freedom versus impositions.

Warhol had a deep creative drive to transform himself and reshape the world, especially America. He invented himself as a superhero alchemist-artist. Everything American captivated Andy's imagination. He was simultaneously charged with gratitude for his country and held a probing critical view of the flaws, the people, and the culture. What most inspired Andy was the fundamental idea that America was a self-created system. He wanted to fulfill his immigrant parents' dream of becoming deeply, spiritually American. His imagination empowered his personal mission to overtake abstract expressionism as the "art of America" and shape America into the center of global pop culture.

Andy's Resurrection: *Reconciliation of Andy's Split Identity*

In his post-assassination/resurrection life, Andy Warhol renewed his self-validation as a cultural leader. He abandoned the underground Factory of the 1960s and re-created the new Factory as headquarters for his business empire. Acutely aware that he was scrutinized with every choice he made, he focused on the relationship between authenticity/superficiality as a target for his art. Abstract paintings emerged in several series of typically ambiguous and ironic works.

In 1978, he experimented with alchemical works, *Oxidation*, using bodily fluids to create paintings. In his masterwork, *Shadows*, 108 paintings commissioned by the DIA Foundation hung in a vast space. They rivaled Monet's *Orangerie Waterlilies.* In 1981, he painted symbols that represented pain, violence, greed, and redemption, *Guns, Knives, Dollar Signs,* and *Crosses*.

In 1984, he made his own *Rorschach* blot paintings, inspired by Swiss psychologist Hermann Rorschach (d. 1922). Rorschach developed a psychological test in which subjects' perceptions of inkblots are recorded and then interpreted to gain insights into the mental functions. Andy gave the viewer a chance to take the test, externalizing the inner phantom stresses in his own brain-body memory. Andy fused art and neuroscience long before the scientific world could study the brain with brain-scanning technology.

In 1986, Warhol acquired the fashionable military camouflage pattern to create his *Camouflage* paintings. They reflect his lifelong separation of his public life from his "camouflaged Catholic" personal family life.

In 1987, he arrived at a critical confrontation with himself and his "closet Catholic identity." Alexander Iolas commissioned him to do a series of religious paintings. Andy chose Leonardo's *The Last Supper* (1495–98) as the primary subject for his project. His personal and cultural transformation would unfold in this massive undertaking. Andy's sense of self was merged with his public persona—he was what he made. If he was to resolve his lifelong codependency with his mother, transcend his conflict within himself about religion and secular life, and find peace in radical acceptance that life is brutally unfair, he would have to resolve these conflicts as he had always done—with art.

Leonardo da Vinci presented the perfect target for his alchemical formula. Like Duchamp, who drew a moustache on a postcard of *La Gioconda* (*Mona Lisa*), Warhol reinvented *The Last Supper.*

Maurizio Vanni observed that Leonardo and Warhol had a lot in common: both were obsessive; both believed in the power of art to transmute reality; and both shared an interest in gender ambiguity. One theory proclaims the *Mona Lisa* to be a self-portrait of Leonardo as a female. In Sigmund Freud's essay, *Leonardo da Vinci: A Memory of His Childhood* (1924), Freud speculates: "When he was still an apprentice, living in the house of his master, Verrocchio, a charge of forbidden homosexual practices was brought against him. . . . When he became a master, he surrounded himself with handsome young boys and youths whom he took as pupils." Although Freud notes

that Leonardo had a male companion until he died, he defers to identify it as a sexual liaison, knowing that speculation can never be proved.

Jessica Beck wrote in *Gagosian Quarterly* (Gagosian.com):

> … more than 100 paintings in Warhol's *Last Supper* series, produced between 1984 and 1986. The dilemma with the current literature on these paintings is that it often makes little reference, and in some cases no reference at all, to the major crisis affecting Warhol's community at the time of their completion: the AIDS epidemic. The ambiguity in the literature on Warhol's subject matter in the last decade of his career stems in part from the conflict between his Catholic faith and his homosexuality. This tension is often ignored in discussions of the work, with the result that the paintings appear one-dimensional. Once these issues are brought to the forefront, a broad discussion of mortality and salvation can emerge as the crux of the *Last Supper* paintings.

Warhol identified with Leonardo, his need for ambiguity, his obsessive-compulsive perfectionism, and his difficulties completing projects. By mirroring Leonardo's personal reality, Warhol created his own authentic version of that critical moment in Christian history. Judas presented a false self to Jesus, an ambiguous identity, and he betrayed the one person who loved him unconditionally. Betrayal, the most destructive action one person can take against a trusted other, is at the core of all human suffering—the betrayal of trust. Redemption becomes the only path out of the self-sabotaging patterns that come with betrayal of oneself, others, and the creative process.

Andy Warhol struggled with insecure attachment issues with his mother, his body, his identity, his artwork, his religious values, and his perception of life. He confronted these invitations to suffering with his Creative Intelligence. Rather than get stuck in feelings of self-pity and resentment, he chose art as his way to transform his reality. Warhol's massive attention in creating his own *Last Supper* may have liberated him emotionally from a life of conflict.

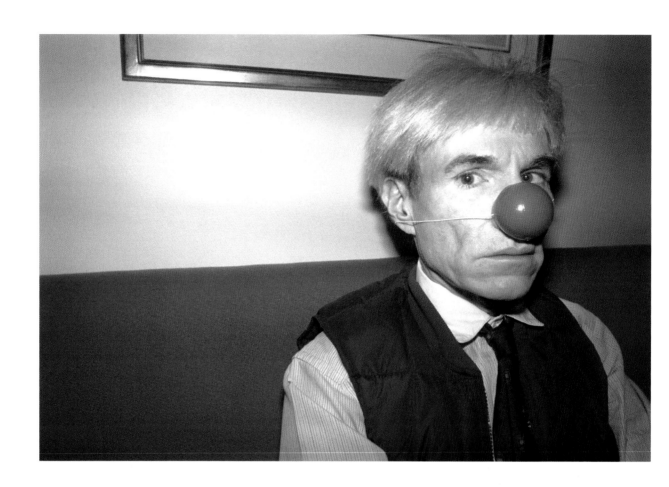

Andy Warhol in Clown Nose at the Hotel Bauer Lac, Zurich, Switzerland during Lent, Christopher Makos, 1982

7 ANDY'S BRAIN-MIND
Consciousness, Creativity, and Culture

Creativity and Resilience: *A Personal Path*

After Andy died in 1987, I struggled with grief, confusion, frustration, and disappointment. I hoped that a conversation with Andy about childhood and creativity would make my project, *The Art Imperative: The Secret Power of Art* (2010), a success. After my conversations with Audrey Flack, Louise Bourgeois, and Isamu Noguchi, I was ready to interview Andy. His sudden death deflated my passion, and my conversation fizzled with Abrams, the art publisher.

I focused on my clinical practice, my assistant professorship at New York-Presbyterian Hospital Child Psychiatry, my family, and my own art studio. I was remarkably busy as an artist with several one-man exhibitions: in New York, Ramscale gallery, 1988; a multimedia gallery installation at Susanna Sheffield at Fotofest, Houston, 1990; two shows at Tansuya Gallery in Soho, New York, in 1992 and 1994; and group shows in Miami, Tribeca, and Houston. I was fortunate to find an international array of collectors from New York, Miami, Tokyo, Paris, and London.

1990s, The Decade of the Brain: *Consilience and Art*

President George Bush declared the 1990s the "decade of the brain." I changed my mission to focus on the emerging brain science revolutionizing psychiatry. Working with Bruce McEwen, author of *The Hostage Brain* (1994), I began to link the social neuroscience of stress and resilience with creativity. I read *Consilience: The Unity of Knowledge* (1998) by evolutionary biologist E.O. Wilson, a Pellegrino University Research Professor at Harvard and author of two Pulitzer Prize–winning books, *On Human Nature (1977)* and *The Ants (1990)*. After reading, I experienced a profound reawakening of my interest in linking art, mind, consciousness, and cultural evolution.

In 2000, Bruce and Ed put together a landmark three-day conference at Rockefeller University, The Unity of Knowledge. It was the Woodstock of science. I had been a stage guard at Woodstock thirty years prior, so the analogy was a visceral memory,

not a confabulation. This blockbuster presented the rockstars of science and scholarship in every field of knowledge—Antonio Damasio, Anne Harrington, Joe Ledoux, Jerome Kagan, Henry Moss, Eric Kandel, Michael Posner, Stuart Kaufman, Pat Kuhl, and others.

After the conference, I went to the Solomon R. Guggenheim Museum for an exhibition, *1900: Art at the Crossroads*. The work of Odilon Redon presaged the emergence of modernist abstraction. A century before the Unity of Knowledge conference, artists were reorganizing their perception of reality, turning away from realistic impressions of the external world, and refocusing inward to their imagination for visual stimuli. Artists were redefining art and themselves.

Science was on a parallel course with Max Planck's quantum mechanics (1900). By designating energy as a packet, called "quanta," Planck reconceived the engine of the cosmos of Newtonian physics. Albert Einstein's Theory of Relativity (1905) consolidated the categories of space and time into a single concept: spacetime.

The road to consilient thinking began centuries ago with the Renaissance. The Enlightenment promoted rational exploration of the world, supporting science and challenging religious dogma. With the discovery of quantum mechanics, Isaac Newton's brilliant classical model of the universe came into doubt. E.O. Wilson, Bruce McEwen, and colleagues promoted a new age of consilient inquiry into the nature of nature.

Sometime later, I had the good fortune to see E.O. Wilson and James Watson, Nobel laureate for identifying DNA, in a conference with talk-show host Phil Donahue. After the conference, I gave Professor Wilson a copy of my outline of *The Art Imperative*. I told him about my epiphany, linking art-science-creativity-evolution, kindled by his Rockefeller conference and my visit to the art museum. Within days, I received a letter from him, stating, "I think you're on to something here. Pursue it. Best Wishes, Ed." He wrote the following book jacket endorsement:

> This attractive and interesting work is an important venture into the borderland between the creative arts and science.

Making Sense of Andy Warhol's Brain-Mind

My exploration of Andy's brain-mind resumed with Victor Bockris' brilliant account, *The Life and Death of Andy Warhol* (1989). He provided a detailed account of Andy's childhood history critical to reconstructing his identity development.

I challenged myself with making sense of the role art played in Andy's individual development and how his POPism could have such a powerful role on cultural evolution. Art, social neuroscience, and cultural evolution recharged my approach to writing about Andy.

Andy Warhol's mind deserves an approach with an understanding of the evolution of the art-mind-culture continuum.

Cultural Evolution: *Cognition, Conflict, Cooperation, and Creativity*

Mindful cultural evolution emerged when the human brain evolved abstract cognition. Abstract cognition produces meaningful narratives. Ancient *Homo sapiens* could imagine a "higher power or greater purpose" for group survival over the individual. Gazing at the stars or looking over a vast terrain triggers reflection, wonderment, and a sense of the human body's tiny size in the immense scale of nature. Awe and imagination emerge. Questions arise in language: "What am I?" "Who am I?" "What is nature?" "What is the meaning of life?"

The rituals of burying the dead, social gathering, toolmaking, self-decoration, and hierarchical society emerged with abstract cognition and creativity. Abstract stories of meaning and purpose, myths and folktales, promote powerful social bonds where members are willing to sacrifice themselves for the group. The linguistic constructs of human imagination frame relationships with the world, with each other, and with oneself.

As with all relationships, the potential for cooperation versus conflict is ever-present. The physical struggle with nature to survive is a fixed reality. The conflict with fellow human beings begins in childhood. The psychological, emotional, and unconscious conflict with oneself is universal. Three great conflicts define human adversity:

- Humankind against nature
- Person against person
- Self against self

The linear structure of language places human life in a framework of time. Memory informs us of the past, perception informs us of the present, and imagination projects future possibilities.

What Has Art Got to Do with It?

Humankind began making cave paintings forty thousand years ago. The creation of pictorial symbols of the living world marked a major leap in the emergence of mindful, reflective consciousness, creativity, and cultural evolution. Making art opened the path toward mindfulness, contemplative practices, and activation of the brain's creativity apparatus. Art offered the mind a vastly different experience from storytelling. Timelessness, nonlinear spatial relativity, and imagination could soar with art, unlimited by linguistic structures. Cave art initiated the evolution of special places for people to gather, to share emotional experiences, and to kindle individual creativity and share social meaning.

Abstraction in art and concrete religious dogma became entangled in spaces created for social congregation. Art could kindle nonlinear imagination in individuals' minds and propagate linear, concrete, religious narratives and constructs. As cognitive and emotional experiences comingle in the brain-mind of the beholders, social communion emerges in collective creativity. Cave art empowered group survival and the creation of greater cultural complexity. It predicted the development of sacred sanctuaries, cathedrals, tombs, museums, and theaters.

The Creativity Machine: *Art and Brain-Mind Development*

The developing brain uses art to empower complex skills for a resilient, creative, authentic identity. These skills include improved visual-motor coordination, language development, heightened attentional focus, creative problem-solving, emotional expression and self-regulation, social communication, cultural awareness, and Creative Intelligence.

In his classic *Creative and Mental Growth* (1947), Viktor Lowenfeld presents six stages of development in which artmaking plays a significant role in the formation of the *self*.

Stage 1, *Scribble* (2 to 4 years), lays the foundation for Creative Intelligence. A change from action thinking to imaginative thinking in pictures ushers in the brain-mind's struggle to integrate the mind-body experience. Children tell stories about their scribbles recruiting language to make sense of their creation.

In stage 2, the *Preschematic* (4 to 6 years), circular images suggest a human or animal figure, and show what the child perceives as most important with little attention to space. Objects float in a haphazard way throughout the picture, and color expresses emotion rather than representation.

Stage 3, the *Schematic* (7 to 9 years) stage demonstrates awareness of the concept of space. Objects are placed in up and down positions with a base and skyline apparent. Colors reflect what the child sees. Shapes and objects are easily definable. Exaggeration between figures expresses the child's emotional charge and focus of attention.

Stage 4, *Dawning Realism* (9 to 11 years) marks the emergence of social group artmaking, usually same sex groups. Self-awareness to the point of being extremely self-critical coincides with the first time that the child becomes aware of a lack of ability to show objects the way they appear in the surrounding environment.

Stage 5, *Pseudorealistic* (11 to 13 years), reveals a shift from the importance of *process* in artmaking to the *product* becoming most important to the child.

Two psychological differences emerge, Visual and Nonvisual. The Visual category appears a stage-like presentation, concrete objectification, and color representation. The Nonvisual category expresses the child's emotions and subjective experience using color to express feelings about the subject.

Stage 6, *Decision* (13 to 16 years old), marks a time when children continue to make art or move on to other activities. Talented children, given validation for their skills, often continue making art, and some develop art careers.

6Rs of Creative Intelligence Training

In my clinical work with stressed-out people, relationships, and families, I developed Logosoma Brain Training (1984) and presented it in *Phantom Stress: Brain Training to Master Relationship Stress* (2010). The method recruits the inborn Creative Intelligence in each person with a program, 6Rs of Creative Intelligence Training (2021). Creative Intelligence (CI) development begins in childhood. It is a concept based on the neuroscience of resilience and creativity. With practice, we can improve our CI skills and share them with others. Creative Intelligence is our *superpower.* The 6Rs are:

(1) By *Remembering* negative emotional experiences, we can activate our cognitive ability to

(2) *Reflect* on our perception of ourselves as victims or hostages. Using our ability to

(3) *Reframe* our experiences by declaring "I am not a victim;" we can practice acceptance of the pain of living with gratitude for our creativity. Using our imagination, we can

(4) *Reimagine* ourselves changing perceptions of "reality." In creative conversations we can

(5) *Reinvent* ways of living. We must create many new "blueprints" for living with each other, from the nuclear family to the ever-shrinking global village. Creating new "maps for cultural change" guide

(6) *Reconnecting* global village communication in all areas of human endeavor.

Andy's 6Rs of Creative Intelligence: *Art = Survival*

1. Remember

Andy's art is filled with *memories* from childhood, beginning with Campbell's *Soup Cans*. *Memory* is the foundation of our sense of an authentic sense of *self*. Intrusive awareness of negative emotional memories, *phantom stress*, can increase their toxic effects and create symptoms of anxiety, depression, and self-sabotaging behaviors. Through artmaking, Andy was able to activate positive emotional experiences to increase his resilience to adversity and diminish the toxic effects of negative memories.

2. Reflect

Beginning in childhood artmaking with his mother, Julia, Andy learned to *reflect* on negative emotional memories, like Sydenham chorea, allowing for implicit learning, acceptance of the painful experience, and gratitude that he and his mother could get through this ordeal together.

Andy struggled to *accept* that his body could *feel* like a victim or hostage when adversity occurs as a part of life. In his artmaking, he distinguished "there-and-then" memories from the past from "here-and-now" creative experiences in the present. In his nose job painting, *Before and After, 4* (1962), he documents the autonomy to change the body to suit the mind's aesthetic preference. With *gratitude* for his mind's creative ability, he adapted to and detoxified the negative circumstances. However, he obsessed about his body throughout his life, probing the idea of beauty, and seeing himself on the ugly side of the "beauty-ugly" spectrum. With photographer Christopher Makos, he created a series of self-portraits, *Altered Image*, exploring Andy's concept of beauty. Andy also became a professional model, doing shoots with Christopher for the Zoli Modeling Agency. He became the beautiful muse for Christopher, the artist. Christopher says, "I use my camera like a paintbrush."

Ascending Beauty of the Spirit

As devout Christians, the Warholas embraced the Christian belief in the Resurrection of Christ. Christ ascended beyond his physical pain and suffering, inspiring the ulti-

mate story of resilience—the *Resurrection*. The conviction that faith transcends flesh helped Andy face his assassination attempt and return to a robust and expanded creative life for another eighteen years. Gratitude and acceptance are deep aspects of Christian faith. Mindfully reflecting on negative memories, Andy made art to re-remember them, an act that neuroscientists call *the reconsolidation of memory*. Negative emotional memories are literally rewired, unlearned, and transformed from "high negativity" to "low negativity."

The traumatic experience of his father's death led Andy to a phobic response to death, funerals, hospitals, and the idea of death. To help himself face the inevitability of impermanence, he used artmaking to reconsolidate his traumatic adverse childhood experiences in works like candy-colored *Electric Chairs,* the daunting *Death and Disaster Series,* and shadowy *Skulls*. Andy obsessively warded off painful experiences, trauma, and chronic stress memories. This is how psychotherapy works. Andy felt that television and art served him better than psychiatry.

3. Reframe

Andy's artmaking literally *reframed* his feelings of being a victim or hostage with creative, mindful practice. Making art was a declaration of independence—"I am not a victim." His Creative Intelligence functions like a protective parent to the emotional body, which is like a child. Art was Andy's first step in creative resilience to adverse childhood experiences.

As a chronically ill child, Andy had great expanses of time for daydreaming. During these long periods of time, he could *reimagine* himself. His brain state of "doing" the behaviors of everyday life (*convergent thinking*) could wander into the brain state of "being" (*divergent thinking*). In divergent cognition, the brain becomes a creativity machine. When the mind refocuses attention to "stop doing" and focuses on "just being," attention turns inward and daydreaming begins. Nonlinear patterns of awareness emerge, and the mind wanders aimlessly, exploring awareness from multiple brain centers of consciousness. These neural networks spontaneously and nonconsciously synchronize in their electrochemical communication. They begin communication with each other, activating creativity and inventing new ways to solve problems. The observing mind, paying attention to this synchronized "brain chatter," may experience insights and solutions to problems during this process.

4. Reimagine

Julia was aware of Andy's interest in movies and movie stars. Together, they empowered his skills to *reimagine* himself. In the movies, the brain's mirror neuron system could identify with Shirley Temple dancing, helping him stay meaningfully connected with his impaired body. His imagination could soar in movie theaters. These dark, cave-like spaces, with black and white, shadowy figures dancing on the screen wall, provided a mirror to his imagination. Shadows, mirrors, and beauty would inform all aspects of Warhol's art. Movies also inspired his collecting memorabilia. Warhol's artist-mind was a complex system of creativity that would produce massive artworks in multiple media. Artmaking helped him document new patterns of thinking and acting. Through his drawing, collecting, researching, and reimagining himself, he reinvented new attitudes and behaviors. His lifelong art production extended childhood play. Art was the vehicle for exploring, experimenting, inventing, risk-taking, and practicing.

5. Reinvent

Andy burst onto the art scene with his *Soup Cans,* a challenge to the reigning aesthetic of abstract expressionism. Andy *reinvented* the definition of art. Simultaneously, he reinvented his professional persona of Raggedy Andy, the award-winning, dilapidated, Madison Avenue graphic artist, to become the Warhol, the master of underground culture and cool center of his private world, the Factory. Warhol and the Factory became the crucible for the 1960s cultural evolution that embraced business as art. Andy's professional skill was reinventing everything. He embraced a philosophical, artistic, humanistic, egalitarian attitude. Paul Morrissey observed:

> Andy was not a hippie or rebel but more like a mischievous child. He was never out to destroy everything. He became a New Yorker, and New Yorkers know, like the media, what's going on around them is a fashion thing that will change to something else.

6. Reconnect

Andy's Creative Intelligence was grandiose, and his drive to make his dreams a reality was unstoppable. Perhaps his greatest creative product was his ability for *re-

connection with the world that was so cruel to him. Artmaking helped him overcome insecurity and amplify his emotional intelligence. His physical, emotional, sexual, and socioeconomic insecurities could be cured with fame. With a heightened self-awareness, he charged into the social networks of the rich and famous as a portrait painter. Socializing became compulsive. Andy reflected with his droll wit:

> I have Social Disease. I have to go out every night. If I stay home one night, I start spreading rumors to my dogs.

With this reconnection process, he extended his creative vision to reinventing culture with POPism. He became the Pope of Pop, a powerful thought leader who could influence other people to materialize his ideas. His fame, fortune, and "aura" became a global phenomenon.

Warhol film director Paul Morrissey reflected:

> Andy wasn't capable of any complicated thoughts or ideas. Ideas need a verb and a noun, a subject. Andy spoke in a kind of stumbling staccato. You had to finish sentences for him. So, Andy operated through people who could do things for him. He wished things into happening, things he himself couldn't do.

Bob Colacello, editor of Warhol's *Interview* magazine, wrote:

> Andy Warhol was uninterested in being a second-tier artist. He was uninterested in being a first-tier artist! He wanted to be, you know, a god. Someone who completely changed the…he wanted to be Zeus with the lightning bolt, and nothing less would have satisfied him.

Andy's sociopolitical influence extended POPism beyond art. Andy was the embodiment of a major global cultural movement driven to connect human beings by elevating ordinary, everyday objects into art. Warhol's POP vision was implicitly charged with American-style, egalitarian values. Emerging from his ambiguous, "closeted" gay-Christian identity, Andy became an all-American superstar.

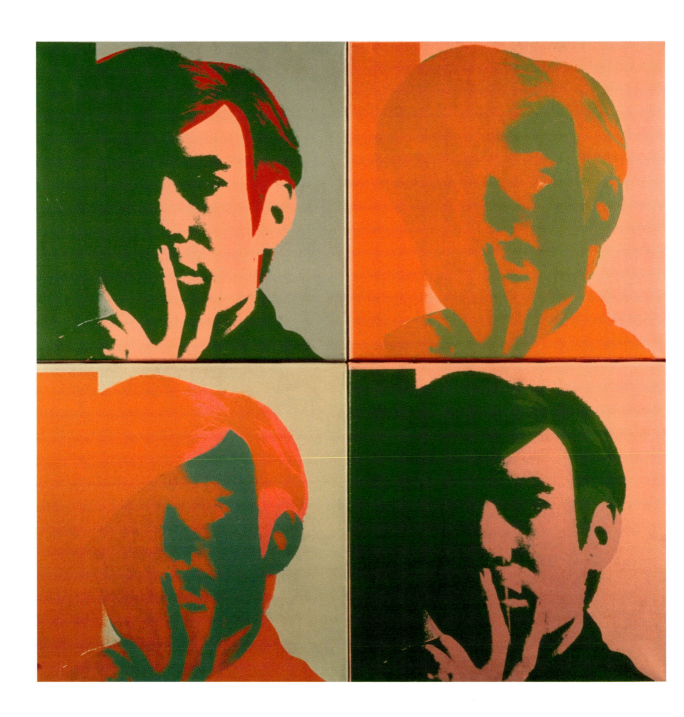

Self-Portrait
Andy Warhol, 1967
Synthetic polymer paint and
silkscreen ink on canvas
72 x 72 inches
182.8 x 182.8 cm

8 ANDY'S IDENTITY
Ambivalence, Ambiguity, and Art

Somewhere between your heart and mine
There's a love I can't understand
And it's there for a while then it fades like a smile
And I'm left in the middle again

Merle Haggard

Falling in love again
Never wanted to
What am I to do?
I can't help it

Marlene Dietrich

I never fall apart because I never fall together.

Andy Warhol

A biopsychosocial approach to identity considers influences from genetics to epigenetics (changes in organisms caused by modification of gene expression rather than alteration of the genetic code itself), patterns of attachment, and social environment. With the science of neuroplasticity, attachment theory, and the neural networks of creativity, we have discovered humanity's superpower—Creative Intelligence. We can adapt to adversity, overcome grave obstacles, and re-create personality traits for survival—a process of self-making called *autopoiesis*. The aphorism "When in Rome, do as the Romans" has profound neuropsychosocial implications.

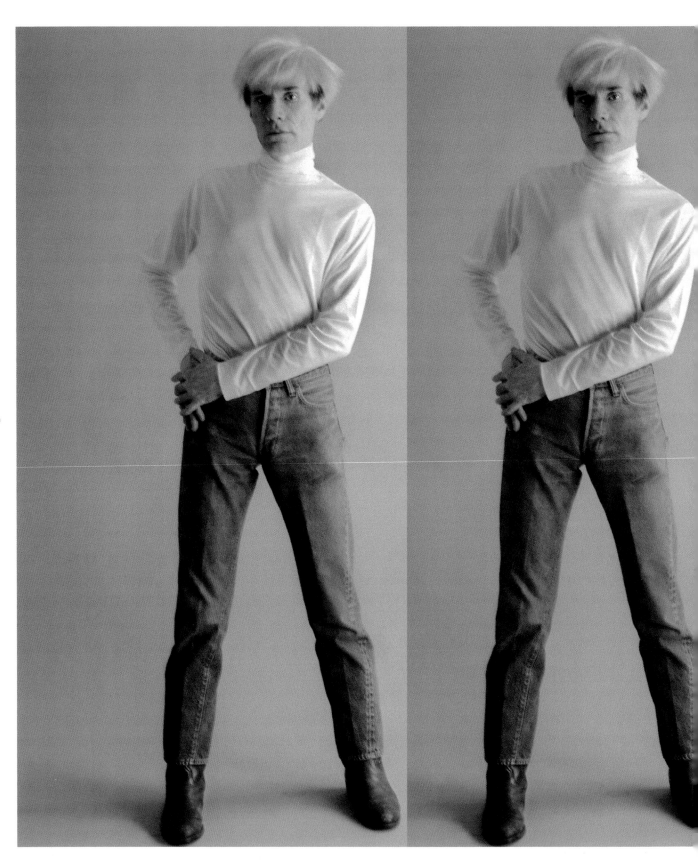

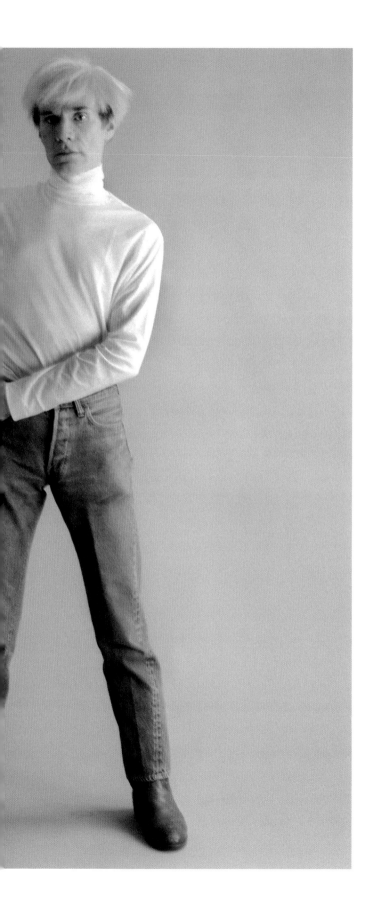

121

Triple Andy,
Christopher
Makos, 2023

The greatest attribute of humankind is the creation of social systems that focus on the survival of the culture and improving the quality of life for the individual—a goal that is still a long way from realization. Andy's complex identity contributed to these values for cultural evolution.

Andy's Creative Personality

In *The Creating Brain* (2005), Nancy Andreasen, MD, PhD, describes the traits of the *creative personality*:

- *Openness to experience*: Creative people approach the world in a fresh and original way that is not shaped by preconceptions. This openness to new experience often permits creative people to observe things that others cannot. Openness is accompanied by a tolerance for ambiguity. Creative people do not crave the absolutism of a black and white world; they are quite comfortable with shades of gray. In fact, they enjoy living in a world that is filled with unanswered questions and blurry boundaries.

- *Rebelliousness*: The lack of commonality with the rest of the world may produce feelings of alienation or loneliness.

- *Adventuresomeness*: Creative people enjoy adventure. They like to explore. As they explore, they may push the limits of social conventions. They dislike externally imposed rules, seemingly driven by their own set of rules derived from within.

- *Individualism*: The disregard for standard interpretations of perception produces the ability to express unique perspectives.

- *Sensitivity*: Paradoxically, the creative person's indifference to convention is combined with high levels of sensitivity to others (empathy) and sensitivity to what the individual is experiencing (vulnerability). Combined with their risk-taking impulses, the creative person's tendency toward "pushing the edge" or "living on the edge of chaos" with emotion, attitudes and behaviors can lead to a sense of rejection by others, injury, or pain.

- *Playfulness*: Creative people tend to be more playful, even childlike, in their intermittently joyous approach to life.

- *Persistence*: Despite the childlike, risk-taking, impulsivity, and "outsider" attitude from mainstream social values, the creative person is persistent, mission-driven, and committed to his or her personal vision. Able to tolerate repeated "rebuffs" or "rejection" from the outside world due to their uniqueness, their internal validation is formidable.

- *Curiosity*: *Intense* curiosity characterizes one of the motivations of the creative person. Eager to understand how things work, to reveal or discover the invisible, or to make things "just right" is also driven by high energy.

- *Simplicity*: These traits tend to be integrated into a singular creative vision that charts the life-path of personal meaning and dedication. It is easy to see that such a person may place their work above all other activities.

Andy Warhol scores 9/9 on the creativity profile. Looking at how he manifested these traits reveals the core of his identity and the scope of his Creative Intelligence.

- Openness

Andy said, "The world fascinates me." His intuitive *openness* to new experiences required that he move out of his shy temperament, social awkwardness, and isolation in his sketchbooks that characterized his adolescence. His adventurous spirit drove him to New York to embark on a job search. His art reflects a deep understanding of ambiguity, informed by his developmental adversities and his resilience through artmaking. He played with gender identity as a personal and social vehicle for creativity. His *Altered Image* series, created with Christopher Makos, reveals the essence of ambiguity. His fascination with beauty (seeing himself as ugly), mirrors, shadows, being, and nothingness reflect his philosophical queries into relativity and possibilities rather than a search for absolutes.

- Rebelliousness

Andy's *rebelliousness* was present since childhood. His brother Paul recalled:

> You could see he was picking up things much better than we did, but he was really mischievous between three and six. Andy picked up some bad language when he was about three. He's heard some kids swear. Swearing wasn't allowed in our house—you couldn't even say "hell!" We'd go to a relative's place and Andy'd say some of these things and it wasn't nice. I'd sometimes smack him in the face. And the more I smacked him, the more he said it—the worse he got. He was real bad: Just because we didn't want him to say it, he'd say it.

- Adventuresome

After graduation from the Carnegie Institute for Technology in 1950, Andy and fellow artist Phillip Pearlstein traveled to New York to begin their careers as artists. This was an extremely adventurous leap for shy, insecure Andy.

- Individuality

Competing with slick Madison Avenue advertising artists, Andy created his own persona, Raggedy Andy, an offbeat bumpkin with enormous talent and individuality. He was able to win sympathy and jobs from the female art directors, and curry favors for his calculated, pitiful persona. He showed up for jobs with a disheveled suit, a frumpy look, and deliberately paint-splattered shoes—the opposite of the stereotypic Madison Avenue business attire. In the 1960s, he morphed into the Warhol—a bad boy image with striped sailor shirt, leather jacket, and dark glasses like Marlon Brando's *Wild One* and James Dean's *Rebel Without a Cause.* He did portraits of both these movie icons that mirrored his ego ideal.

- Sensitivity

Part of the Warhol persona was his *sensitivity* displayed in an ingenue-like demeanor—the "dumb blonde" affect inspired by Marilyn Monroe—his most famous portrait. Rejected in efforts to form intimate relationships in the 1950s, Warhol sublimated his unrequited love and wounded emotions into the cutting edge of avant-garde. Always appearing vulnerable, he did not hesitate to live on the risky edge of the underground culture where sex, drugs, and rock-and-roll became subjects of his films.

- Playfulness

Andy created the Factory, which served as his art studio by day and an underground social experiment by night. It was a nonstop, amphetamine-driven funhouse. Celebrities mixed with drug dealers and mentally ill groupies. With the Velvet Underground, Gerard Malanga, and others, he created an archetypal multimedia circus-like production, the traveling *Exploding Plastic Inevitable*. Valerie Solanis, suffering from paranoid schizophrenia, tried to woo Andy for her feminist manuscript S.C.U.M. (Society to Cut Up Men). On June 3, 1968, feeling dismissed, she arrived at the Factory with a gun and shot Warhol and another person. Warhol died on the operating table and required open chest cardiac massage to survive.

- Perseverance

After convalescence, Warhol's *perseverance* emerged. He did a series of self-portraits depicting his scarred postoperative abdomen and chest with Richard Avedon. He became more productive than ever, moving from underground artist to society portraitist, taking on social issues from gender diversity to endangered species to racial bias. Within ten years, he would travel the world, despite his phobias, meet the Pope, walk the Great Wall of China, and be anointed as the Pope of Pop.

I first met Andy in New Orleans, 1976. I had direct experience with Andy's wit, *playfulness*, and social mischievousness. At his opening for *Ladies and Gentlemen,* he introduced me to Hazel Guggenheim, Peggy's sister. Although I was a med student, he referred to me as Dr. Romero. He asked Hazel to "show the doctor your recent appendectomy scar." Hazel instantly obliged, right in the middle of the art opening, lifting her blouse and revealing her abdominal scar! Andy had everyone laughing. I had witnessed the Warhol in creative, playful action. He was a talented curator of people and choreographer of social dynamics. The silver-haired social dames, debutants, and beautiful boys queued up around him, extended their arms, giving Andy a marker pen, and begged, "Sign me, Andy, make me a Warhol."

- Curiosity

Andy's *curiosity* was endless. In our many conversations over the last ten years of his life, he was fascinated by my research to link developmental psychology, brain science, cultural evolution, and creativity. He agreed to do an interview with me for my book *The Art Imperative: The Secret Power of Art*. He was eager to discuss his own childhood creativity. He said:

> I really needed you when I was a kid. It's too late for therapy to help me, but I think your Art Imperative idea is great. I have that. I don't know what I'd do if I couldn't make art.

- Simplicity

Despite his compulsive collecting, hording, and clutter in his home, Andy loved simplicity. Charged with his ironic wit, he said:

> I really believe in empty spaces, although, as an artist, I make a lot of junk. Empty space is never-wasted space. Wasted space is any space that has art in it.
>
> I like boring things.

Andy and Julia: *"Somewhere Between Me and You"*

Andy's core identity was shaped by his childhood relationship with Julia. Conflict, ambiguity, ambivalent attachment, and self-doubt rippled over the generations from Julia's traumatic loss of her first-born child, Maria, to her idealized attachment with infant Andek. The long shadow of phantom stress shaped the patterns of attachment and charged his creativity. His artworks, from the *Soup Cans* to the *Death and Disasters,* to the *Portraits*, and eventually to his masterworks, *Shadows* (1978–79) and *The Last Supper* (1984–86), reflect his core identity—everything an artist makes is a self-portrait. Andy's Creative Intelligence would challenge the stress of his symbiotic attachment to Julia. Andy compulsively sought liberation from the feelings of emptiness in the codependent relationship with Julia. He reinvented his identity in the endless, compulsive remaking of self-portraits. He reflected:

> If you want to know all about Andy Warhol, just look at the surface of my paintings and films and me, and there I am. There's nothing behind it.

Julia's Phantom Stress: *Maria's Ghost in the Nursery*

The origins of Andy's Creative Intelligence emerge in a complex mother-child experience of conflict, posttraumatic stress, love, and play. Psychoanalyst-pediatrician D.W. Winnicott articulates this period:

- It is in playing and only in playing that the individual child or adult is able to be creative and to use the whole personality, and it is only in being creative that the individual discovers the self.

- Artists are people driven by the tension between the desire to communicate and the desire to hide.

- The mother gazes at the baby in her arms, and the baby gazes at his mother's face and finds himself therein… provided that the mother is really looking at the unique, small, helpless being and not projecting her own expectations, fears, and plans for the child. In that case, the child would find not himself in his mother's face, but rather the mother's own projections. This child would remain without a mirror, and for the rest of his life would be seeking this mirror in vain.

Winnicott focused on the mother-infant relationship as the foundation of human identity. In the interaction, he saw the attuned mother as a the physical and emotional "holding environment" for the child. Her attention, her validation of the child's impulses, her empathy for the setbacks, and her skill at creating limits for the child's impulses contribute to what he termed "good enough mothering." The child is free to play, to experiment, to explore, to invent, to take risks, to practice. The child emerges from this experience with spontaneity, a secure sense of mother's firm and flexible presence, and a budding sense of authenticity—a *True Self*.

When the holding environment is experienced as insecure, either inattentive or smothering and overcontrolling, the result is a self-doubting sense of identity. The perpetual feelings of conflict and insecurity drive the child to please mother at any cost and/or an oppositional-defiant attitude battling for autonomy—a *False Self*.

Julia's ability to provide a secure holding environment was compromised by her post-traumatic stress (PTS) from Mikova, the ongoing stressors of poverty, and the toxic environment of Pittsburgh. Andy's birth may have triggered Julia's projections of her lost daughter, Maria. His temperament and effeminate demeanor during childhood may have triggered projections of unresolved grief. Andy, whose best friends were girls, was highly sensitive, and eventually his chronic illness provided her a child that needed her to survive. She turned to Andy to console her grief for her lost Maria. Julia regressed with him in creative play as her own art therapy. A symbiotic attachment emerged where Andy's identity never quite differentiated from his mother—Maria's ghost haunted Andy's life, his art, his philosophy, and his stress. Self-doubt shaped his nonconscious, ambivalent approach to intimate attachments throughout his life. The mirror of his mother's face reflected Maria and himself, a very confusing core identity. He had to struggle with Julia's projections of Andy as a replacement for Maria, leaving him with a chronic conflict of self-doubt.

PART THREE

CREATIVITY

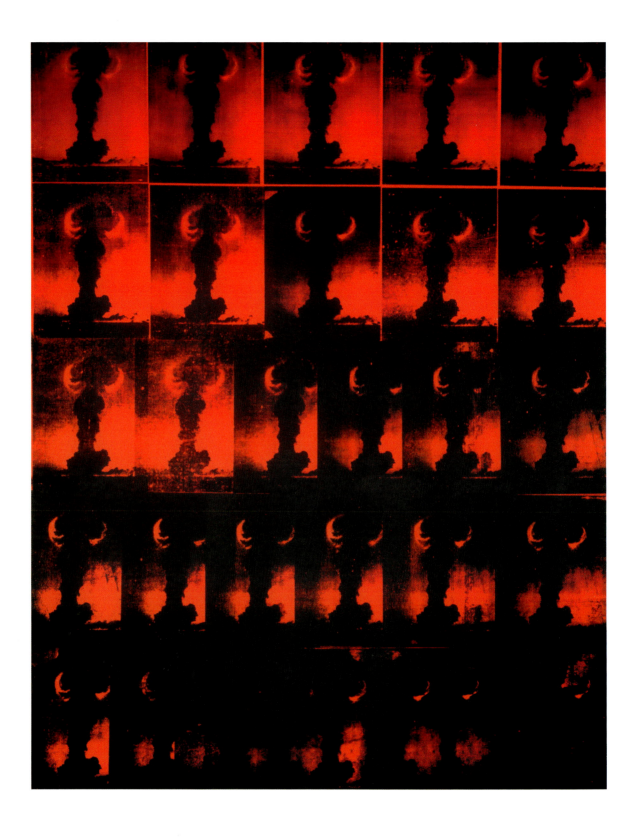

Red Explosion (or Atomic Bomb)
Andy Warhol, 1963
Silksceen ink and acrylic on linen
103.75 x 80.25 inches
263.5 x 203.8 cm

9 Andy's Art I
1950–1968
Apocalyptic Anxiety, Advertising, and Alchemy

I don't believe in art. I believe in artists.

Rational intelligence is dangerous and leads to ratiocination. The painter is a medium who doesn't realize what he is doing. No translation can express the mystery of sensibility, a word, still unreliable, which is nevertheless the basis of painting or poetry, like a kind of alchemy.

The individual—man as a man, man as a brain, if you like—interests me more than what he makes because I've noticed that most artists only repeat themselves.

Marcel Duchamp

Andy's Art: *Content, Context, and Creativity*

The complexity and uniqueness of Andy Warhol's art requires a cultural evolution approach to explore the content and context of his work. Andy Warhol emerged midway through the most destructive century in human history. Revolutions in art had been unfolding for fifty years when Warhol and pop art took center stage in 1960. Andy challenged the art values of modernism by deliberately re-evaluating the content of art.

What did Andy Warhol see when he looked at a can of Campbell's soup?

He saw lunch. He saw childhood memories with his mother. He saw the "tin flowers she (Julia) made of those fruit tins, that's the reason why I did my first tin-can paintings.... My mother always had lots of cans around, including the soup cans. She was ... a real good and correct artist, like the primitives."

He saw a brand-name food product. He saw a tin can with sealed food with a very long shelf-life that could be distributed around the world without spoiling. He saw the factories of mass production. He saw art. A masterpiece of human ingenuity, creativity, truth, beauty, and goodness. He saw pop art. A can of soup was an integral, meaningful part of the complex system of human civilization and cultural evolution.

Warhol placed ordinary, mundane, emotionally bankrupt images on canvas. He challenged the viewer to make sense of his nonsense. Warhol's creativity expanded the definition of art beyond the content of paintings and films into the cultural context shaping the zeitgeist of his generation.

From 1950 to 1960, Andy developed a successful career in advertising art. He had a ringside seat as the rise of American abstract expressionism (AE) in New York dominated the global Renaissance of modern art after the devastation of World War II. He met Barnett Newman at a party and remembered:

> I think Barney went to more parties than I did. He always asked me how I was. He was so kind.

Andy envied the grand scale and cultural importance of the AE artists. He wanted their fame, notoriety, and influence. In 1944, Newman wrote in a piece titled "On Modern Art: Inquiry and Confirmation":

> ...modernism brought the artist back to first principles. It taught that art is an expression of thought, or important truths, not of sentimental and artificial 'beauty'. It established the artist as a creator and a searcher rather than a copyist or maker of candy.

Andy may have come across these ideas during his art studies at Carnegie Tech or in the New York art scene in the fifties. He confronted them head-on. He made art that challenged these values, their ideas, and the images. In *POPism*, he wrote,

> Abstract Expressionism had already become an institution, and then, in the last part of the fifties, Jasper Johns and Bob Rauschenberg and others had begun to bring art back from abstraction and introspection stuff. Then Pop Art took the inside and put it on the outside, took the outside and put it inside.

Andy camouflaged his important truths and thoughts with sentimental images (*Soup Cans*) and artificial beauty (*Marilyn*) by literally copying movie stills and painting them with candy color. It's as though he had read Newman's declaration and presented himself as a "lost copycat" artist, rather than a creator and searcher. He turned Newman's words inside out. After all, he and Julia privately printed *25 Cats Name Sam and One Blue Pussy* (1954), a limited-edition artist's book. It consists of 19 lithographs that were hand-colored with watercolor by the artist and his friends.

The up-and-coming Neo-Dadaists Jasper Johns and Robert Rauschenberg shrugged him off. He became obsessed with figuring out a way to become relevant. He transformed his advertising artist identity from Raggedy Andy to a bad-boy anti-hero, the Warhol, fully committing himself to the path of notoriety—he must become important. His expertise in advertising, in how media influenced public opinion and how wealth is created, would be critical elements for his creative alchemy in reinventing a complex identity as an art-business-anti-hero. For Andy, becoming a famous artist was a serious business.

Andy knew that high ideals and important truths must be profitable if they were going to influence cultural change. Warhol was no stranger to the ruthless greed and lack of compassion in the cut-throat, bottom-line advertising business. Arrogance, indifference, and contempt for the common person was rampant in the wealthy classes. He knew firsthand from his experience with poverty and exposure to the elite class while he attended the art classes at the Carnegie Museum in Pittsburgh. He smuggled egalitarian values into the cultural mainstream with his art.

Andy's POPism was an original, paradoxical, ambivalent, and alchemical response to the values of modernism.

The Age of Art-Science in the Twentieth Century

Human cultural history in the twentieth century can be divided in two segments, 1900 to 1945 and 1945 to 1999. The atomic bombings mark the tipping point where *Homo sapiens* arrived at the technological capability to self-exterminate, and we demonstrated a willingness to use it. Self-destruction, the consequence of person-

al dysfunction, addictive behaviors, and brain-stress burnout escalated beyond national conflicts and war to become an existential threat to human life on Earth. The horrors of destructiveness in the first half of the century seemed paltry compared to real possibility of species extinction.

Creativity in the first half the century saw major leaps in both science and art. Scientific understanding of nature, both its creative force and destructive power, played a vital role in reinventing material civilization. Modernist explosions in the arts challenged the antiquated hierarchy of European socioeconomic structure.

Two world wars transformed civilization—the planet was now a battlefield. The "hot wars" of the first half of the century destroyed nineteenth-century civilization. The "cold war" of the last half hijacked civilization in a nuclear holocaust end game of species extinction—the age of anxiety.

The hot wars came to a dead halt by dropping two nuclear bombs at Hiroshima and Nagasaki, killing 200,000 people. The total number of military and civilian casualties in World War I was around 40 million. There were 20 million deaths and 21 million wounded. The total number of deaths includes 9.7 million military personnel and about 10 million civilians. Seventy-five million people died in World War II, including about 20 million military personnel and 40 million civilians. World War II losses of the Soviet Union from all related causes were about 27 million, both civilian and military. The Holocaust was Nazi Germany's deliberate, organized, state-sponsored persecution and machinelike genocide of 6 million European Jews and at least 5 million prisoners of war, Romany, Jehovah's Witnesses, gay people, and other victims.

The "Cold War" began when the Soviet Union developed nuclear arms capability in 1949.

Modern Art Imperative: *Make It New*

In his 1934 collection of essays, American poet Ezra Pound (1885–1972) declared "Make It New," a creativity imperative. This dictum for modernism impelled artists to create distinctively individualized, innovative work and break with the formal and contextual standards of their contemporaries. Individualism sparked modernism.

The artist's mission was to consider the aesthetics of the past in the context of the present moment and create something from their personal perspective—art as a reflection of personal truth. The first great waves of modernism began at the turn of the century with Cubism, Vorticism, Futurism, Fauvism, Dada, Surrealism. With champions like Picasso, Duchamp, and Dali, art took a significant role in reorganizing culture. An art-science continuum emerged: Surrealism-Psychoanalysis, Dada Reinventing Meaning, Cubism-Relativity theory. The Art-Science Century launched.

Parallel creativity in science saw the nineteenth-century of chemistry displaced by the new age of physics. Quantum mechanics emerged gradually from the shared works of Max Planck, Albert Einstein, Niels Bohr, and others. They redefined the classic Newtonian model of reality with a super-complex system that spanned the subatomic world to the edge of the cosmos.

Quantum mechanics and Relativity Theory inspired Cubism, Vorticism, and other ideas in art. Creativity in the arts and sciences comingled in the evolution of redefining cultural reality. The old ways were being replaced by the creation of new frameworks.

During the eighteenth century, the Enlightenment philosophical movement dominated Europe and promoted the idea that *reason* is the primary source of authority and legitimacy. This led to the belief that man could use reason to control nature with science and separate his need for belief in God from the functions of state.

Martin Heidegger employed phenomenology to examine ontology in *Being and Time* (1927). Inspired by Heidegger, Jean Paul Sartre's *Being and Nothingness: An Essay on Phenomenological Ontology* develops existentialism, a philosophy dealing with topics such as consciousness, perception, social philosophy, self-deception, the existence of "nothingness," psychoanalysis, and the question of free will. Existential phenomenology incorporated Eastern philosophical concepts of nothingness, dualism, and non-theistic models of reality.

In physics, Nobel laureate Niels Bohr, inspired by Taoism, with its yin-yang union of opposites, embraced contradictions in his *theory of complementarity*. He devoted himself to finding a mechanistic, unified field theory that would supersede quantum mechanics—a quest that would last the rest of his life.

Trained as a neurologist, Sigmund Freud bridged the arts, sciences, and philosophy with his probes into the unconscious processes of the human brain-mind system. Despite theoretical errors, his work inspired present day neuroscience to integrate the brain-mind system, consciousness, quantum physics, and creativity.

Modernism represents a consilient approach to understanding existence—a unity of knowledge that incorporates all human creativity as the source for meaning. Like our ancient ancestors, when we gaze into a star-filled night sky, we experience a state of wonder and awe. The Platonic values of truth, beauty, and goodness reflect the cognitive-emotional experience of stargazing that has transfixed the wondering-wandering mind of human consciousness since the dawn of time. These values are in perpetual conflict with patterns of self-destructiveness driven by greed, ignorance, fear, and lust.

American Art After the Bomb: *From "Make it New" to "the Destroyer of Worlds"*

As Robert Oppenheimer, the "father" of the atomic bomb, witnessed the first detonation of a nuclear weapon on July 16, 1945, he reflected on the most well-known line from "The Bhagavad-Gita": "Now I am become Death, the destroyer of worlds."

In the shadow of the atomic bomb, America kindled Russia, its ally in defeating Nazi Germany, to become a nuclear power and initiate a new Cold War. Capitalist greed and communist fascism extended the human compulsion for conflict into a new kind of war. The world quickly became engulfed in a pandemic of nuclear holocaust terror—*the atomic age of anxiety*. We had the ability to exterminate ourselves and, it seemed as if we were committed to an arms race toward species extinction.

President Dwight Eisenhower served during the 1950s and made the new warfare explicitly psychological and cultural.

> Our aim in the Cold War is not conquering of territory or subjugation by force. Our aim is more subtle, more pervasive, more complete. We are trying to get the world, by peaceful means, to believe the truth. That truth is that Americans want a world at peace, a world in which all people shall have oppor-

tunity for maximum individual development. The means we shall employ to spread this truth are often called "psychological." Don't be afraid of that term just because it's a five-dollar, five-syllable word. "Psychological warfare" is the struggle for the minds and wills of men.

I vividly recall the Cuban Missile Crisis, October 16 to October 28, 1962, from my fourth-grade vantage point. Port Arthur Texas, the largest oil refinery center in America, was number three on Russia's nuclear target hit list. The Cold War was on the brink of becoming super-hot. We had regular, citywide, duck-and-cover, air raid drills. We were instructed to get under our desks, kneel and crouch, and hold our hands over our heads until the all-clear alarm sounded. The teacher reminded us in case of water shortages: "Don't drink the water from the toilet bowl, but you can drink the water in the tank." I had posttraumatic stress nightmares for years to come.

In 1963, Warhol painted *Red Explosion (or Atomic Bomb)*. In 1964, Marshall McLuhan, a futurist media expert, culture philosopher, and likeminded contemporary of Warhol, coined the term *global village*. He predicted the World Wide Web almost thirty years before it was invented. McLuhan commented:

> Societies have always been shaped more by the nature of the media by which men communicate than by the content of the communication.

> Ads are the cave art of the twentieth century.

> Ideally, advertising aims at the goal of a programmed harmony among all human impulses and aspirations and endeavors. Using handicraft methods, it stretches out toward the ultimate electronic goal of a collective consciousness. Art at its most significant is a Distant Early Warning System that can always be relied on to tell the old culture what is beginning to happen to it.

Abstract Expressionism: *Art Against Human Destructivity*

Barnett Newman, cofounder of the abstract expressionist movement, recalls:

> …we felt the moral crisis of a world in shambles, a world devastated by a great depression and a fierce war, and it was impossible at that time to paint the

kind of paintings we were doing—flowers, reclining nudes, and people playing the cello. At the same time, we could not move into the situation of a pure world of unorganized shapes and forms, or color relations, a world of sensations. And I would say that for some of us, this was our moral crisis in relations to what to paint. So that we actually began, so to speak, from scratch, as if painting were not only dead but had never existed.

The moral crisis permeated American culture after President Harry Truman decided to weaponize science to annihilate human beings with two atomic bombs. The idea of species' self-termination in a nuclear winter was now a reality. There could be no winners in a nuclear war.

The US invested huge sums of unaccounted funds into the CIA's campaign to "culturally" fight communism, culminating as the Congress for Cultural Freedom by 1950. American art (writing, visual arts, music) was antithetical to Stalinist dictums that art should promote the communist state—art as propaganda, an attitude created by Adolf Hitler and Joseph Goebbels. Nazi art suppressed creativity in favor of militant design—art as advertising.

American art represented "freedom of expression" and the sacredness of the individual as written into our Declaration of Independence. Nelson Rockefeller purchased over 2,500 pieces of abstract expressionist art, decorating the lobbies of Chase Manhattan banks with these paintings. His Museum of Modern Art championed the movement over others. The abstract expressionists were individualistic, autonomous, exuding despair, anxiety, and fear of atomic annihilation. The media proclaimed abstract expressionism as the true art of American culture. American art flexed its muscles in the cultural challenge to communism.

Jackson Pollack embodied artists as rugged individualists—he was the iconic American hero of alienation, the model for Hollywood anti-heroes like Marlon Brando and James Dean. Martha Holmes's photographs of Pollock action-painting splashed across the pages of *Life* magazine, owned by Henry Luce, an American magazine magnate called "the most influential private citizen in America." He transformed journalism and the reading habits of millions of Americans with *Time*, *Life*, *Fortune*, and

Sports Illustrated. Luce created the first multimedia corporation. In 1941, he declared the twentieth century would be the "American Century." Warhol's Creative Intelligence may have been inspired by Luce's accomplishments as he reimagined his future. Andy became both a multimedia mogul and paradoxical thought leader promoting the values and freedom of his beloved America.

Abstract expressionism put American art at the top of innovation in the art world, displacing European dominance since the Renaissance. America was victorious in ending the hot war. Warhol wanted to put POPism at the center of American culture. World leadership promised a new global structure as the vanguard of capitalist cultural evolution for the world. Warhol's art challenged the perpetual politics of human destructivity. He was committed to supporting America winning the cultural Cold War and preventing a nuclear holocaust.

In 1982, Andy did a self-portrait film while eating a Burger King cheeseburger. On December 8, 1987, ten months after Andy died, President Ronald Reagan and Mikhail Gorbachev signed the Nuclear Disarmament Treaty, beginning the end of the Cold War. On January 31, 1990, McDonald's golden arches first lit up on Moscow's Pushkin Square to great fanfare. An estimated 38,000 Soviets lined up for hours for what they might have heard of but never tasted: a McDonald's hamburger. American pop culture arrived.

Andy's Apocalyptic Anxiety: *Art Against Fear*

> What do you think an artist is? ...he is a political being, constantly aware of the heart breaking, passionate, or delightful things that happen in the world, shaping himself completely in their image. Painting is not done to decorate apartments. It is an instrument of war.
>
> **—Picasso**
>
> Any art worthy of its name should address "life," "man," "nature," "death" and "tragedy."
>
> **—Barnett Newman**

Andy Warhol embraced what he knew—advertising and media—to address the "big issues" of art. He used American consumerism as a medium for his art. As an antidote to global stress, Andy's paradoxical imagery challenged the anxiety of impermanence triggered by the atomic age. By painting fear-triggering symbols—car crashes, electric chairs, hammer and sickle, Mao, guns, skulls—he confronted fear directly. In *Tunafish Disaster* (1963), Warhol lifts a story of two housewives directly from newspapers: Mrs. Brown and Mrs. McCarthy shared a sandwich made from tainted storebought tuna and died of food poisoning. Their deaths made headlines across the country. Warhol elevated this news story to a major artwork. In *Artnews*, 1963, Gene Swanson wrote:

> Warhol's repetitions of car crashes, suicides and electric chairs are not like the repetition of similar and yet different terrible scenes day in and day out in the tabloids. These paintings mute what is present in the single front page each day and emphasize what is present persistently day after day in slightly different variations. Looking at the papers, we do not consciously make the connection between today's, yesterday's, and tomorrow's "repetitions" which are not repetitions.

The foreword to Andy Warhol's *Death and Disasters*: *The Menil Collection* (Houston: Houston Fine Art Press, 1988), explains:

> Warhol's art [*Death and Disasters*] will convey the range, power and empathy underlying his transformation of these commonplace catastrophes. Finally, one can sense in this art an underlying human compassion that transcends Warhol's public effect of studied neutrality.

In the spirit of Martin Heidegger, Warhol lived his truth through making art. Heidegger said:

> If I take death into my life, acknowledge it, and face it squarely, I will free myself from the anxiety of death and the pettiness of life—and only then will I be free to become myself.

Andy's Alchemy I: *Personal Transformation from Raggedy Andy into the Warhol*

Andy Warhol was a talented "reader" of social trends, and he used this talent to excel on Madison Avenue's advertising stage. He had powerful aspirations to become a "fine artist," to make his own individualist, alienated art. But the lineup of the abstract expressionists was a bunch of rough and ready white men, like a military platoon or football team. How could he fit into that scene? Even the two Neo-Dadaists emerging in the 1950s, Robert Rauschenberg and Jasper Johns, who were also gay, were in the closet and appeared like macho individualists.

In his 1980 memoir *POPism: The Warhol Sixties*, Warhol recounts a conversation with his friend Emile de Antonio ("De"), an agent and filmmaker who was also close to Rauschenberg and Johns.

> I'd been wanting to know for a long time why they [Rauschenberg and Johns] didn't like me. Every time I saw them, they cut me dead... I finally popped the question and De said, "Okay, Andy, if you really want to hear it straight, I'll lay it out for you. You're too swish, and that upsets them... First, the post-Abstract Expressionist sensibility is, of course, a homosexual one, but these two guys wear three button suits—they were in the army or navy or something! Second, you make them nervous because you collect paintings…And third, you're a commercial artist, which really bugs them because when they do commercial art—windows and other jobs I find them—they do it just 'to survive.' They won't even use their real names. Whereas *you've* won *prizes*! You're *famous* for it!"

De Antonio's psychological interpretation was mutative for Andy. It triggered a critical awakening for Warhol. His creative brain was aware that his financial and professional success were not enough, and his Raggedy Andy persona was a mask to protect him from social anxiety and interpersonal insecurity. He wanted to emerge as a true self, no matter what people thought. He used his Creative Intelligence as an alchemist. And he had all the ingredients to transform his leaden, false identity into a golden artist—an identity that could pursue his personal truth in art for the rest of his life. But he had to reconcile his phantom stress from childhood plus adversity.

At eight years old, Andy Warhol was diagnosed with an autoimmune disease. He suffered severe Sydenham chorea, and he was bedridden for months after episodes of involuntary shaking that led to bullying at school. With creative support from his mother, he found comic books—the portal to his future. His new idol was Superman, an alien boy from another planet whose superpowers led him to be a champion for "truth, justice, and the American Way." Andy mirrored the superhero's need for a secret identity, the tale of Clark Kent. As an insecure young boy, Warhol found hope in Kent's transformation from underdog to superhero. More than anything, Andy wanted to become a superhero. His superpower was creativity and art. One of his first pop art paintings was *Superman* (1961), a hand-painted rendering of Superman using his super-breath to extinguish a fire. The thought caption read, "Good! A mighty puff of my super breath extinguished the forest fire!"

Is this painting a private joke about his homosexuality? Superman saving people with a blow job?

Andy realized he had played the role of Clark Kent in the 1950s, a mild-mannered, sexually ambiguous, commercial artist. It was time for him to come out as the superhero he knew he could become. He reinvented himself as the Warhol—iconoclastic, individualist, and outsider of every "in-group." He knew that, like Superman, he needed to create his own fortress of solitude—the Factory (1962–87). Warhol emerged as the super-cool, participant-observer, impresario alone at the volatile center of culture—a spinning vortex of assistants, celebrities, and outsiders in a dance of creativity-destructivity.

Andy's Alchemy II: *Cultural Transformation from Individualism into Collectivism*

In July 1962, Warhol debuted *Soup Cans*—a challenge to the reign of monumental abstract expressionism. The artists represented American rugged individualism that placed American art at the center of the emerging global culture. *Soup Cans* are "concrete expressionless" art—the studied opposite of AE. Warhol's pop art alchemy promoted collectivism by reflecting the shared reality of mass consumer culture. Campbell's soup is an everyday food for all socioeconomic levels—a symbol for an

egalitarian society where "all men are created equal, that they are endowed by their Creator with certain unalienable Rights, that among these are Life, Liberty and the pursuit of Happiness." Warhol cultivated the idea that ordinariness is worthy of becoming exalted by art. Andy expressed his American values:

> What's great about this country is that America started the tradition where the richest consumers buy essentially the same things as the poorest. You can be watching TV and see Coca Cola, and you know that the President drinks Coca Cola, Liz Taylor drinks Coca Cola, and just think, you can drink Coca Cola, too. A coke is a coke, and no amount of money can get you a better coke than the one the bum on the corner is drinking. All the cokes are the same and all the cokes are good. Liz Taylor knows it, the President knows it, the bum knows it, and you know it.

POPism seemed to be art-light, fun, and playful, but the issues presented by Warhol were also dark, powerful, negative emotion, like the AE artists. Warhol's POPism continued the cultural wave of art against human destructivity, exuding invitations for contemplation and activating creative intelligence in the beholder. AE used individualistic, heroic, mythopoetic themes to challenge and renew civilization in the face of the atomic auto-annihilation potential of the nuclear age that began with Hiroshima and Nagasaki. If we are about to destroy all that we made, even the ordinary things become precious. Warhol reframed ordinariness, charging it with emotional significance and making it extraordinary.

In November 1958, Nikita Khrushchev declared "We will bury you," widely interpreted as a nuclear threat to America and the capitalistic West. He set the paranoid stage of the Cold War. The 1960s witnessed escalating East-West tensions, with the rapid sale of nuclear fallout shelters stocked with canned goods, like Warhol's rows of *Soup Cans*, to survive the nuclear winter of a holocaust. POPism reacted to this dark nightmare with vibrant colors, banal content, and elevated American advertising art to the level of "high" art. Everyday things became worthy of our attention. The pop zeitgeist seemed to be declaring: "if we destroy ourselves, then all that we created is meaningless."

POPism was an artistic antidote to nuclear holocaust anxiety. Pop art functioned as a confusing, mind-numbing, pre-traumatic, creative defense to the escalating stress of the Cold War. Warhol wrote in *POPism*:

> ...in the last part of the fifties, Jasper Johns and Bob Rauschenberg and others had begun to bring art back from abstraction and introspective stuff. Then Pop Art took the inside and put it on the outside, took the outside and put it inside.

Warhol's art reframed the cultural obsession and anticipatory anxiety of nuclear Armageddon that triggered global village stress in the 1960s. Pop art seemed to declare: "Nothing really matters, so don't be afraid! Live as if everything is okay."

The apocalyptic fantasies of horror, annihilation, and suffering were firsthand experiences for Andy. He brought his pain, his fear, his anguish, and his objective, philosophical, clinal mind to each canvas. As a keen observer of himself and the world, Andy reflected on repetition. He said:

> I'm afraid that if you look at a thing long enough, it loses all of its meaning.

This awareness of repetition and meaninglessness are critical to understanding Andy Warhol's practice of using multiple images. He realized that emotions could be paralyzing, especially the fear of pain. He observed the escalating, addictive, mindless consumerism of the 1950s exploding in the 1960s. His critical observations expanded the complexity of his art.

> My fascination with letting images repeat and repeat—or in film's case "run on"—manifests my belief that we spend much of our lives seeing without observing.

> During the 1960s, I think, people forgot what emotions were supposed to be. And I don't think they've ever remembered.

Warhol's art in the 1960s reflects his central themes: anxiety, ambiguity, and death. The Factory was his laboratory for cultural anthropology, an adult playground to act out all his grandiose fantasies, filled with a cast of superstars to amuse him. He could flex his creative superpower as the anti-hero of the night. This swirling silver world of sex, drugs, and rock-and-roll would meet its tragic end when Valerie Solanas shot Andy Warhol in 1968.

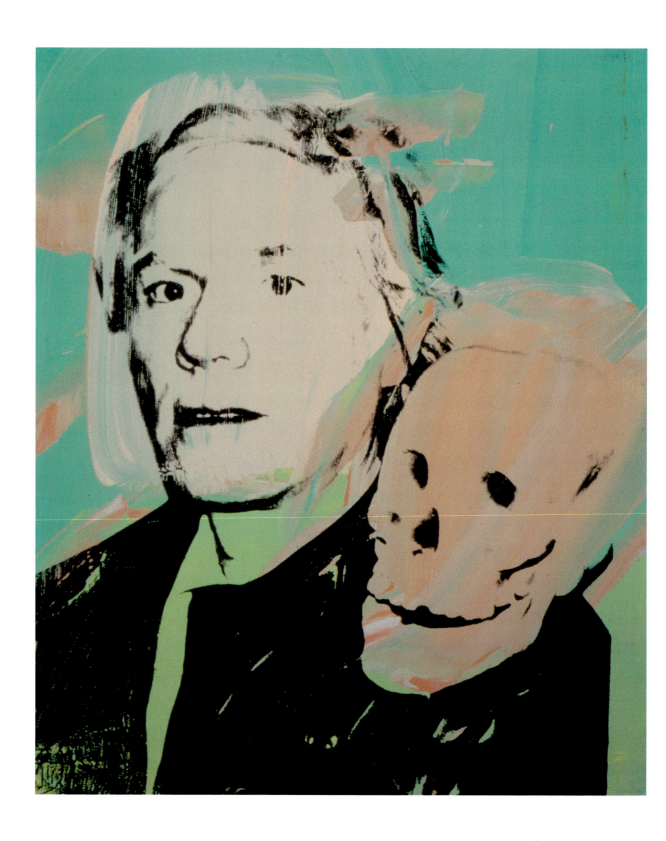

Self-Portrait with Skull
Andy Warhol, 1978
Synthetic polymer paint and
silkscreen ink on canvas
16 x 13 inches
40.6 x 33 cm

10 ANDY'S ART II
1968–1987
Shadows of Resurrection: Wealth, Power, and Fame

I think his portraits of Jackie, Liz, Marilyn, Mao, Elvis, Lenin—and objects like the soup cans, the dollar signs, the hammer and sickle, it's all about icons. It's all about what people worship in an irreligious or secular world . . . he made religious art for a secular society which is why it has so much appeal.

—Bob Colacello

Resurrection/Reinvention

As a devout Catholic, Andy Warhol may have felt "resurrected" by God after his assassination. He died on the operating table. Dr. Giuseppe Rossi, a brilliant surgeon, resuscitated him using open chest manual cardiac massage. His long recuperation provided him with extended time to focus his Creative Intelligence for resilience and peace of mind. He could remember his life, with his many conflicts, and reflect on his mortality. He reframed his approach to making POPist art, reimagining his creative productivity, and eventually remaking himself and his art in the shrinking global village.

It was time for Warhol to reinvent himself. The post-assassination course of his artwork traces a moving shadow of his personal journey. He expanded his vision beyond pop art to include abstract images, experiments with new processes, collaboration, and monumental scale. His creativity exploded after the near-fatal trauma. Already an active collaborator, Warhol made films with Paul Morrissey, fashion projects with Halston, paintings with Jean-Michel Basquiat, photo series with Christopher Makos, and returned to his commercial art past creating ads for everything from vodka to perfume to gasoline. Eventually, his explorations in abstraction kindled a reconcilia-

tion process of his lifelong struggles between the multitude of conflicts that plagued his life. Warhol lived in an entangled web of identity dialectics between his public and private experience—life-death, poverty-wealth, obscurity-fame, isolation-socialization, gay-straight, concrete-abstract, cognition-emotion, religion-secularism, spiritualism-materialism.

America was a great screen for Andy Warhol's creative projections. He also used it as a reciprocal mirror. He said:

> People are always calling me a mirror, and if a mirror looks into a mirror, what is there to see?

Andy was America, and America was Andy. He reflected about his own fantasy life in his struggle to consolidate his identity. In his compulsive search for inner peace, Warhol reflected (1985):

> Everyone has their own America and then they have the pieces of a fantasy America that they think is out there, but they can't see... And you live in your dream America that you've custom made from art and schmaltz and emotions just as much as you live in your real one.

Through his art, Warhol worked on his quest to understand himself. His lifelong identity conflicts were mirrored in his childhood obsession with the Clark Kent-Superman dual identity. He struggled to create an authentic identity in the transition from his 1950s persona, Raggedy Andy, to become the superstar artist the Warhol.

My Reflections from San Francisco

In 1971, after completing my pre-medical courses and applying to all the Texas medical schools, I moved to San Francisco and worked at the Rip Off Press. Dave Moriaty, a fellow Port Arthurian, co-owned the press with cartoonists Gilbert Shelton and Jaxon. They published their work and the rising underground comic book art stars, Robert Crumb, Dave Sheridan, S. Clay Wilson, and many others. Shelton felt a rivalry with the New York pop art scene and championed the Bay Area cartoonists as the real cultural avant-garde. Like Warhol, Shelton had his own Factory in the Rip Off Press. We had our scene, the parties, and all that goes with it. He created a spoof superhero by

conflating, I believe, Superman and Warhol into a clumsy, brutish character, *Wonder Warthog*, that did more damage than the villains and whose name rhymes with Andy Warhol. Dave Sheridan drew a spoof comic character of a Warhol-like artist painting a large canvas holding a brush between the cheeks of his rump—a sharp visual jab at the gay pop scene in Warhol's New York.

America: *Warhol's Perpetual Subject and Muse*

Warhol's art mirrored America, the good, the bad, and the ugly. He revealed the paradoxes of American identity, triggering a discourse that is more relevant today than it was over half a century ago. The present-day cultural crisis in America is being played out in deep, fundamental fractures in America's identity that threaten the democratic institutions invented by the founding fathers. Warhol implicitly warned America and the world about fractures in the foundations of American/global culture. Warhol's art reflected abounding greed in *One Dollar Bill (Silver Certificate)* (1962), which sold for $32.8 million in 2015, and *Dollar Signs* (1981). In the series *Race Riot* (1964), Warhol documents the racial bias endemic to America's history of slavery, civil war, and suppression of African American people. Painting from the tabloids, he X-rayed and mirrored the ugly American truths of violence, socioeconomic disparity, and the phony self-righteousness of America's core identity as a compassionate immigrant sanctuary.

Achille Bonito Oliva presents a brilliant book, *Andy Warhol: The American Dream* (2013), that documents Andy's complex relationship with America. Warhol looked deeply into American culture, beginning during his advertising art career. His reflections reveal efforts to enlighten American culture to its own deep flaws. Oliva's visual masterpiece spans Warhol's creative life and art, providing a visual journey through Warhol's consolidation of everyday objects with famous and talented creative people.

America is in a perpetual struggle for its own identity. Warhol, like all human beings, has his own issues with identity, authenticity, and the meaning of life. For Andy, his identity reconciliation between his camouflaged Christian faith and his glamourous life infuses his art with a degree of empathy for the individual and the collective minds of our species.

Andy's Creative Intelligence: *Repurposing Repetition-Compulsion*

Warhol created his paintings in a ritualistic-like method of image repetition that sparks the viewer into a dreamlike trance. Andy's world of repetition-compulsion has a mission, an aesthetic purpose.

> My fascination with letting images repeat and repeat—or in film's case "run on"—manifests my belief that we spend much of our lives seeing without observing.

For Andy, and perhaps for human beings, art has a defensive function, a distracting, creative kindling effect for the beholder. Creativity protects us from the painful past and inspires us to create a better present for a more secure future. Creative Intelligence harnesses our inborn resilience and creativity. It is an ongoing mind-body process of effortful attention: remembering, reflecting, reframing, reimagining, reinventing, and reconnecting with oneself and the world.

Freud describes the psychodynamics of the repetition-compulsion:

> The patient cannot remember the whole of what is repressed in him, and what he cannot remember may be precisely the essential part of it... He is obliged to repeat the repressed material as a contemporary experience instead of remembering it as something in the past.

When the brain processes traumatic stress, the flood of adrenalin can short-circuit the memory function leading to symptoms of posttraumatic stress. Symptoms include numbness, hypervigilance, dissociation, avoidance, flashbacks, and anxiety. In my book *Phantom Stress: Brain Training to Master Relationship Stress* (2010), I propose a brain-mind process of activating creativity to "unlearn" the traumatic past and relearn adaptive ways of processing negative emotions. Warhol was no stranger to these experiences. On greeting Andy, I often gave him a gentle hug. He seemed so fragile. And there was always a slight startle response on contact, revealing a physical manifestation of posttraumatic stress. During a conversation with Andy about my *Art Imperative* book project, Andy said:

> I have that art imperative thing. I don't know what I'd do if I didn't make art. I'd be a mess.

Repetition and Reframing: *Art and Gay Liberation*

Warhol, the commercial artist, also understood the value of repetition in advertising. To sell an idea, a product, or to imbed an image in the unconscious memory, repetition is required. Andy's interest in changing cultural values toward a more open, egalitarian society was a fundamental motivation across his career. In the *Death and Disaster* series, he reflected how we have become numb to death. His films and paintings that reframed pornographic and homoerotic imagery as art used repetition to desensitize the viewer's automatic response of shock, excitement, or repulsion. His male nude drawings and paintings were implicitly designed to neutralize the homophobic reaction in the beholder's experience and find a more objective appreciation of beauty attuned with his experience. In *Andy Warhol. Love, Sex, and Desire: Drawings 1950–1962* (2020), Michael Dayton Hermann, Drew Zeiba and Blake Gopnik, reveal his unapologetic, sensitive, homoerotic drawings. His desire to bring queer images to the public as art took many forms throughout his life. Warhol was the tip of the spear in the art world for *gay liberation.*

Celebrity Portraits: *Art Pays the Bills*

Edmund Gaultney introduced me to Andy in 1976 in New Orleans. He moved to New York and opened his own gallery—the Gray-Gaultney gallery. It opened with a big bang with Andy Warhol's diamond dust portrait, *Georgia O'Keeffe.* Edmund was friends with Georgia and arranged for the shoot. The gallery opening was a celebrity bash with everyone from the governor, Hugh Carey, to Diana Vreeland, Dennis Hopper, and countless others. As a Factory insider and art dealer, Edmund was networking with the celebrities to sell portraits by Andy and to curate shows for developing artists. Edmund commissioned Andy's final screen-print series *Cowboys and Indians* (1986). He worked closely with Rupert Jasen Smith, Andy's master printer, inviting many people who wanted to "become a Warhol." Edmund unexpectedly died in 1986, and I was the executor of his estate. This meant that I stood in for him with Rupert and Andy to complete the series.

I met Andy one afternoon shopping for men's clothing with Jean-Michel Basquiat as I pushed my daughter in the stroller. Andy interacted with her, and said, "Oh, you should bring her to the Factory, I'll do her portrait." My budget could not afford the going rate of $40,000 for such a commissioned work, and I have my regrets for not pursuing it. The series had a further complication when Andy died on February 22, 1987. It was one of the saddest times I had known.

Andy's Shadows: *A Journey Through the Cave of Abstraction*

Andy identified with shadows as a symbol to mirror his self-perception. He made a self-portrait as *The Shadow* for the print series *Myths* (1981) that includes *Superman, Howdy Doody, Dracula, Uncle Sam, Santa Claus,* and other recognizable figures of American film, history, and culture that he may have identified with at one time or another. His body felt like a *Howdy Doody* puppet during the episodes of Sydenham chorea. He loved America as much as Uncle Sam. His generosity may have reflected his inner-Santa. He lived the split identity of private Catholic and public superstar, like Clark Kent and Superman. And he certainly knew the vampiric yearning for life, earning the nickname Drella (Dracula + Cinderella), from Ondine, one of his superstars in the Factory.

In 1968, recovering from an assassination attempt that ruptured his vital organs, flat-lined his heart, and tattooed his emotional memory with a multitude of phantom stressors, the idea of the Shadow would provide him with much needed sanctuary. His prolonged recovery provided him time to "do nothing." His brain spent extensive time in the divergent brain state, daydreaming, and activating the 6Rs of Creative Intelligence. He could spend time remembering, reflecting, reframing, and reimagining his life. This time in divergent consciousness proved to be the crucible for re-inventing himself, and ultimately, reconnecting with art and the global village. Andy emerged from his chrysalis of transformation into a new version of the Warhol. The 1960s, the Factory, and all the chaos, characters, and creativity of that period fertilized his Creative Intelligence with a more integrated sense of himself. He would become a prolific thinker, writer, and entrepreneur, as important as his paintings.

Seven years after his assassination, Andy Warhol painted skulls, a grim reminder that he had died and been resurrected by Dr. Rossi. In *Skulls* (1976), he used the quintessential symbol of death as a prop for many self-portraits. He explained:

> Before I was shot, I always thought that I was more half-there than all-there—I always suspected that I was watching TV instead of living life… Right when I was being shot and ever since, I knew that I was watching television. The channels switch, but it's all television.

Andy took a leap into pure abstraction and process art with *Oxidation* (1977–78) and *Shadows* (1978). These two series of paintings emerge from Andy's dualistic approach to everything. The *Oxidation* and *Shadow* series implicitly drew on the Christian duality of the Body and the Spirit of Christ, the neural operations of concrete and abstract cognition, and the philosophical duality of being and nothingness.

In making the *Oxidation*, *Piss*, and *Cum* paintings, also called the "Piss paintings," Warhol spread canvases out on the floor and coated them with a copper paint. He would typically direct his assistants or Factory visitors to urinate on them while the paint was still wet. Like an alchemist, Warhol used the oxidation reaction between the paint and human secretions of urine and semen to produce art.

The *Shadow* series are quintessential abstractions—paintings of nothing.

Phillip Barcio (2017) associated Warhol's *Shadows* with Plato's "Allegory of the Cave."

> I believe "Shadows" is a manifestation of the "Allegory of the Cave," a story invented by the Greek philosopher Plato to explain his Theory of Forms. The Theory of Forms posits that the most accurate version of reality exists in the non-physical realm of ideas. Everything we experience with our senses while moving through physical existence is but a shadow of an idea that exists in that enigmatic realm. To explain this theory, Plato told a story of some people imprisoned in a cave. The people are seated, facing a blank wall. Unbeknownst to them, a fire is burning in the back of the cave. Between the fire and the people, a puppet show is going on. The light from the fire casts shadows of the puppet shows onto the wall. The people are watching the shadows on

Triple Self-Portrait with Andy Warhol's Shadows (1978), Phillip Romero, 2014

the wall, but they do not know they are watching only superficial, enigmatic representations of reality. They think the shadows have substance.

When we look at Warhol's *Shadows* (1978–79), we see a wall of shadows. We are surrounded by this wall—a fortress of shadows. We may feel claustrophobic, smothered, oppressed, or imprisoned. Or we may feel safe, protected, and delighted. The beholder's share of art activates reciprocal creativity in their brain-mind. Art is a brain-mirror, charged with private emotions, associations, and memories. The viewer must make their own personal meaning of the art. Warhol knew *Shadows* would invite endless interpretation, insuring him perpetual, timeless fame. He reflected:

> The idea is not to live forever, it is to create something that will.

With this abstract painting, the scale and display consume the viewer, like a black hole in the cosmos, into another dimension of cognitive-emotional-spatial reality. The painting invites the viewer's brain to reinvent itself in a private experience. It is a portal for the beholder's creativity.

In 2015, during the *Shadows* exhibition at MOCA, Los Angeles, I filmed *ART=SURVIVAL: Andy Warhol: Shadows "Into the Light #1 and #2"* (https://www.youtube.com/watch?v=Xw-daE2uAPA&t=). I planned to walk through the show unscripted. I imagined that the artwork would stimulate me to spew a running commentary of free associations. The opposite occurred. I was dumbfounded, wordless, speechless, transfixed in my gaze, swallowed up in the space, surrounded by the maze of shadows in silence. I had an epiphany that took me back to the day Andy died, and I felt cheated out of my conversation with him. I realized the profundity of Andy's self-awareness when he made what seemed like a smirky comment many years ago:

> If you want to know all about Andy Warhol, just look at the surface of my paintings and films and me, and there I am. There's nothing behind it.

This film is my conversation with Andy, an abstract-concrete encounter with myself and Andy, with being and nothingness. Andy inspired me to understand how art creates meaningful connections in life. Andy presented a kind of psychoanalytic neutrality in many conversations, cultivated by his personal traumata, alienation, insight, and Creative Intelligence.

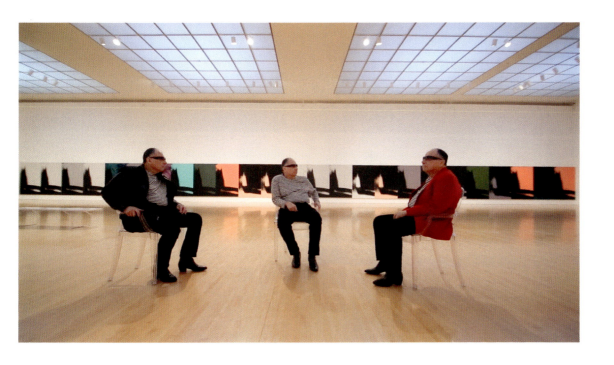

Andy Warhol's *Shadows* (1978–79) is a single work that consists of 102 canvases that hang end to end to form a single monumental installation. Reminiscent of Monet's *Water Lilies* at the Orangerie, Paris, *Shadows* is one of Warhol's most ambitious abstract works that cohesively synthesizes key elements of his practice, including film, painting, photography, and screen-printing. He reflected:

> I called them "Shadows" because they are based on a photo of a shadow in my office. It's a silkscreen that I mop over with paint. I started working on them a few years ago. I work seven days a week. But I get the most done on weekends because during the week people keep coming by to talk.

Warhol photographed two shadows and combined them to create a series of silkscreen canvases. Limiting himself to two colors for each canvas, they are shadows of a shadow. Warhol juxtaposed a single bright color on a black background. These dynamic fields of color embody the dualistic conflicts between light and darkness, joy and despair, enlightenment and self-sabotage, creativity and destructivity.

Myths: The Shadow
Andy Warhol, 1981
Screenprint with diamond dust
on Lenox Museum Board
38 x 38 inches
96.5 x 96.5 cm

Andy's Shadow Self: *The Myth of Creativity*

Carl Jung proposed the notion of the "Shadow" to illuminate the unconscious, its nature, and the process of creativity. He said:

> The shadow personifies everything that the subject refuses to acknowledge about himself and represents a tight passage, a narrow door, whose painful constriction no one is spared who goes down to the deep well.

> [If and when] an individual makes an attempt to see his shadow, he becomes aware of (and often ashamed of) those qualities and impulses he denies in himself but can plainly see in others—such things as egotism, mental laziness, and sloppiness; unreal fantasies, schemes, and plots; carelessness and cowardice; inordinate love of money and possessions.

Artists spend much of their "working time" in the divergent brain state, where daydreaming and creativity are produced by the brain's creativity machinery. Gazing into the abyss of the unconscious is part of the job for the artist, the contemplative, philosophers, and scientists. Warhol experienced himself in the world as a shadowy, "as if" identity. In 1934 and 1942, psychoanalyst Helene Deutsch described the "as if" personality type—individuals who leave other people with an impression of inauthenticity. They seem to enjoy "normal" relations with those around them and appear perfectly well adjusted. However, despite showing empathy, they betray a lack of emotional depth. This phenomenon reflects a lack of authentic emotional attachment. She wrote about their creations:

> a spasmodic, if skilled, repetition of a prototype without the slightest trace of originality… Another characteristic of the "as if" personality is that aggressive tendencies are almost completely masked by passivity, lending an air of negative goodness, of mild amiability which, however, is readily convertible to evil.

Warhol wrote in his diary in November 1978:

> I said that I wasn't creative since I was shot, because after that I stopped seeing creepy people.

Further reflections reveal significant symptoms of posttraumatic stress, including numbness, hypervigilance, and dissociation.

> Before I was shot, I always thought that I was more half-there than all-there—I always suspected that I was watching TV instead of living life. People sometimes say that the way things happen in movies is unreal, but actually it's the way things happen in life that's unreal. The movies make emotions look so strong and real, whereas when things really do happen to you, it's like watching television—you don't feel anything. Right when I was being shot and ever since, I knew that I was watching television. The channels switch, but it's all television.

From early childhood, his core identity may have struggled with the unconscious, shadowy emotional conflict: "Am I loved for being me or for replacing Maria—who am I?"

Art = Survival: *Creating an Authentic Identity*

In one conversation in 1986, Andy confided to me:

> My doctor said I should see you as a therapist for my stress. She thinks you can help me. I needed you (a child psychiatrist) when I was a child. It's too late for me to change now. My mother was so confusing to me then. It was so hard for me to make connections to other people. In the 1950s, I tried psychoanalysis, but I flunked out. So, I got a TV, and that helped me in being alone. TV was my companion. When Mom moved in with me, we started making art together again, like when I was sick. I made it a business. We made books together. I have to keep making art. Making art gives me peace.

Andy was acutely aware of his identity confusion and his codependence with Julia—they needed each other to feel stable. Feeling like a hostage struggling for freedom was a perpetual emotional reality. It triggered his obsession with mirrors and a search for the "idea of beauty." Three of his aphorisms reflect his feeling trapped in a mirror, in an endless search for himself.

> Being born is like being kidnapped. And then sold into slavery. People are working every minute. The machinery is always going. Even when you sleep.
>
> People are always calling me a mirror, and if a mirror looks into a mirror, what is there to see?
>
> I always thought I'd like my own tombstone to be blank. No epitaph, and no name. Well, actually, I'd like it to say "figment."

For Andy to feel authentic, he needed to reinvent himself periodically. Refueling his motivation to carry on was an adaptation to chronic ambivalent attachment. The quest for secure love could be found during his artmaking experiences. His love of beauty, fame, and social acceptance could be explored endlessly with his fertile imagination.

Christopher Makos: *Shared Creative Intelligence*

In collaboration with Christopher Makos, Andy transformed his insecure, doubting self-image into one of his most revealing self-portraits, *Altered Image* series (1981). According to Peter Wise, assistant to Makos for the shoot, "Andy wanted to explore 'the idea of beauty.' Halston offered him several of his gowns, but Andy did not see this as a 'drag' project of cross-dressing." In 2009, Makos wrote,

> As the 1980s began, Andy Warhol and I decided that we would collaborate together on a project. There was a perfect understanding between us. Sexually repressed by a very bigoted Catholic education, we both looked on life and the world in the same way, and we each benefited from our relationship.
>
> Andy and I also both loved Duchamp, Dali, and Man Ray, all Surrealists. I knew that some people considered Andy to be a latter-day Dadaist and I saw clearly that I should take as my starting point the famous photograph of 1921 in which Man Ray portrayed Duchamp, wearing a woman's hat and dress. They had called this collaboration "Rrose Selavy."

Considering the emotional state of culture throughout the world in 2009, the "Mistaken Identity" images, created in 1981, continue to speak eloquently to the contemporary viewer. For me they continue to remind me of Man Ray, my great inspiration, and Andy Warhol, my great model and friend.

In his newest book, *Andy Modeling Portfolio Makos* (2022), Christopher reveals little known works from their long collaboration where Andy could be the muse for Makos, the artist. This role reversal helped Andy become "the idea of beauty," realizing liberation from his "ugly self."

The 1980s would be the decade where Warhol's art explored many transformations toward his personal ascendence from the "as if" persona.

Andy's Pop Zen Koan: *"Make Something Out of Nothing"*

Like a Pop Zen master, Andy Warhol personified the core struggles for human existence: *What am I? Who am I? What am I doing here? What's it all about?* He embodied the depth of Buddha's Truths—*emptiness and impermanence*—the critical triggers of human suffering.

He answered the questions as an artist. Andy's Creative Intelligence responded to the existential angst of ambivalence, ambiguity, and confusion. He became a social mirror reflecting our collective shadow. His monumental productivity had profound effects on culture. The Andy Warhol Foundation reflects his generosity, addressing the conflicts we all struggle with. Perhaps one reflection about himself and his art reveals his solution to the suffering in life:

> Well, it doesn't mean if you don't believe in nothing that it's nothing. You have to treat the nothing as if it's something. Make something out of nothing.

Andy's Diary

Andy Warhol began his 807-page diary on November 24, 1976, and made entries for eleven years. The journal ends on February 17, 1987, just five days before his death. Warner Books first published it in 1989 with an introduction by Pat Hackett. A recent

Netflix documentary series, *The Andy Warhol Diaries,* brings Warhol's final decade to life with critical commentary from many Warhol experts and his closest friends. The series reflects Warhol's thought processes, his philosophy, his motivations, his emotional life, his relationships and attachments, and his ever-expansive influence in the art world. Perhaps Andy's perpetual insecurity emerges as the most compelling force that drives his compulsive Creative Intelligence. Some of the most natural, relaxed, and secure attachments appear with his closest friends, including Christopher Makos, Peter Wise, Bob Colacello, Halston, and Liza Minnelli.

Resurrection of Painting: *Shared Creative Intelligence* and Jean-Michel Basquiat

In the arc of adult development, Erik Erikson formulated eight stages of psychosocial development. The seventh stage, **Generativity versus Stagnation,** unfolds from ages 40 to 65. Erikson wrote:

> Psychologically, generativity refers to "making your mark" on the world through creating or nurturing things that will outlast an individual… often having mentees or creating positive changes that will benefit other people.

Warhol was facing stagnation in his creativity, fearing that he may be running out of ideas. Securely embraced by the wealthy collectors, fashion aficionados, aging celebrities that fueled his portrait business, and investors who commissioned his print-series for quick profits, Andy felt dismissed by the art world. He felt that he was no longer relevant. Although he was producing masterpieces, from *Shadows* to the *Camouflage* series, to the *Rorschach* paintings to *The Last Supper*, he was not earning the external validation that sustained him. His obsessive self-doubting fed a craving for fame, his addiction.

Andy looked to the up-and-coming downtown art scene for inspiration. It felt reminiscent of the 1960s. Fashion, music, beauty, and vibrant youth were thriving. Warhol's agent, Bruno Bischofberger, had discovered the hottest talent on the scene, Jean-Michel Basquiat. Bischofberger introduced Andy to Jean-Michel on October 4, 1982, igniting a collaboration that would rejuvenate Warhol as a painter and provide

Basquiat with the mentor in the art world he needed. They cocreated 150 paintings until 1986. Their shared addiction to fame took its toll, though. After their blazing shared Creative Intelligence, Andy Warhol would die in 1987 from chronic malnutrition, toxic stress, and complications from emergency gall bladder surgery. Jean-Michel's cocaine and heroin addictions would consume his brilliant talent at age 27 in 1988.

Andy's Long Brain Shadows

From a neuroscience perspective, the creativity function of the brain starts with how the brain perceives the world. In an interview, Nobel neuroscientist Eric Kandel explained:

> When you look at a bottle or a work of art, your brain doesn't take a picture of the bottle or art, it deconstructs the neural impulses triggered by light hitting the retina and transmitted to the visual cortex. There the brain deconstructs all the elements from line and color to context. It reconstructs these elements in the mind's eye. It also associates the image with personal memories, feelings, thoughts, and learned experience, making perception of the bottle or art a unique experience. In every sense, the brain is a creativity machine, and our perceptions are works of art.

Paleolithic cave paintings, like Plato's *Cave*, flickered on the walls in the firelight of prehistoric humans, activating their imagination. The cave dwellings, the first museums, the first temples, marked the shadowy dawn of contemplative consciousness and culture. The abstract realm of the imagination, the dark side of consciousness, the unseen, the repressed, the forgotten terrors of childhood are imprinted in our emotional memory. From the darkness, we seek the light, we imagine a better tomorrow. We invent new ways to face adversity. Creativity empowers our struggle through life in the light-filled concrete world of the present, interacting with people, places, and things, perpetually repeating and reinventing patterns of thought, feelings, and behavior.

In his post-assassination recovery, Warhol's ability to perceive, deconstruct, and reconstruct reality empowered his biological resilience with mindful creativity. With his powerful Creative Intelligence, his art enhanced his chances for survival, mitigating stress, and transformed adversity into new possibilities that changed him. As an artist with a deep conviction to make art that reaches the masses and proclaims the truth and beauty in the ordinary, Andy Warhol had monumental influences on culture that persist today.

11 ANDY'S ART III
Faith and Transcendence of the Secular and Spiritual

Andy's Spiritual Journey into the Light: *Transcending the Secular and the Spiritual*

In John 6:53-54, Jesus tells us that unless one eats his body and drinks his blood, we have no life.

> Most assuredly, I say to you, unless you eat the flesh of the Son of Man and drink His blood, you have no life in you.

Archdiocese of Atlanta wrote:

> In Holy Communion, we receive Jesus Christ, who gives Himself to us in His body, blood, soul, and divinity. This intimate union with Christ both signifies and strengthens our union with Him and His Church. Jesus speaks of the importance of Holy Communion when He states, "unless you eat the flesh of the Son of man and drink His blood, you have no life in you." Because Holy Communion unites us to Jesus, it also strengthens us against sin, helps us to live a Christian life, and prepares us for the heavenly banquet.

For Warhol, a "camouflaged" Catholic, these deeply learned beliefs informed the post-assassination choices he made as an artist until he died. People with deep religious conviction often imagine their pain and suffering is a consequence of their sinful attitudes and patterns of behavior. It's impossible to know whether Andy Warhol believed that Valerie Solanas was an agent of God's will who was sent to punish him for the "sins of the 1960s." The trauma was a powerful motivator to change his ways.

Warhol's post-assassination art tracks a path of redemption, like a long spiritual pilgrimage toward reconciliation of his deepest conflicts—arrogance against humility, pride against surrender, indifference against compassion, and conflict between his homosexual nature and the Bible he worshipped.

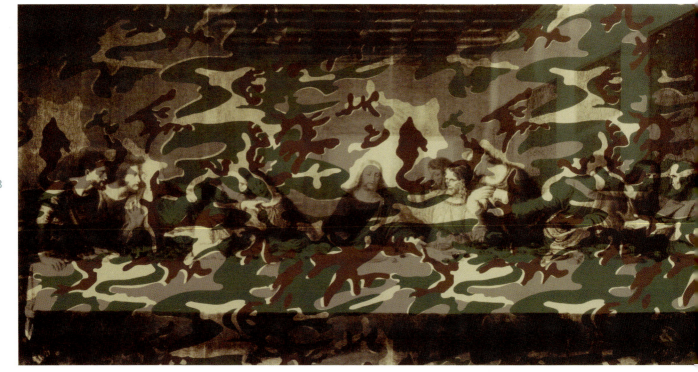

The Last Supper (The Last Supper Twice With Camouflage)
Andy Warhol, 1986
Synthetic polymer paint and silkscreen ink on canvas
84 x 450 inches
213.4 x 1143 cm

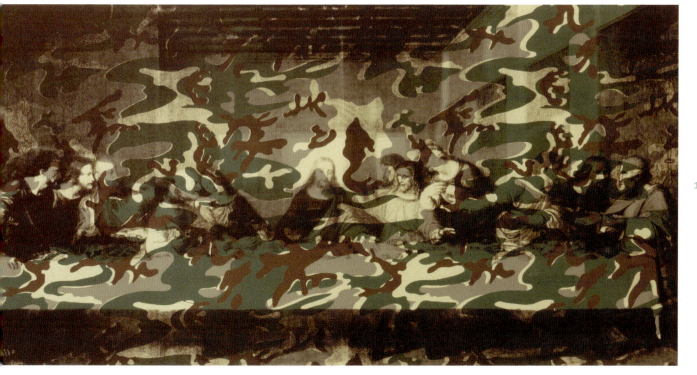

> Leviticus 20:13 "If a man practices homosexuality, having sex with another man as with a woman, both men have committed a detestable act. They must both be put to death, for they are guilty of a capital offense."

What social neuroscience provides is a mechanism that demonstrates his survival from trauma reactivated his artistic talents and Creative Intelligence in the autopoiesis of reinventing himself.

Andy struggled with conflicts between the Christian doctrines and his own truth, his own experience of reality, his sexuality, informed by ambiguity and ambivalence about everything. After his 1968 "death," he created great symbols of his personal journey toward redemption, transcendence, and ascension.

After Andy died, Lou Reed and John Cale, founding members of Andy's band, the Velvet Underground, expressed the wit and sarcasm of the Factory culture with *Songs for Drella* (1990). Drella was a nickname for Warhol coined by Warhol superstar Ondine, a contraction of Dracula and Cinderella, used by Warhol's crowd but never liked by Warhol himself. The song cycle focuses on Warhol's peculiar interpersonal relations and experiences. The portmanteau moniker frames Andy's identity as a powerful, self-centered vampire who doesn't reflect in mirrors, the ultimate false self, a kind of phantom personality, camouflaged as an ingenue persona of feminine innocence. Andy's reaction to the name reflects his inner conflict with the polarities of his private spiritual values and his external materialistic persona. His true self, his Christian values, were hidden.

Andy's Ambiguity: *"Noli me tangere"*

In John 20:17,

> Jesus saith unto her (Mary Magdalene), "Noli me tangere" (touch me not); for I am not yet ascended to my Father: but go to my brethren, and say unto them, I ascend unto my Father, and your Father; and *to* my God, and your God.

Andy Warhol's body had a heightened physiological startle response to being touched—the hypervigilance sequelae of chronic posttraumatic stress. I recall greet-

ing Andy with a hug at the BAM Gala (Brooklyn Academy of Music) preperformance dinner for Pina Bausch on October 1, 1985. He flinched automatically but continued to connect emotionally in the moment. We sat at Hedy and Kent Klineman's table for ten and talked about shared experiences with his dermatologist, a friend of mine.

Andy remarked, "Oh, my doctor said I should talk with you about my stress, but I flunked out of psychiatry in the 1950s. I needed you when I was a child."

We refocused the conversation to how Andy took his limousine all over the city to photograph kids on the street to get inspiration on their fashion and hairdos. "Kids are the real telltale of what's coming next," Andy reflected.

We also discussed my close friend, Edmund Gaultney, who was publishing Andy's next screen-print series, *Cowboys and Indians*. Edmund was very excited about the project. When Edmund died six months later, I became executor of his estate and stepped in to complete the screen-print series, working closely with Rupert Jasen Smith. Andy typically avoided funerals. It took all my powers of persuasion to get Andy to attend Edmund's memorial service, a rare behavior. Terrified of death since his father died when he was a tween, Andy did not even attend Julia's funeral when she passed.

Andy Visits the Pope: *A "Coming Out" Party*

Warhol "came out" Catholic when he made a very public appearance with Pope John Paul II on April 2, 1980. The following year, he produced a telltale oeuvre of symbolic paintings: *Crosses, Dollar Signs, Guns, Knives*, and *American Myths*, featuring his childhood icon Superman flying up, up, and away. Like the ascending Superman, Warhol felt like an alien within his own belief system and yearned for a personal ascension. Superman is a Christ-like hero, soaring into the imagination of creativity as Christ promises escape from the agony of worldly conflict by placing faith in him. Andy struggled to rescue himself and the world with art. Making work that saw the beauty in the everyday, the sacredness of the ordinary, and the potential reconciliation with the truth within one's darkest feelings. The Bible taught him this most critical value.

> John 8:32 "And you shall know the truth, and the truth shall make you free."

Andy's Paradise Lost: *Modern Madonna Drawings* (1981)

John Milton's *Paradise Lost* (1667) mirrors feelings and thoughts that Warhol wrote about.

> Solitude sometimes is best society.
>
> Better to reign in Hell, than to serve in Heaven.
>
> The mind is its own place, and in itself can make a heaven of hell, a hell of heaven.

Artists use imagination to explore bodily experiences lost in pre-memory. The sensory and symbolic origins of infant-mother attachment form the core of Christian iconic imagery, the *Madonna and Child.* This irresistible image has greater power to hijack the viewer's nonconscious yearning for love and security than any image made by artists. It is a religious icon charged with the most potent invitation to faith.

On November 15, 1980, Andy Warhol visited the Maria Laach Benedictine Abbey near Cologne, Germany. Dr. Dieter Koepplin wrote:

> ...the *Modern Madonna* project, as Warhol called it, had started before this visit to the monastery... Christopher Makos and Andy Warhol hired breastfeeding mothers and had them sent around to their studio. Warhol photographed them...

As a Catholic artist, the *Madonna Lactans* was a potent subject, too charged, and personal for Andy to neglect. These sensitive drawings reveal a deep emotional connection to the images of the infant-mother bond. Andy, the voyeur, focuses on the embodied image, the sacred symbol of his own *paradise lost.*

Andy's Last Supper

Warhol's life was in perpetual conflict, contributing to the chronic stress he endured. His private life included a lifelong, codependent attachment with his mother, Julia, a strong family bond with the Warhola family, and a deep devotion to his Catholic faith.

His public life was an art opening, a book, a tabloid, a television show, and Studio 54—*fame and infamy.*

The implicit and explicit conflicts within each of these worlds and between them were a source of chronic stress for Warhol. Warhol drew on his Christian faith to face adversity. It is likely that the story of Christ, his crucifixion, and his resurrection empowered Warhol's Creative Intelligence to sublimate his traumatic assassination experience into art—art camouflaged with a secret spiritual truth. He painted this as one of his final masterworks—*Camouflage Last Supper.*

With *The Last Supper* (1986), commissioned by art impresario Alexander Iolas, Warhol created a monumental series of masterworks based on Leonardo da Vinci's *Last Supper* (1495–97). Exhibited in Milan in January 1987, one month before his premature death, these religious paintings seem to reconcile Andy's lifelong schism between his secular, public persona the Warhol, Pope of Pop, and his private life as a devout Catholic.

St. Andy: *Andy Warhol's Legacy*

In March 2017, Jonathan Jones wrote in the Guardian, "Andy Warhol should be made a saint—he makes every day sacred." He reflects on the value of interpreting Warhol's art as a "closet Catholic" versus a decadent narcissist. The more we understand the facts about anyone, the deeper our understanding of their art. On a personal level, we can see Warhol's art as a process of conflict resolution and identity integration—he embodied both the sacred and profane aspects of life. He struggled throughout his life, in his art, and as a person with deep emotional, psychological, and social conflicts. Jones makes some brilliant observations about Warhol's work.

> I am not joking about Warhol becoming a saint. The Vatican should start by considering his Last Supper paintings. These are Warhol's last works—how did he know they would be his legacy? Surely, it cannot be coincidence that an artist facing a serious operation leaves as his last visual testament a series of stark images, derived from a cheap replica of Leonardo's masterpiece, in which shadowy, spectral black-and-white copies of Christ saying farewell to

his disciples fade into washes of colour. The ghost of Christ has become the wraith of Warhol, slipping out of the flesh and into an ethereal world of the spirit, bidding a last goodbye to everyone at the Factory.

Here lies the rational explanation for Warhol's anticipation of his own death, not only in The Last Supper but the macabre images of skulls and death-shadowed self-portraits that date from his later years. He knew he was on borrowed time. A re-examination of his medical history recently confirmed what any close observer of his art already knew—that Warhol existed under the shadow of death from the moment Solanas shot him. His gallbladder operation in February 1987 was not so "routine"—how could it be for someone who had been that severely wounded? As he said after he was shot: "I don't even know whether or not I'm really alive—or whether I died. It's sad."

It gets spookier, and the case for sainthood stronger. Critics accustomed to recycling pejorative images of Warhol as an amoral observer of other people's misery, a superficial starfucker or even the man who let Edie Sedgwick die, were confounded when "Napoleon in rags" turned out to be a different person behind the pale mask. Speaking at Warhol's memorial service in New York, his friend John Richardson revealed that Warhol had never abandoned the Catholicism of his childhood. Not only was the supposedly cynical "business artist" a devout Catholic but he secretly worked in New York soup kitchens. While all the moral people were looking down on Warhol, he was out on the streets doing good works.

Of course, not every good Catholic or every moral person deserves to be made a saint. Yet Warhol was much more than this. He was a martyr who let himself be vilified, hated, and even shot while making art whose compassion was rarely acknowledged in his lifetime. Even today, academic theorists don't grasp the simplicity of Warhol's message. Once you know that Christianity was such a big part of his life, his images of suicides, car crashes and the electric chair acquire a heartbreaking sense of pity.

Warhol's understanding of the modern world is so clear and accurate that it resembles a mystical revelation. How did this artist, at the very dawn of the celebrity age, predict so many aspects of the 21st century? Warhol is not just quotable about everything from reality TV to social media—often within the same quote—but redemptive of it. His portraits see through celebrity to reveal human vulnerability. This Catholic artist always looked for the spiritual in the material, the ghost in the machine.

Look again at those soup cans and Brillo boxes. Their clean lines and simple shapes are ethereal, pure. The ordinary is sacred. Like a still life by Zurbaran, these everyday objects are transfigured by mysticism. Warhol painted Campbell's soup for the soul.

Probably none of this is enough for Pope Francis to consider canonization. Yet Warhol's mystery and fascination and the astonishing pertinence of his art have already canonized him in modern culture. He made himself our mirror in a unique art of prophecy. Raise a Coke to Saint Andy.

Andy reflected on his impermanence in several aphorisms.

> Dying is the most embarrassing thing that can ever happen to you, because someone's got to take care of all your details.

> I always thought I'd like my own tombstone to be blank. No epitaph, and no name. Well, actually, I'd like it to say "figment."

> The idea is not to live forever, it is to create something that will.

PART FOUR

LEGACY

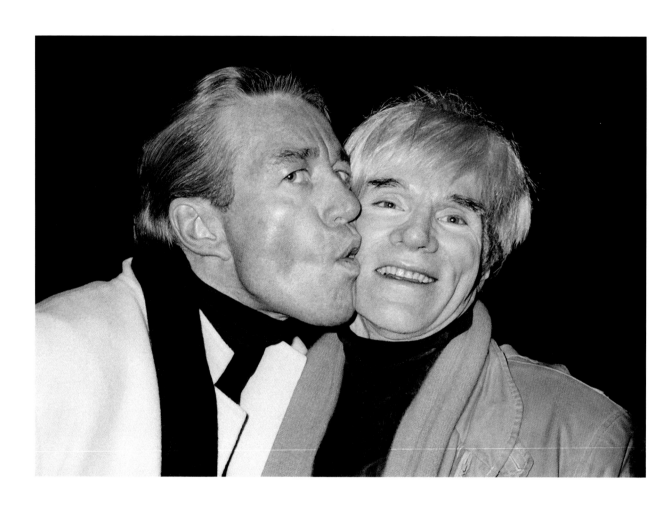

Halston and Andy Warhol,
Roxanne Lowit, 1984

12 ANDY WARHOL and HALSTON
Shared Creative Intelligence

Andy and Halston: *A Dynamic Duo*

Andy Warhol and Halston formed a deep personal friendship and a creative team that empowered American values. Halston focused his creativity on the *concrete realm* of fashion while Andy devoted his creativity to the *abstract worlds* of art and philosophy. Both created extraordinary business models that reinvented fashion, art, and culture. Marshall McLuhan, a media and communication theorist, coined the term *global village* in 1964 to describe the phenomenon of the world's culture shrinking and expanding at the same time due to pervasive technological advances (television, advertising, mass production). The world is connected by instantaneous sharing of culture. McLuhan observed:

> Television brought the brutality of war into the comfort of the living room. Vietnam was lost in the living rooms of America—not on the battlefields of Vietnam.

Warhol and Halston intuitively read the trends in cultural evolution. With their shared Creative Intelligence, their reciprocal creative kindling, they sparked a complex cultural evolutionary process—POPism, a distinctly American process that persists today. Long before the *global brain* of the internet changed the world, their shared Creative Intelligence envisioned the concept of *global mind.* Their egalitarian vision aimed to elevate the ordinariness of life toward Platonic aesthetics of truth, beauty, and goodness.

Shared Creative Intelligence: *A Mechanism of Cultural Evolution*

Shared Creative Intelligence (CI), a comingling of the innate traits of resilience and creativity, plays a critical role in survival and cultural evolution. In conversations that spark creative expansion, a shared WE narrative emerges from powerful individual talents. CI can be transmitted between members of the group and across the generations through experiential learning. With the communication of values, technology, and experimentation, group survival is enhanced. The co-creation of ways of living promotes the evolution of human civilization.

Chris Royer: *The Muse of Creative Triangles*

As Halston's muse, house model Chris Royer collaborated in Halston's creative process. Halston recruited her Creative Intelligence with his constant innovative ideas. With two brain-minds, their reciprocal kindling experimented and played with variations of fashion, form, and movement. How Chris's demeanor, her movements, posture, and graceful walk brought Halston's designs into the world. She embodied Halston's imagination.

In *Halston and Warhol: Silver and Suede* (2014), Chris Royer and friends (Nicholas Chambers, Abigail Franzen-Sheehan, Patrick Moore, Signe Watson, Matt Wrbican) wrote:

> Halston and Warhol traced parallel and improbable paths, rising from mundane circumstances to become big-city cultural icons that helped transform the age. Each pursued the American Dream—shaping a desired future through hard work… Halston's innovative designs and Warhol's work embraced new materials and technology at every turn. Both unabashedly marshaled the new plastics, synthetics, and machinery suddenly at their disposal…Through hard work, Halston and Warhol created a distinctly modern American aesthetic in fashion and art…

> Halston understood the changing role of the twentieth century woman: her inclusion in the workplace, ever-widening social circles, and active lifestyle required modern clothing options… Halston took cues from the fashion greats, paring down flattering couture to sportswear and stylish separates that were priced accessibly for the middle class…

> Warhol's method of reproduction mirrored the way images were presented in the media. The process of photographic silkscreen printing allowed him to borrow imagery directly from consumer culture, to maintain its photographic quality, and to mechanically reproduce the imagery in multiples, thus elevating the mundane to high art. The subjects—products, celebrities, news headlines, and advertisements—reflected society's predilections for consumption, while their repetition mimicked the numbing barrage of commercial images

in the media. Through these means he forced the high-art establishment to reconsider what can constitute a work of art, in both subject matter and in the way it is made.

In this same book, Valerie Steele, director of the Fashion Institute of Technology (FIT), wrote:

> For both Halston and Warhol, the arc of fame has lasted for much longer than fifteen minutes. And, because this intersection of fashion, celebrity, media, and glamour remains so potent today, Halston and Warhol were prescient.

I first saw Chris on the runway in the Olympic Tower for a Halston fashion show. My wife worked as the liaison between her Japanese company, Micalady, the manufacturer of Ultrasuede, the synthetic fabric that Halston made famous. At the head of the elongated seating, Liza Minnelli, Liz Taylor, and Andy Warhol sat with Halston to view the Halstonettes gracefully floating down the runway. I remember thinking of them as mermaids because Halston gowns were like a second skin that propelled seamless movement. Chris Royer embodied the quintessential Halstonette style. Jackie Mallon interviewed Chris about her Halstonette Memoirs in *Fashion United* (2021):

> "He liked me because I had a creative background (she was a former Pratt design student). I knew what draping and pinning meant, and I could stand for a long time." The workroom often created patterns right from the draped fabric gently removed Royer's form, or sometimes Halston cut right into fabric, achieving the fluid lines he became known for, thanks to what Royer describes as his "sculptor's hands." Hardworking, disciplined, and strict when it came to his work, he conducted fittings at night because meetings consumed his days. He might work until 3am but expected models to return at 8 the following morning… Royer inspired many of Halston's designs, one of which was the "Sarong" dress conceived during a 1974 vacation on Fire Island. She stepped out of the pool and wrapped herself in a towel. Halston jumped up and began to twist and pull the towel this way and that. When he was happy with the effect it was cut on bias silk charmeuse, fitted with an ingenious bra construction, and soon seen on society figures such as Barbara Walters,

Lee Radziwill and Marisa Berenson. The designer found inspiration all around and often named his pieces. The "Slink" came about when the designer noticed one of the silver window blinds which were ubiquitous throughout his Olympic Towers offices had been left hitched up at one side. Halston started sketching and the idea became a ruched toga-style evening gown. Ease of wear was always important despite the glamor associated with Halston's creations, and he is credited with having created the elastic waist pant.

In an interview with Chris, she recalled:

> For a Christmas gift I gave Halston a Jacques Cousteau book on sea-life, since Halston loved nature. He was fascinated with the ocean photographs in the book and promptly started creating his Sea-flower beaded design concept which represented the fluidity of the ocean. He worked with Naeem Khan, his young assistant in creating this new modern Kimono style using a dolman wrap top and what he called a tulip style skirt with a mermaid-train and a matching satin Obi sash. He wanted the design to look like swirling water around the body. The dress was backed in sheer organza which gave an illusion of sheerness. This was created by Naeem Khan's family beading company for Halston exclusively. Since this was shown in the Halston Global Trip/Japan, China, and France it became an iconic modern version of the Kimono dress.

Chris and Halston's shared Creative Intelligence exemplifies "reciprocal kindling," when two brain-minds invent something beyond their individual effort. As his idyllic muse-mermaid, Chris seemed to feel at home in Halston gowns, wearing his designs like a mermaid swimming through the waves.

Chris formed a close friendship with Andy Warhol. Andy was obsessed with the idea of beauty. With Christopher Makos, Warhol explored the experience of being beautiful in *Altered Image* (1981). Chris recalls:

> We first met and spoke at one of Halston's parties, since both Andy and I like to sit down and watch people we were a perfect match. I instantly liked him, I thought he was an amazing talent. He was very shy, but still could be a very mischievous little boy. He had an amazing dry sense of humor. We were constantly at all the same events including Halston parties and Salvador Dali din-

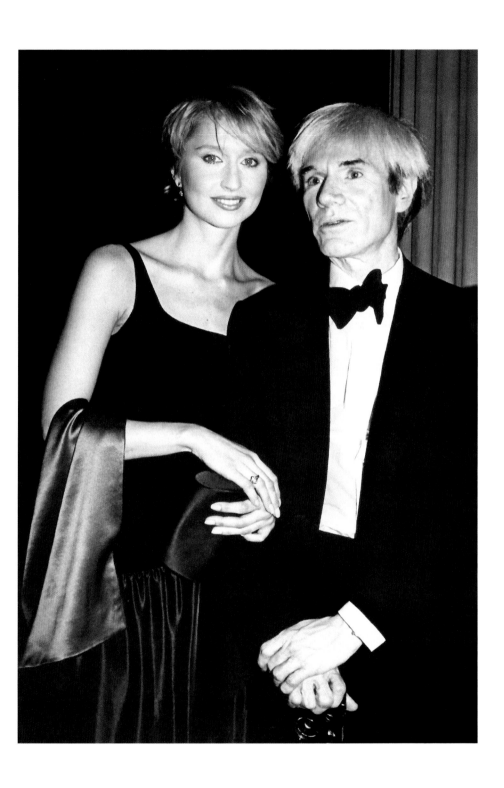

Chris Royer and Andy Warhol,
Roxanne Lowit, 1983

ners at Trader Vic's. We had a very similar sense of humor, and we all shared the same friends. Jerry Hall and I would visit Andy at The Factory and look at his artwork being created.

Andy created Popism, but it really evolved from Dadaism. In that circle of Andy and Halston, Dada art became Pop art. I loved and respected Dada art, like Duchamp's Mona Lisa and Andy Warhol's Brillo boxes, Campbell Soup Cans, and Mega-star portraits.

During one of The Met Galas, Andy decided to create a series of sketches dedicated to me, my mom, and my sister using the dinner napkins on the table. When Andy was signed with Zoli model agency he autographed one of his model cards to me. He was so excited to be considered a model.

I was in NYC, when I heard about his death on the news. I was shocked over his unfortunate passing; he was such a great artist and a wonderful friend. Everyone thought he would recover from the surgery.

Art-Fashion-Culture: *A Family Affair*

Andy, Halston, and Chris formed a triangle of Creative Intelligence, the two great artists with Chris as their shared muse. The Warhol-Halston dynamic reveals the family system's nature of Creative Intelligence. Like parents in an extended family, they collaborated with many others. The Halstonettes brought Halston's imagination to the world supported by the talents of Joe Eula, Elsa Peretti, and Victor Hugo. Andy's Factory minions helped him crank out industrial quantities of paintings, prints, films, publications, and publicity. Warhol supporters included poet John Giorno, Gerard Malanga, Ondine, Lou Reed, Paul Morrissey, and especially Edie Sedgwick, his core muse/mirror, calling her his "wonderful, beautiful blank."

Chris Royer was Halston's family house muse, but she was no "blank." Trained at Pratt, she had the grit, creativity, and beauty that Halston idealized. They were a perfect match. Andy's infatuation with the "idea of beauty" found the ideal American man and woman in Halston and Chris. Their "perfect family" bridged art and fashion into a single domain of creativity. An excerpt from Chris Royer's *Halstonette Memoirs* reveals their creative process.

Andy Warhol called the color of this Halston dress "Lettuce" because it was luxurious and expensive. He loved the fact that it matched his green "Dollar Sign" artwork. In 1982 Halston commissioned Andy Warhol to create a major ad campaign of Halston men's and women's apparel, fashion accessories, and fragrance. These ad layouts he combined certain signature Halston looks such as silver studded scarfs, belts, handbags, and accessories. For the fragrance and cosmetic group ad layout, Andy incorporated the Elsa Peretti design silver compact, fragrances, and makeup. Andy also created ads incorporating Halston shoe designs.

Warhol, Halston, and American Philosophy

Halston and Warhol shared the core American philosophy, rooted in the self-organizing system designed by the founding fathers—pragmatism, egalitarianism, and creatively aiming toward "a more perfect union." Both wanted to expand the audience for art and fashion.

Halston wanted every "ordinary" American woman to feel beautiful, glamourous, and sexy. He knew that self-esteem emerged from a secure mind-body perception. His fashions ensure comfort, ease, and practicality for the wearer, enhancing self-esteem.

Warhol's pop art subjects did not simply elevate the humble soup can to fine-art status, but he confronted the viewer with the monumental ordinariness of American indifference to mass death in *Death and Disaster* series (1963) and the moral conflict about the death penalty in *Electric Chair* (1964).

Warhol and Halston inspire mindful appreciation of the abstract "idea of beauty," living beyond the concrete drudgery of the workaday world. Appreciation of the truth of "ordinariness" is critical to transcending the bias, resentment, and self-pity that cripples much of the population. They challenged the deep socioeconomic divisiveness in America with innate "goodness" in art and fashion. Using color, form, and movement, their shared philosophy liberates individual imagination from the traditional hierarchies of culture into self-creation. Joy and wonder are sparked. Bright

colors elevate the beholder's mood. Implicit comfort in familiar objects and forms reveal the truth, beauty, and goodness of the ordinary.

Both artists created one-man empires of cultural influence that carry on today. With their own "blood, sweat, and tears" of hard work, and without internet social media, they became global icons of Creative Intelligence. Warhol and Halston wanted to raise American consciousness. They experienced the potential in American cultural for self-creation. Ordinary people could become glamorous in a Halston ready-to-wear gown from Penny's. Andy reflected:

> I just happen to like ordinary things. When I paint them, I don't try to make them extraordinary. I just try to paint them ordinary-ordinary.

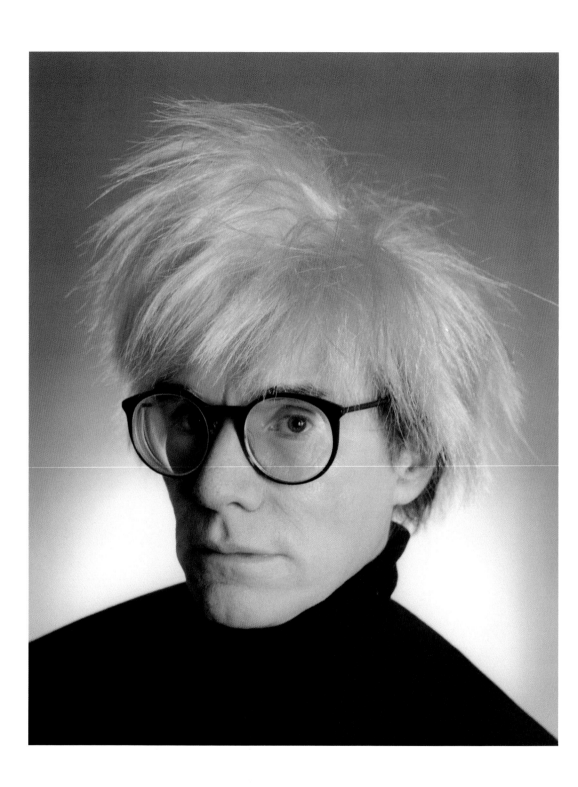

Favorite Portrait of Andy Warhol,
Christopher Makos, 1986

13 ANDY'S GLOBAL MIND
Perpetual Creative Intelligence

This is the eternal origin of art that a human being confronts a form that wants to become a work through him. Not a figment of his soul but something that appears to the soul and demands the soul's creative power. What is required is a deed that a man does with his whole being.

And if there were a devil it would not be one who decided against God, but one who, in eternity, came to no decision.

Martin Buber, I and Thou, 1923

Andy Warhol: *POP Philosopher*

As a mind hungry for an identity, Andy absorbed his idealized heroes by painting them, capturing their power in the magic of art. He became what he painted. As someone with limited verbal skills, Andy's literary productivity is immense. Always looking for subject material, he depended on others to point him in a direction, then he would "make the subject a Warhol." Warhol marshaled his Creative Intelligence to overcome his damaged brain. Suffering with the "doubting disease" of obsessive-compulsive disorder, he transformed symptoms of repetition-compulsion, hoarding, and social anxiety into art. Facing his own fears, phantom stress, and physical limitations, Andy reinvented himself to promote cultural evolution.

Ten Portraits of Jews

The idea for Warhol's *Ten Portraits of Jews* (1980) came from art dealer Ronald Feldman. It was not born out of Warhol's ideas, but Andy resonated with the concept. Susan Morgenstern, the art gallery director of the Jewish Community Center of Greater Washington, chose the men and women for Warhol to highlight. Some critics projected apathy onto Warhol about the subjects of his work, but this was dispelled when he dubbed the series "Jewish Geniuses."

Martin Buber fit perfectly into Warhol's idea of a personal, idealized superstar. He was an Austrian Jew and Israeli philosopher best known for his philosophy of dialogue—Andy's favorite pastime. His form of existentialism was centered around consciousness, religion, modernity, and ethics—all important topics for Warhol's creative focus. Although Buber came from an observant Jewish family, he broke typical customs to study philosophy—Andy could identify with the maverick and self-making in Buber. Buber wrote the famous essay "I and Thou," which focuses on a person's relationship with existence—Andy's favorite topic. Buber was nominated for a Nobel Prize in literature ten times. Additionally, he was nominated for the Nobel Peace Prize seven times. Surely Buber was a Warhol superhero.

POPism and Perpetual Creative Intelligence: From Global Brain to Global Mind

In *POPism* (1980), Andy Warhol wrote:

> By 1960, when Pop Art first came out in New York… Abstract Expressionism had already become an institution, and then, in the last part of the fifties, Jasper Johns and Bob Rauschenberg… had begun to bring art back from abstraction and introspective stuff. Then Pop Art took the inside and put it on the outside, took the outside and put it inside. The Pop artists did images that anybody walking down Broadway could recognize in a split second—comics, picnic tables, men's trousers, celebrities, shower curtains, refrigerators, Coke bottles—all the great modern things that the Abstract Expressionists tried so hard not to notice at all… My friend Henry Geldzahler, curator of the twentieth-century art at the Metropolitan Museum… described the beginnings of Pop this way: "It was like a science fiction movie—you Pop artists in different parts of the city, unknown to each other, rising up out of the mulch and staggering with your paintings in front of you."

Art movements are cutting-edge harbingers of cultural evolution or devolution. Art functions for society the way daydreams help the individual brain-mind solve problems intuitively and creatively. Artists mirror society, illuminating the conflicts between creativity and self-sabotage. Artists drive culture toward humanism, toward

the realization of the biological fact of Species Tribalism. As sources of creativity, invention, and experimentation, art is a direct challenge to the dark side of human nature—the mindless, fear-driven, toxic forces of greed, bias, and destructiveness. From the Renaissance to Dada to Surrealism to POPism, shared perpetual Creative Intelligence inspires resilience and creativity for a better world.

Warhol's Egalitarian Vision: *Out of the Dark Ages into the Light*

The humanist cultural momentum that ignited the Renaissance is reflected in the content of Warhol's art. In the 1330s, the Italian scholar Petrarch kindled the idea of the Renaissance when he originated the term *Dark Ages.* He compared the post-Roman, "dark" centuries (lack of records) with the "light" (abundance of records) of classical antiquity. Europeans made few advances in science and art during a time of war, ignorance, famine, and pandemics. There was little regard for ancient Greek and Roman philosophies and learning at the time.

During the fourteenth century, a cultural movement called humanism emerged promoting human achievements in education, classical arts, literature, and science. In 1450, Gutenberg invented the printing press—the first internet—allowing these new ideas to spread more quickly throughout Europe. Little-known texts from early humanist authors, such as Francesco Petrarch and Giovanni Boccaccio, were printed and distributed to the masses promoting the renewal of traditional Greek and Roman culture and values.

The Renaissance started in Florence, Italy. The Medici family ruled Florence for more than sixty years and were the primary backers of the movement. They encouraged wealthy citizens to support budding artists. Great Italian writers, artists, politicians, and others participated in an intellectual and artistic revolution that would be much different from what they experienced during the Dark Ages.

The movement totally restructured trade, finance, art, science, and religion and melted cultural boundaries. Platonic values thrived. Expanding to other Italian city-states, such as Venice, Milan, Bologna, Ferrara, and Rome, it continued to spread during the fifteenth century from Italy to France and then throughout western and northern Europe.

Civilization: *Shared Creative Intelligence*

Jessica Stewart wrote "The Story Behind Raphael's Masterpiece *The School of Athens*" for *My Modern Met* in 2016. She notes that the Renaissance was an extraordinary time of shared creativity that linked many talented individuals, patrons, and historians to initiate a rebirth in local culture that spread to a global civilization. If there is a single painting that conveys the essence of the Renaissance, the rebirth of classical Greek culture, it is *The School of Athens* by Raphael Sanzio. She observes:

> *The School of Athens* is one of four wall frescoes in the Stanza Della Segnatura. The room was set to be Pope Julius' library, and therefore Raphael's overall concept balances the contents of what would have been in the pope's study.
>
> In the 15th century, a tradition of decorating private libraries with portraits of great thinkers was common. Raphael took the idea to a whole new level with massive compositions that reflected philosophy, theology, literature, and jurisprudence. Read as a whole, they immediately transmitted the intellect of the pope and would have sparked discussion between cultured minds that were lucky enough to enter this private space.
>
> *The School of Athens* was the third painting Raphael completed after *Disputa* (representing theology) and *Parnassus* (representing literature). It's positioned facing *Disputa* and symbolizes philosophy, setting up a contrast between religious and lay beliefs.
>
> Set in an immense architectural illusion painted by Raphael, *The School of Athens* is a masterpiece that visually represents an intellectual concept. In one painting, Raphael used groupings of figures to lay out a complex lesson on the history of philosophy and the different beliefs that were developed by the great Greek philosophers.

The Renaissance marks the greatest example of collective Creative Intelligence in history—the activation of resilience and creativity to reinvent the world. The world had been devastated by the Black Plague, believed to have started in China in 1334. It spread along trade routes reaching Europe via Sicilian ports in the late 1340s. The plague killed an estimated 25 million people, almost a third of the continent's popu-

lation. The Black Death lingered on for centuries, particularly in cities, but it could not stop the creative forces implemented by the Renaissance.

Creative Intelligence Conversations: *From Plato and Aristotle to Bohr and Planck*

Plato and Aristotle stand at the center of *The School of Athens* directly under the archway in the fresco's vanishing point. They represent two different schools of philosophy. Plato's finger points to the sky. The gesture indicates his Theory of Forms, his philosophy argues that the "real" world is not the physical one, but instead a spiritual realm of ideas filled with *abstract* concepts and ideas. Aristotle's hand reaches out of the painting into the space with the beholder. This represents his belief that knowledge comes from experience. Empiricism, as it is known, theorizes that humans must have *concrete* evidence to support their ideas and is very much grounded in the physical world. The dialectic of concrete reality versus abstract reality charges the discourse that was the core theme of the Renaissance that sparked humanism, science, and art. Eventually, Isaac Newton, employing Aristotelian logic, created an incredible mathematical model of the known universe with precision formulas based on measurements of gravitational force that could predict the motion of bodies in space over time. In the Enlightenment, empowered by science, the belief that humankind could control the forces of nature led to centuries of hubris that pushed civilization to a critical brink of survival.

The Modern Neo-Renaissance

At the dawn of the twentieth century, a burgeoning swell of shared Creative Intelligence swept the world. Physics reinvented reality. Inspired by awareness of Asian philosophy and art, European art was turning inward for inspiration. Medicine began to link the mind-body system in understanding wellness and disease. The "discovery" of the unconscious inspired neuroscience. The industrial revolution generated a new world of machines powered by burning carbon-based fuel. The machines would shrink the time to travel from one place to another and create a toxic atmosphere that is threatening life on the planet. The new technology meant new weapons for humans to kill each other.

The discovery of quantum mechanics recruited the classical debate between Plato and Aristotle about the nature of reality—Newton's *classical concrete* model and the *quantum abstract* model. We now know that both models of reality, concrete and abstract, coexist as a multilayered continuum from subatomic information to the expansive reaches of the cosmos. Classical Newtonian reality and the modern quantum reality of Niels Bohr and Max Planck are different levels of a continuous dynamic, complex system of creativity-destructivity. The cosmos is a perpetual creativity machine.

Shadows of the Mind: *Self-Creativity in Living Systems*

In *Shadows of the Mind: A Search for the Missing Science of Consciousness,* Nobel laureate Roger Penrose presents a bold, consilient concept of mind. He argues for the possibility of "quantum consciousness" where cytoskeletal structures—microtubules—may act as mini-quantum computers and perpetuate large-scale quantum action in the brain. A wide variety of anesthetic agents produce "loss of consciousness" and inactivity in everything from slime mold to paramecium to the human brain. This points toward the idea that the complexity of human consciousness, and hence, creativity, bridges the quantum systems and the classical realm. Quantum reality reflects the ancient Taoist and Buddhist notions of cosmic creative consciousness, the idea that consciousness pervades the universe. In the self-organizing systems of nature, our human consciousness is the most creative instrument we know.

Our Time: *A Tipping Point*

Although we are living in a technologically advanced age, we still struggle with serious mental and emotional stresses, war, international terrorism, cybercrime, marked socioeconomic divisiveness, deadly religious conflict, political brain lock, and the natural threats of pandemic and climate change. We are at a tipping point between

the dark side of human self-sabotage and genuine creativity. We must recruit Creative Intelligence on a global scale. Like our Renaissance ancestors, we can expand humanistic values to challenge fear, anger, confusion, hatred, lies, and greed. Our collective survival has always depended on shared Creative Intelligence.

Andy Warhol reflects how the power of one artist's Creative Intelligence can kindle waves of cultural transformation. By integrating the wisdom implicit in his life, perhaps we can recruit humanistic values toward a cultural framework of species tribalism.

Liza Minnelli, Halston, and Martha Graham,
John Barrett, 1982

14 AFTER ANDY
Halston, Liza Minnelli, and Martha Graham

Andy's Memorial: *St Patrick's Cathedral*

On April 1, 1987, a memorial ceremony for Andy Warhol was held at Saint Patrick's Cathedral. Two thousand people attended, and photographer Christophe von Hohenberg documented the day in a book, *Andy Warhol: The Day the Factory Died* (2006), a Who's Who of New York celebrities. Rupert Jasen Smith greeted me at the entrance and took me to my seat. We had just had dinner together the week before to discuss his "art-marriage" with Andy. We also discussed Andy's latest screen-print series, *Cowboys and Indians*. My friend Edmund Gaultney commissioned the new work but died before seeing it brought to the public. He named me executor of his estate, so I worked closely with Rupert and Andy on the final proofs. Andy's death traumatized us all, and Rupert and I spent a lot of time sorting through the legal aspects from the two estates. The somber tone of the event called for a few words. We all knew that something profound was unfolding, and the long shadow of this day would affect us all.

Andy's Memorial Auction: *Hosted by Halston and Liza Minnelli*

Sometime later, the Warhol Foundation sponsored a fundraiser auction. Halston and Liza Minnelli presided over the glamourous exhibition that served as another memorial service and a Warhol-style event. Surrounded by his art, the celebrity attendance, and struggling with my own grief, I kept seeing Andy out of the corner of my eye. I knew I could not afford to buy an artwork, but perhaps some bit of memorabilia would fit in my budget for the night.

In Catherine Johnson's brilliant concept book *Thank You Andy Warhol* (2012), Liza explains her friendship with Andy.

> My thank you to Andy is a personal one. Above all, he was a good listener.
>
> He wasn't the type to give advice. He understood things really well and was perceptive. He was a very good chum… Hanging out at Studio 54 happened

for a practical reason. You could get people to leave your house at a decent hour because they had someplace else to go. That's the truth! I remember Halston telling me about having people over to his place. He said, "They always stay until three or four in the morning. It's driving me crazy." Once Studio 54 opened, the new drill became, "Okay, at 10:30 everybody out, and let's go see what's going on at Studio 54…" People might not realize that we had a lot of work to do during the day. Many of those nights at Studio 54, we would walk in the front door and immediately walk right out the back door and go home to bed!

One night when Halston, Andy, and I were having a quiet private dinner, Andy was talking about the families that were so important to him in the history of American entertainment. By the end of the dinner, he said he would like to start to keep a record of these families by "doing portraits of your family to celebrate you and your parents. And I want to start with you."

As the auction commenced, Halston and Liza took turns remembering Andy. It activated my memories of visits to Olympic Tower for Halston fashion shows. At the head of the elongated seating, Liza, Liz Taylor, and Andy would sit with Halston to view the Halstonettes gracefully floating down the runway. I remember thinking of them as mermaids because Halston gowns were like a second skin that propelled seamless movement.

When the auction offered an evening for three guests at Halston's home with Martha Graham, Dom Perignon, and caviar, I made sure I took that home. My Japanese wife, a fashion designer turned executive, had been the liaison between Halston and Micalady, the manufacturer of Ultrasuede, the synthetic fabric that Halston made famous. She had worked closely with Halston for five years in designing gowns for the Japanese body and left the position to become a mother. She hadn't seen Halston in several years. I was happy to provide them with a great reunion. Her friend, Yuki Masuda, Japanese fashion entrepreneur, owner of Best International Boutique chain in Japan, adored Martha, and featured Halston in his boutiques.

Halston was the ultimate gracious host. He presented Martha Graham as an empress of the arts, in the regal setting of his stunningly minimalist home designed by Paul Rudolph. He orchestrated a kind of musical chair where we each were given a generous amount of time with each of them. He had a keenly attuned feeling for the fact that we were all grieving Andy in our own ways. We shared a group conversation remembering Andy, and it proved to be truly a healing celebration for us all.

Like the creative power of the Halston-Warhol dynamic duo, Halston also brought his magic to working with the sorcery of Martha Graham. He designed costumes for many of her dances for over a decade. Both Martha and Halston approached the human body as a work of art. Their collaborations seamlessly revealed the dancer and costume as a single entity, a metahuman being, charged with magic and mythic in defying gravity, time, and space.

Halston: *Fluid Creative Intelligence*

In 2014, the Warhol Museum mounted an historic reflection on American creative collaboration, *Halston and Andy Warhol: Silver and Suede*. The exhibition had videos from Halston shows, and I saw my favorite Halstonette, Chris Royer, gliding across the runway in her ethereal movements. It reawakened my memories of meeting her at a party of Halston assistant's Akira. I recall Chris always looking stunning in red, with her porcelain skin and silky blond hair. The flashback sparked my desire to return to my book, *Andy Warhol's Brain: Creative Intelligence for Survival*.

As I reflected on the evening with Halston and Martha Graham, memories emerged in holographic detail. I asked Halston about his collaborations with Andy. I remembered the *Space Fruit* fabric designs from Warhol's paintings that Halston transformed into vehicles for effortless movement through space and time.

Halston described working with Andy: "Andy was so much fun. He was so quick-witted and had such a brilliant sense of art and design. Working with him was more like play. We were like children making things up as we go. We all worked very hard, so when it came time to rest, we'd go to Studio 54 to unwind and laugh. I loved Andy; I will miss him deeply."

I asked him about Andy's *Altered Image* portraits with Christopher Makos. Halston reflected, "I love that series where Andy really gets into the whole idea of beauty. He was inspired by Man Ray's portraits of Marcel Duchamp as *Rrose Selavy*. I offered to let him use any of my gowns, but he was adamant, 'I'm not doing a drag series. I just want to explore the feelings of what it's like to go through all the trouble to become beautiful.'"

Halston continued to reflect on their shared American values: "Andy and I both came from humble backgrounds. We did not fit in. New York offered the opportunity to explore our talents. We could become anything here. But we both had roots in the simple, American values. We believe those values are beautiful. We feel that honesty, kindness, and equality are deeply American attitudes to live by and to practice."

Halston reminded me of the Platonic values of truth, beauty, and goodness imbedded in all of nature.

Halston replied, "Yes, I agree with that. Everyone is beautiful. We just want to awaken them to that fact. We do not create beauty; we reveal the truth, beauty, and goodness in everyone. That is what makes America so special. We have the freedom to be true to ourselves."

Martha Graham: *Transforming Tension with Creative Intelligence*

When my turn to sit with Martha came around, I felt like a child visiting Santa at Macy's. She looked like an empress, dressed in a shimmering sequined Halston gown, elegantly seated on Halston's grand, throne-like couch.

Martha attuned with my nervous excitement, and her smile put me at ease. She asked, "How did you know Andy?"

I told Martha that I had scheduled to interview Andy for my book, *The Art Imperative: The Secret Power of Art,* when he suddenly died. Her empathy radiated and seemed to warm the room. As we continued talking, she validated my passion for exploring the creative process, and she told a story of how she created a dance.

Martha recalled: "I was visiting a Navajo reservation to get inspiration for my new work.

As I watched a mother do her daily activities while carrying her papoose on her back, I had a deep inspiration for dance movements. It was amazing how her movements took the child into account. The tension of the child's weight, the emotional safety of the child, and the need to execute her activities required that she focus her attention on every movement. She and her baby formed a unique creature, something beyond humans, like a spirit animal. I saw these marvelous stone carvings depicting mythic birds on the reservation. I want to create that magical world for my dance."

I reflected. "What a splendid example of seamless mind-body-emotion integration in action. We know that secure attachment in childhood is rooted in mother's attuned attention to her baby. When the baby experiences itself as one with the mother, and feels love for being, truly this is the root of our creativity. I can't wait to see the dances that you create from those experiences."

On October 13, 1988, we attended opening night for Martha Graham's *Night Chant*. Anna Kisselgoff covered the event for the *New York Times*.

> The world of Martha Graham is a creative universe and in her wondrous new "Night Chant" she has delved into the American Indian experience and produced a work of magic theater.
>
> Even in this splendid current season by the Martha Graham Dance Company, nothing could have prepared the audience at Thursday night's world premiere for the astounding final image that capped what had been one surprise after another.
>
> *Suddenly but serenely, the petroglyphs, or abstract stone representations of birds, found in the Southwest seemed mysteriously to cross a dark sky. They were in fact three seemingly headless women carried upside down on their partners' shoulders. With legs bent upward, they were barely recognizable as human.* A sculptor of the human body, Miss Graham had molded these dancers into mythic and anthropomorphic forms.
>
> The beauty of "Night Chant" lies in its power as a choral piece—ensemble after ensemble appears onstage—and the perfect integration of production

values. This was undoubtedly the impact produced in the packed house at the City Center, 131 West 55th Street. The celebrities on hand included Liza Minnelli and Mikhail Baryshnikov, both of whom have performed with the Martha Graham Dance Company.

Isamu Noguchi, the distinguished sculptor who has been Miss Graham's collaborator since 1930, was in the audience as well. At the close of the evening, he went onstage for a bow and received a standing ovation. Except for the opening "Diversion of Angels," which has no scenery, all the works in the program had sets by Mr. Noguchi…

Halston provided costumes for the Gala opening that stunned the *New York Times*.

I remember feeling so privileged that I had heard the story of how Martha created *Night Chant* long before she brought it to the public.

Halston, Martha, and Andy live on in my emotional and creative memory. Having the privilege to share creative conversations with such brilliant artists charges my own mission to explore and promote the power of Creative Intelligence for everyone.

Night Chant, Chris Gulker,
Martha Graham Dance
Company, 1988

15 ANDY'S PARADOX
Transforming Culture with the Art-Philosophy of "Nothingness"

Andy Warhol's America: **The Art of Reinventing the Self and the Social System**

When *Homo sapiens* created art forty thousand years ago, it was the dawn of Creative Intelligence, mindful reflection, and empowering the imagination to reinvent the way we live together. Creative Intelligence plays a critical role in individual development and cultural evolution—it is the foundation of the self-organizing system of human civilization. We reimagined the hunter-gatherer cave dwelling lifestyle and went on to create our present global village.

Andy Warhol's life exemplifies how a single artist can influence the complex biopsychosocial systems of brain-mind/art-culture to reinvent themselves and alter the course of civilization.

Like his creative predecessors, from Leonardo to Duchamp, Warhol took inspiration from his personal reality. Warhol grew up as an impoverished immigrant at the lowest socioeconomic stratum. The pride and experience of poor immigrant refugees from World War I idealized the richness of America. Even at the bottom rung, American life was superior. His parents' idealism propelled him to face adversity, get education, and cultivate a high degree of self-motivation and productivity.

America was Andy's perfect muse, his perpetual subject, and the beacon of his aspirations. As he brought his artists' piercing gaze to America, he saw the homophobia, the violence, the greed on Madison Avenue, the obsession with fame and wealth, the shame of being poor, and the rejection of his sexual nature. Not only did he transform himself, but Andy also transformed the definition of art and triggered Popism, a social movement that continues to inform cultural values.

Andy Warhol All American,
Christopher Makos, 1983

Andy's Art Imperative: *His Secret Power of Art*

The Warhol persona was the ultimate paradox of the 1960s. Called Drella by his bevy of assistants, a portmanteau created by Ondine from Dracula and Cinderella, was the enigmatic majordomo of the Factory. Warhol ruled over this nocturnal counterculture denizen of sex, drugs, rock-and-roll. With his ice cool affect, sunglasses at night, silver wigs, where a look could kill, he exerted a Jedi-like mental force to get people to do his bidding. Andy Warhol projected himself with soulless indifference, attention seeking, and emotionally bankrupt—innocence and experience fused. Warhol was the embodiment of the American culture of narcissism.

Andy Warhol camouflaged his humble beginnings, his Catholic faith, and his private life with his family. He challenged his traumatic childhood and highly conflicted emotional experiences with Creative Intelligence. He balanced his public life as a celebrity with his private life as a devoted Christian. Transforming himself from an insecure gay man in the 1950s, he reinvented himself as an enigmatic, sexually ambiguous philosopher-artist. Despite feeling like an emotional pretzel, his body twisted and bent by trauma, agony, conflict, toxic stress, and loss, Andy sublimated his suffering into art that transformed culture. Andy did not surrender to his physical, mental, emotional, and social trauma. He chose the arduous path of self-creation over the self-pity and resentment of drug addiction. Warhol used ubiquitous amphetamines to support his workaholic patterns. Injured in love and obsessed with a pursuit of fame, he was motivated to create a new life, a new reality. He camouflaged his Christian values, brotherly love, charity, and compassion. He left the Andy Warhol Foundation to support emerging artists as a legacy beyond his massive art production.

Warhol's authentic core values drove his Creative Intelligence to culture-shaping waves far beyond his life and art.

Despite feeling like a hostage of adversity since childhood, Andy discovered the secret power of art—art can be a defense against stress and a weapon against destructivity to remake his world. Compelled to observe his embodiment, his attachment in relationships, his problems with language, his academic weaknesses, he gained some degree of acceptance that he could not change the world, but he could change

himself. In making art, he found sanctuary from the pain and stress of his world and tapped into the power of Creative Intelligence to reframe feeling like a victim. He recruited his innate power to create a paradoxical perspective to express the complex jumble of thoughts and feelings that made life seem so strange.

Andy's Art-Philosophy of "Nothingness"

Andy created a path out of adversity with art by cultivating a personal philosophy of "nothingness." He intuitively embraced nothingness as a value system. His experience attuned with paradoxical Buddhist philosophy. Making art is a mindful practice, mobilizing resilience to adversity and imagining a better life. Andy spent much of his childhood making art—in the mindful, divergent, brain state. It is as though he had been in a meditative retreat most of his life. He came to an experiential understanding of Buddha's great truths that hinged on a deep awareness that human perception constructs its own reality. There is *no* ultimate "reality." In the Heart Sutra, Buddha teaches:

> Body is nothing more than emptiness,
> emptiness is nothing more than body.
> The body is exactly empty,
> and emptiness is exactly body.

> The other four aspects of human existence—
> feeling, thought, will, and consciousness—
> are likewise nothing more than emptiness,
> and emptiness nothing more than they.

> All things are empty:
> Nothing is born, nothing dies,
> nothing is pure, nothing is stained,
> nothing increases, and nothing decreases.

Out of the dialectics of nothingness, Andy would re-create himself. Courageously expressing his vision of the truth, mirroring the despair and emptiness of consumer culture, his art was charged with the compassion he felt for the ordinary person. He camouflaged himself as the Warhol, a counterculture superhero, embracing capital-

ism, the perceived enemy of the destructive revolutionary propaganda of his peers. Rather than assault the advertising industry, Warhol became an integral part of the system with covert intentions to reveal the truths of greed, lies, and corruption that hid behind false advertising. Using the tools from print advertising, he triggered a revolution with silk screen paintings. Andy charged his art with paradox, ambiguity, irony, and ambivalence. Implicit were Christian and Buddhist principles to promote compassion, a critical ingredient on the path toward enlightenment. It would be decades before an in-depth assessment of the person and his art would emerge.

It is ironic that one of Warhol's contemporaries, Donald Trump, would identify with him as an artist in *The Art of the Deal* (2009). Trump quoted Warhol's aphorism in his book. Andy said:

> Making money is art and working is art and good business is the best art.

Trump pursued wealth and fame beyond Warhol's dreams to become the first clinically diagnosed pathological malignant narcissist to be elected president of the United States. His niece, Mary L. Trump, a clinical psychologist, stated in *Too Much and Never Enough: How My Family Created the World's Most Dangerous Man* (2020):

> Donald today is much as he was at three years old: incapable of growing, learning, or evolving, unable to regulate his emotions, moderate his responses, or take in and synthesize information. Donald's need for affirmation is so great that he doesn't seem to notice that the largest group of his supporters are people he wouldn't condescend to be seen with outside of a rally. His deep-seated insecurities have created in him a black hole of need that constantly requires the light of compliments that disappears as soon as he's soaked it in. Nothing is ever enough. This is far beyond garden-variety narcissism; Donald is not simply weak; his ego is a fragile thing that must be bolstered every moment because he knows deep down that he is nothing of what he claims to be.

It is no surprise that artists and psychopaths share many attributes and patterns of personality in psychological testing. The significant difference is, at their core, sociopaths are self-serving, greedy, and destructive consumers of what other people

make. Artists are authentically creative and generous with making art for the public. Trump's damaging effects on culture are playing out with characteristic sociopathy, lies, greed, violence, and illegal behaviors—a direct assault on truth, beauty, and goodness.

Creative Intelligence and Cultural Evolution: *Tibet and Mexico*

Cultural evolution emerges from conflict. The dark forces of greed, ignorance, and anger force cultural change through subjugation and destructive power. The forces of enlightenment, wisdom, and compassion perpetually challenge human destructiveness with Creative Intelligence for the greater good of humanity. Human beings suffer under the dark forces of devolution, and people thrive individually and collectively in enlightened cultures.

Two examples in cultural history make this point clear: Tibet and Mexico.

Padmasambhava, the renowned tantric meditation master credited with importing Buddhism into Tibet, founded Samye Monastery (799 AD) as a seed for the rise of Buddhist monastic-centered culture. The story goes that he was offered gold by the king to come to Tibet, but he refused, believing that he had a mission to spread Buddhist teaching to this part of the world. He and the Buddhist scholar Santaraksita laid the foundation for tantric mindfulness practices and scholarship, the two paths toward enlightenment—the gradual path of learning and the direct path of meditation. Without brain science, the ancient science of mind-guided monks to master and integrate divergent and convergent cognition. The core teaching of compassion charged every aspect of Tibetan culture for centuries.

In direct contrast, Spanish conquistador Hernan Cortes brought religious conflict in the conquest of Mexico. Repulsed by the blood sacrifices and flesh-eating practices of the Aztecs, Cortes chose subjugation of the culture under the Spanish monarchy with massacres of innocent people. Spilling blood in the name of Christ perpetuated a culture of ruthless violence that implicitly supports drug cartels, violent crime, and corruption in all levels of government. Greed, power, and political control structured life in Mexico, even after the Revolution (1910–20).

Global Brain/Global Mind: *Andy's Art at a Tipping Point*

The 1960s pushed America to a tipping point—the Vietnam War versus peace. The divisiveness of ingrained racism, sexism, and military arrogance were challenged by antiracism, women's and gay liberation, the peace movement, and art. Andy Warhol emerged attuned with his time. As a cultural icon, like Bob Dylan, John Lennon, and Marshall McLuhan, he used his creative power to shape the course of history. He and Marshall McLuhan shared a vision of how media shapes thought and behavior, constructing social reality. Both men challenged the advertising industry and its power to manipulate the masses. Before the invention of the global brain of the World Wide Web, Marshall McLuhan focused on how television is rapidly altering culture, a medium that had the potential for creative and destructive consequences. In *Understanding Media: The Extensions of Man* (1964), McLuhan warned:

> With the arrival of electric technology, man has extended, or set outside himself, a live model of the central nervous system itself. To the degree that this is so, it is a development that suggests a desperate suicidal autoamputation, as if the central nervous system could no longer depend on the physical organs to be protective buffers against the slings and arrows of outrageous mechanism.

As an ornery optimist he prognosed hope.

> I expect to see the coming decades transform the planet into an art form; the new man, linked in a cosmic harmony that transcends time and space, will sensuously caress, and mold and pattern every facet of the terrestrial artifact as if it were a work of art, and man himself will become an organic art form. There is a long road ahead, and the stars are only way stations, but we have begun the journey.

He may have had Andy Warhol in mind when he reflected:

> The artist is always engaged in writing a detailed history of the future because he is the only person aware of the nature of the present.

As a futurist, Warhol pursued making art with the emerging reality of the personal computer. The Warhol Museum mounted an exhibition, *Warhol and the Amiga* (2017–2019). They wrote:

> In the summer of 1985, Warhol was given his first Amiga 1000 home computer by Commodore International and enthusiastically signed on with the company as a brand ambassador. For their launch, Commodore planned a theatrical performance, which featured Warhol onstage at Lincoln Center with rock 'n' roll icon and lead singer of Blondie, Debbie Harry. In front of a live audience, Warhol used the new computer software ProPaint to create a portrait of Harry. He later made a series of digital drawings including a Campbell's soup can, Botticelli's *The Birth of Venus*, and flowers. The video of the launch performance and these early computer-based artworks are a testament to Warhol's engagement with and embrace of new technology.

In 1982, he commissioned an Andy Warhol robot, *A2W2*, by Alvaro Villa. Extending the reach of his tabloid, *Interview,* Andy started his own television show, *Andy Warhol's Fifteen Minutes.* He interviewed old and new counterculture celebrities on MTV from 1985 to 1987, including Courtney Love, Debbie Harry and Chris Stein of Blondie, Nick Rhodes, Ric Ocasek of the Cars, the Ramones, Grace Jones, Yoko Ono, Judd Nelson, Kevin Dillon, John C. McGinley, and William S. Burroughs.

Art as Détente: *Warhol and Rauschenberg*

As Warhol traveled the world to visit Pope John Paul II (1980) and walk the Great Wall of China (1982), he became an artist-ambassador to use *art as détente,* demonstrating Creative Intelligence can link East and West, despite political adversity.

Robert Rauschenberg's belief in the power of art as a catalyst for positive social change was at the heart of his participation in numerous international projects in the 1970s and early 1980s, and which culminated between 1984 and 1991 with his Rauschenberg Overseas Culture Interchange (ROCI). ROCI (pronounced "Rocky," the name of the artist's pet turtle) was a tangible expression of Rauschenberg's long-term commitment to human rights and to the freedom of artistic expression. Funded

almost entirely by the artist, Rauschenberg traveled to countries around the world often where artistic experimentation had been suppressed, with the purpose of sparking a dialogue and achieving a mutual understanding through the creative process. Between 1985 and 1990, the project was realized in ten countries in the following order: Mexico, Chile, Venezuela, China, Tibet, Japan, Cuba, the Union of Soviet Socialist Republics (USSR), Germany, and Malaysia with a final exhibition held in 1991 at the National Gallery of Art, Washington, DC.

Andy's Personal Reconciliation and Ascension: *The Last Supper*

In his final series of religious paintings based on Leonardo da Vinci's *The Last Supper,* Andy came to terms with his lifelong schism between his private life, his true beliefs, and his public persona. In this series, Warhol amalgamates elements from advertising to religious icons. He declares himself whole, reconciles his conflict between the sacred and profane aspects of his life, and struggles toward personal liberation. *Apollo* magazine reports:

> As with most subjects, Warhol approached *The Last Supper* through mediations of the original, rather than the original itself. He used a commercial reproduction of Da Vinci's famous mural painting to create more than 60 silkscreens, paintings, and works on paper. The seeming irreverence for the distinctions between the sacred and the profane, high art and commercial design reflects Warhol's inevitable transformation of a deeply religious work into a cliché whose profound message has become muted through repetition.

A psychosocial-spiritual interpretation views Warhol commenting on how the material world has replaced the spiritual world in modern life. And yet, the abstract, spiritual realm of life is found by looking inward. Art is a mirror, activating the beholder's Creative Intelligence, and inviting transcendence of the conflicts between the concrete body and the abstract spirit. Warhol's use of repetition rendered powerful negative emotions, the fear of death, bearable, like the use of a rosary and prayer. For the viewer's share, the repetition triggers a shift in the brain, from intellectualizing about the content to simply "being" with the overwhelming scale of a single image repeated over and over.

Sadly, Andy's final masterworks that seem to reconcile his lifelong conflicts coincided with his death.

EPILOGUE

My First Conversation with Andy Warhol

My first meeting with Andy Warhol kindled a lifelong exploration of Creative Intelligence. I often remember how Andy sparked my inspiration to link art and medicine. His kind attentiveness, validating and empathetic, had a generous streak of social mischievousness. He was fun and funny. My first conversation with Andy Warhol was in New Orleans, 1976. The ramp to this meeting involved other artists, friends, and good luck.

I was an artist-medical student in 1975, and I had a subscription to *Art in America*, the slick, mainline art magazine for the public. I came across a full-page ad for an exhibition at the Freeman-Anacker Gallery in New Orleans: Marcel Duchamp's *Green Box*. Duchamp was my first art-hero at the time. I was reading his writing, making mini paintings on glass inspired by his glass masterpiece, *The Bride Stripped Bare by Her Bachelors, Even* (1915–1923). Duchamp's radical reinvention of what art could be hijacked my imagination and inspired my own experiments that included objects from my medical school studies, art history, and the Galveston shipyards. I decided to make my pilgrimage to see the master of Dada.

Edmund Gaultney, exhibition curator, chose Duchamp to debut the Freeman-Anacker Gallery owned by Tina Freeman, photographer, and Coca-Cola heiress. Edmund met Tina in Aspen when they were neighbors, and he ran a gallery. Edmund introduced Tina to Andy for a portrait in 1975.

I reflected, "I see Duchamp as the 'art-father' of Andy Warhol. Andy is a pop culture hero. His totally 'cool' attitude, his new way to make paintings, and his revolutionary ideas make him an art personality icon. He extends Duchamp's understanding of art as a mindful concept. Andy takes art across the boundaries of high art and commercial art, from the museum to Campbell's *Soup Cans*. He goes beyond the plastic features of the art object into the philosophy of art."

Edmund responded, "You must meet Andy! We are closing the season with Andy's latest print series and other works. He will love the way you think."

I had recently met Thomas Downing, Washington Color School minimalist "dot painter" who was the visiting artist-in-residence at the Contemporary Art Museum in Houston. He was living in a loft on The Strand, the hip, downtown street in old Galveston where the cast-iron and brick buildings from the nineteenth century had been converted into artist lofts. Before returning to New Orleans in the spring for the Warhol opening, Tom Downing asked me to "Say 'hello' to good old Andy for me. We showed together at the Stable Gallery in the early 1960s." I felt privileged to have that introduction to Andy from Tom.

When Edmund introduced me to Andy, I relayed the message from Tom, and his emotionless, public face brightened up with a genuine smile. His eyes widened in surprise, and he said, "Oh wow. How is Tom? I haven't seen him for years."

Suddenly he warmed up to me and escorted me to the back of the gallery and introduced me to a group of celebrity guests, including Hazel Guggenheim, the sister of Peggy, the famous collector. Andy asked Hazel, "Show Dr. Romero your appendectomy scar."

Without a flinch, she lifted her blouse and revealed fresh stitches! Startled, I uttered, "I'm glad to see it is healing well."

Everyone laughed. I had just been part of a Warhol social scenario, where Andy's power to command behaviors seemed magical. Other women approached him, holding out their arms, giving him an ink marker, and asking, "Sign me, Andy. Make me a Warhol original." I strolled through the gallery looking at a giant Mao, a portrait of Mick Jagger, the new series, *Ladies and Gentlemen*. A recent auction catalogue for the series says:

> In 1975, *Interview* magazine editor Bob Colacello strolled into The Gilded Grape, a dive nightclub in New York City's Hell's Kitchen, with one question. He approached a group of glamorous drag queens, asking them if they'd be willing to model for "a friend" for $50. That friend happened to be Andy Warhol, who later photographed the queens just like any of his other iconic muses—at a three-fourths angle with his Polaroid camera. Of these Polaroids, Warhol chose 10 photographs for his silkscreen series "Ladies and Gentle-

men," which portray the queens as confident, coy, and vulnerable. Fascinated by the queens' exhibitionism and meticulous grooming, Warhol once mused, "They do all the things: They think about shaving and not shaving, of primping and not primping, of buying men's clothes and women's clothes. I guess it's interesting to try to be another sex."

I wandered to an upstairs room and found a pony-skin Le Corbusier lounge, my favorite piece of modernist furniture. As I turned around to recline, I came face to face with a giant black and white Avedon portrait of Warhol's scarred torso in a leather jacket, *Andy Warhol, Artist, New York City, August 20, 1969/1975*. The detailed abdominal terrain of the assassin's 1968 gunshots that killed Warhol and the surgical scars of the resurrecting surgeon's scalpel presented a phantom image, a shadow of Andy's trauma. I dropped into the lounge, challenged by the raw power and beauty of the photograph. It occurred to me that Andy had just coaxed Hazel Guggenheim to bare all in her postsurgical scar, as if Andy were replaying the near-death experience where he and Avedon transformed death into art.

My emotional memory banks were tattooed with excitement, wonder, optimism, and hope that afternoon. We began lengthy conversations that evolved into a decade-long, episodic discourse. Andy invited me to visit the Factory when I moved to New York for my residency at St. Vincent's Hospital. "You must visit the Factory. It's right near your hospital!"

Fortunately, I was able to get a copy of the photograph of my first encounter with an artist of a different kind.

After I moved to New York, I discovered that Edmund had moved to Gramercy Park, New York. He reintroduced me to Andy at a Factory luncheon. Andy remembered our first encounter, and we continued our "art conversations" until he died.

Edmund Gaultney with Andy Warhol's Tina Freeman Portraits, David Richmond, 1976

IN MEMORIAM
Edmond Gaultney, Andy Warhol, and Rupert Jasen Smith

Andy Warhol's Brain: Creative Intelligence for Survival emerged over many years of creative conversations with my friends, three artists, Edmund, Andy, and Rupert. They died within three years of each other: Edmund passed May 26, 1986 (age 39), Andy died on February 22, 1987 (age 58), Rupert succumbed to illness on February 15, 1989 (age 37).

Edmund named me as executor of his estate, and that included completing the publication of *Cowboys and Indians* (1986), Warhol's last print series. Rupert and I worked closely with Andy to make sure the art fulfilled Edmund's dream. It would be Andy's final print series.

Edmund worked with Andy at least since 1970, when Warhol photographed him. Rupert became Andy's "master printmaker" and art director since 1974. Rupert and I often talked, in a lighthearted way, about his art-marriage to Andy. My expertise in relationship stress provided some validation and empathy for the stress in their shared Creative Intelligence. After all, their baby was lots of artworks.

My memories of the many hours in creative conversations we spent for over a decade inspired this book.

WORKS CITED
AND
ARTWORK CREDITS

Andreasen, Nancy C. *The Creating Brain: The Neuroscience of Genius*. New York: Plume Book, 2006. Print.

Barcio, Phillip. "IdeelArt: The Online Gallerist." *IdeelArt.com*. 2017. Web. Accessed: 14 Jan. 2022.

Beck, Jessica. "Andy Warhol: My Perfect Body Jessica." *The Andy Warhol Museum*. 2017. Web. Accessed: 15 Jan. 2022.

Beck, Jessica. "Andy Warhol: Sixty Last Suppers." *Gagosian Quarterly*. 01 May 2017. Web. Accessed: 14 Jan. 2022.

Beck, Jessica. "Warhol's Confession: Love, Faith, and AIDS." *The Andy Warhol Museum*. 2020. Web.

Beck, Jessica, and Andy Warhol. *Marisol and Warhol Take New York*. Andy Warhol Museum, 2021. Print.

Bockris, Victor. *The Life and Death of Andy Warhol*. Fourth Estate, 1998. Print.

Colacello, Bob. *Holy Terror: Andy Warhol Close up*. HarperPerennial, 1991. Print.

Colavito, Jason. "It's Time We Let James Dean Be the Queer Icon He Is." Esquire.com, 30 Sept. 2021. Web. Accessed: Jan. 2022.

Comenas, Gary. "Warholstars." *Warholstars*. 2020. Web.

Dillenberger, Jane. *The Religious Art of Andy Warhol*. Continuum, 2001. Print.

Erikson, Erik H. *Childhood and Society*. London: Vintage Digital, 2014. Print.

Franzen-Sheehan, Abigail. *Halston & Warhol: Silver & Suede*. Abrams, 2014. Print.

Gopnik, Blake. *Warhol: A Life as Art*. Penguin, 2021. Print.

Grout, A., D. Bronna, and Leslie Romanoff. "The Myth of the Replacement Child: Parents' Stories and Practices after Perinatal Death." *Death Studies* 24.2 (2000): 93–113. Print.

Grudin, Anthony E. *Warhol's Working Class Pop Art and Egalitarianism*. U of Chicago, 2017. Print.

Hackett, Pat. *The Andy Warhol Diaries*. Simon and Schuster, 1989. Print.

Harvey, Ian. "Hair or Art? How Andy Warhol Used Wigs to Craft His Enigmatic Image." *The Vintage News*. 29 Apr. 2021. Web. Accessed: 02 Feb. 2022.

Heilbrunn, Gert. "Neuroses and Character Types: Clinical Psychoanalytical Studies by Helene Deutsch." *International Journal of Group Psychotherapy* 16.2 (1966): 248. Print.

Hermann, Michael Dayton, Blake Gopnik, and Drew Zeiba. *Andy Warhol. Love, Sex, and Desire: Drawings 1950-1962*. Taschen, 2020. Print.

Johnson, Catherine and Andy Warhol. *Thank You Andy Warhol*. Glitterati Incorporated, 2012. Print.

Jung, Carl Gustav. *Carl Gustav Jung / the Structure and Dynamics of the Psyche*. Routledge, 1992. Print.

Kandel, Eric R. *The Age of Insight: The Quest to Understand the Unconscious in Art, Mind, and Brain: From Vienna 1900 to the Present*. Random House, 2011. Print.

Lüthy, Michael, Kay Heymer, and Andy Warhol. *Andy Warhol, Modern Madonna Drawings; on the Occasion of the Exhibition Andy Warhol "Modern Madonna" at Jablonka-Galerie, June 4 through July 31, 1999*. Jablonka-Galerie, 1999. Print.

Makos, Christopher, Charles Gute, and Andy Warhol. *Andy Warhol by Christopher Makos*. Ed. Charta, 2002. Print.

Margulis, Lynn, and Dorion Sagan. *What Is Life?* U of California, 2000. Print.

Maturana, Humberto R., and Francisco J. Varela. "Autopoiesis and Cognition." *Boston Studies in the Philosophy and History of Science*. 1980. Print.

Maurizio, Vanni. *Andy Warhol: The Alchemist of the Sixties*. Silvana, 2019. Print.

McEwen, Bruce S. and Harold M. Schmeck. *The Hostage Brain*. Rockefeller UP, 1994. Print.

McFarland Solomon, Hester. "Self-Creation and the Limitless Void of Dissociation: The 'As If' Personality." *Journal of Analytical Psychology* 49.5 (2004): 635–56. Print.

Reed, Lou. *I'll Be Your Mirror: The Collected Lyrics*. Hachette, 2020. Print.

Rizzolatti, Giacomo, Frances Anderson, and Corrado Sinigaglia. *Mirrors in the Brain: How Our Minds Share Actions and Emotions*. Oxford University Press, 2008. Print.

Romero, Phillip. *Phantom Stress: Brain Training to Master Relationship Stress*. Xlibris, 2010. Print.

Romero, Phillip. *The Art Imperative: The Secret Power of Art*. Xlibris, 2010. Print.

Romesín, Humberto Maturana, and Francisco J. Varela. *Autopoiesis and Cognition: The Realization of the Living*. D. Reidel, 1980. Print.

Rusinko, Elaine. "We Are All Warhol's Children: Andy and the Rusyns." *The Carl Beck Papers in Russian and East European Studies* 0.2204 (2012). Print.

Warhol, Andy, and Achille Bonito Oliva. *Andy Warhol: The American Dream*. Silvana, 2013. Print.

Warhol, Andy, and Pat Hackett. *POPism: The Warhol Sixties*. Studentski Kulturni Centar, 1989. Print.

Warhol, Andy, Carla Schulz-Hoffmann, and Corinna Thierolf. *Andy Warhol: The Last Supper: Exhibition at the Bayerische Staatsgemäldesammlungen / Staatsgalerie Moderner Kunst, Munich, from 27 May to 27 September 1998*. Cantz, 1998. Print.

Warhol, Andy. *Andy Warhol: Death and Disasters*. Houston, TX: Menil Foundation, 1988. Print.

Warhol, Andy. *From A to B & Back Again: The Philosophy of Andy Warhol*. London: Picador, 1976. Print.

Watson, Steven. *Factory Made Warhol and the Sixties*. Pantheon, 2003. Print.

Wilson, Edward O. *Consilience*. Alfred Knopf, 1998. Print.

Image	Title	Credits	Photographer/Date	Page
1	*Warhol and Makos rowing at the Bois de Boulogne*, Paris, France 1982	Copyright © Christopher Makos	Christopher Makos, 1982	13
2	The author's first meeting with Andy Warhol,	Copyright © David Richmond	David Richmond, 1976	16
3	*Thomas Downing with his painting "Pepper"*	Copyright © The Washington Post	James M. Thresher, 1979	19
4	Medicine Buddha	Artist and date unknown, Courtesy the Conrad Harvey Private Collection	Owned by Dr. Conrad Harvey	25
5	*Rorschach* 1984 Synthetic polymer paint on canvas 167 x 115 inches 424.2 x 292.1 cm	The Andy Warhol Foundation	Museum of Modern Art, 1984	34
6	*Nosepicker II* Tempera on Masonite 37 x 18 inches 94 x 45.7 cm	The Andy Warhol Foundation	The Andy Warhol Foundation, 1948	48
7	*Andy Warhol Artist, New York City*	Courtesy Avedon Foundation	Richard Avedon, 1969	60
8	Raggedy Andy, New York	Copyright © Leila Davies Singelis	1950	65

Image	Title	Credits	Photographer/Date	Page
9	*Young Charles Lisanby in garden*	Public Domain, Courtesy James Madison University	Unknown	67
10	James Dean, *Rebel Without a Cause*	Ian Dagnall Computing/Alamy Stock Photo	*Rebel Without a Cause*, 1955	72
11	Elvis Presley, *Flaming Star*	20th Century Fox Ronald Grant Archive Alamy Stock Photo	*Flaming Star*, 1960	72
12	Marlon Brando	Marlon Brando, Alamy Stock Photo from *The Wild One*	*The Wild One*, 1953	72
13	Marilyn Monroe	Marilyn Monroe, Getty Images from *Niagara*	*Niagara*, 1953 Photo by Donaldson Collection/Michael Ochs Los Angeles - Circa 1952	72
14	*Marilyn Diptych* 1962 Acrylic, silkscreen ink and pencil on linen 81 x 57 inches each (two panels) 205.7 x 144.8 cm	The Andy Warhol Foundation	1962	81
15	*Rod LaRod, Andy Warhol and Paul Morrissey*	Copyright © Stephen Shore	Stephen Shore, 1965	86
16	*Altered Image*	Copyright © Christopher Makos	Christopher Makos and Andy Warhol, 1981	96
17	*Andy Warhol in Clown Nose at the Hotel Bauer Lac*, Zurich, Switzerland during Lent,	Copyright © Christopher Makos	Christopher Makos, 1982	106
18	*Self-Portrait* Andy Warhol, 1967 Synthetic polymer paint and silkscreen ink on canvas 72 x 72 inches 182,8 x 182,8 cm	The Andy Warhol Foundation	1967	118
19	*Triple Andy*	Copyright © Christopher Makos	2023	120-121
20	*Red Explosion (or Atomic Bomb)* Andy Warhol, 1963 Silksceen ink and acrylic on linen 103.75 x 80.25 inches 263.5 x 203.8 cm	Warhol Foundation	1963	132
21	*Self-Portrait with Skull* Andy Warhol, 1978 Synthetic polymer paint and silkscreen ink on canvas 16 x 13 inches 40,6 x 33 cm	The Andy Warhol Foundation	1978	148

Image	Title	Credits	Photographer/Date	Page
22	*Triple Self-Portrait with Andy Warhol's Shadows* (1978)	Copyright © Phillip Romero	Phillip Romero, 2014	157
23	*Myths: The Shadow* Andy Warhol, 1981 Screenprint with diamond dust on Lenox Museum Board 38 x 38 inches 96.5 x 96.5 cm	The Andy Warhol Foundation	1981	158
24	*The Last Supper (The Last Supper Twice With Camouflage)* Andy Warhol, 1986 Synthetic polymer paint and silkscreen ink on canvas 84 x 450 inches 213.4 x 1143 cm	The Andy Warhol Foundation	1986	168-169
25	*Halston and Andy Warhol*	Copyright © Roxanne Lowit	Roxanne Lowit, 1984	178
27	*Chris Royer and Andy Warhol,*	Copyright © Roxanne Lowit	Roxanne Lowit, 1983	183
28	*Favorite Portrait of Andy Warhol,*	Copyright © Christopher Makos	Christopher Makos, 1986	188
29	*Liza Minnelli, Halston, and Martha Graham*	Copyright © John Barrett	John Barrett, 1982	196
30	*Night Chant,* Martha Graham Dance Company	Copyright © Chris Gulker, Courtesy Los Angeles Public Library	Chris Gulker, 1988	203
31	*Andy Warhol All American*	Copyright © Christopher Makos	Christopher Makos, 1983	204
32	*Edmund Gaultney with Tina Freeman Portraits*	Copyright © David Richmond	David Richmond, 1976	218

*Every effort has been made by the author to contact copyright holders for the photographs contained in this book. For further information please contact G Editions/www.geditions.com.

INDEX

Andy Warhol's Brain Index

Page references in italics indicate a photograph.

ACE. *See* Adverse Childhood Experiences (ACE)
abstract expressionism (AE), 103, 115, 134-135, 139-141, 144-145, 190
Adverse Childhood Experiences (ACE), 47, 49-50, 53, 70, 100
AE. *See* abstract expressionism (AE)
Andreasen, Nancy, 45-47, 122
 The Creating Brain: The Neuroscience of Genius, 45, 122-126
Andy Warhol Foundation, 162, 197, 206
Andy Warhol Museum, 21, 56-58, 79, 101, 199, 211
Aristotle, 193-194
ART=SURVIVAL: Andy Warhol: Shadows "Into the Light #1 and #2 (Romero), 156
'as if' personality, 87-88, 92-93, 159, 162
atomic bomb, 135-136, 138-140, 145
autopoiesis, 30-31, 73-74, 119, 170
Avedon, Richard, 125, 217
 Andy Warhol, Artist, New York City, 60, 217
Basquiat, Jean-Michel, 41, 149, 154, 163-164
Beck, Jessica, 41-42, 101-102, 105
Bockris, Victor, 54, 67-68, 99, 109
 The Life and Death of Andy Warhol, 54, 99, 109
Bohr, Niels, 137, 194
Bourgeois, Louise, 17, 21, 107
brain-mind/art-culture, 20-21, 31, 37, 40-41, 44-45, 61
Brando, Marlon, *72*, 74, 79, 83, 124, 140
Buber, Martin, 189-190
Buddhism, 23-24, 30, 162, 194, 207-209
Cale, John, 93, 170
 Songs for Drella, 93
Carnegie Institute for Technology, 91, 124, 134
Carnegie Museum of Art, 91, 135
Clemente, Francesco, 41
Coca-Cola, 45, 145
Colacello, Bob, 39, 116, 149, 163, 216
 Holy Terror: Andy Warhol Close Up, 39
Cold War, 136, 138-141, 145-146

Creative Intelligence, 15, 18, 23-27, 30-31, 35-42, 45-47, 49, 53, 55-56, 58, 61-63, 74-75, 78, 83-84, 89-91, 93, 97-98, 102, 105, 111-116, 123, 127, 141, 143, 149, 152, 154, 156, 162-165, 170, 179-180, 182, 184, 186, 189, 193, 195, 199, 202, 205-207, 211, 219

 Creative Intelligence Training, 31, 36, 112-116

Comenas, Gary, 67

da Vinci, Leonardo, 104-105, 173, 205, 211

 The Last Supper, 104-105, 173. *See also* Warhol, Andy: Artworks: *Last Supper*

Dada, 137, 161, 184, 191, 215

Dalai Lama, 23, 51

Dali, Salvador, 137, 161, 182

Dean, James, *72*, 74-77, 79, 83, 124, 140

Downing, Thomas, *19*, 216

Duchamp, Marcel, 39, 40, 43, 104, 133, 137, 161, 184, 200, 205, 215

 Fountain, 40

 Green Box, 215

 L.H.O.O.Q. (Mona Lisa), 104, 184

 Rrose Selavy, 161, 200

 The Bride Stripped Bare by her Bachelors, Even, 215

Einstein, Albert, 42, 108, 137

 Theory of Relativity, 108

Enlightenment, 108, 137, 193

Erikson, Erik, 163

Escobar, Marisol. *See* Marisol

Factory, the, 17, 22, 41, 43-45, 58, 70, 84-85, 87, 91-92, 103, 115, 125, 144, 146, 153-154, 174, 184, 206, 217.

 Factory Additions, 82

Flack, Audrey, 17, 21, 107

Freeman, Tina, 215

Freud, Sigmund, 47, 104-105, 138, 152

Gaultney, Edmund, 153, 171, 197, 215-217, *218*, 219

Geldzahler, Henry, 40-41, 190

Giorno, John, 41, 184

Graham, Martha, *196*, 198-202

 Night Chant, 201-202, *203*

Halston, 149, 161, 163, *178*, 179-182, 184-186, *196*, 197-200, 202

Happening, 44, 92

Haring, Keith, 15

Heidegger, Martin, 137, 142

John Paul II, 84-85, 125, 171, 211

Johns, Jasper, 134-135, 143, 146, 190

Jones, Jonathan, 173-175
Jung, Carl, 159
Kandel, Eric R., 35, 40, 51, 108, 164
 The Age of Insight: The Quest to Understand the Unconscious in Art, Mind, and Brain, 35
Kaprow, Allan, 44, 92
Kent, Clark. *See* Superman
Lisanby, Charles, 66-69
Logosoma Brain Training (LBT), 24-25, 29, 51, 62, 112
Lowenfeld, Viktor, 111
 Creative and Mental Growth, 111-112
Makos, Christopher, *13*, 41, 113, 123, 149, 161-163, 172, 182
 Andy Modeling Portfolio Makos, 162
 Andy Warhol All American, 204
 Altered Image, 113, 123, 161, 182, 200
 Favorite Portrait of Andy Warhol, 188
 Triple Andy, *120-121*
Malanga, Gerard, 41, 125, 184
Marisol, 41-42
 John Wayne, 42
 Looking at the Last Supper, 42
McEwen, Bruce, 50-52, 107-108
 The Hostage Brain, 50, 107
McLuhan, Marshall, 139, 179, 210
 Understanding Media: The Extensions of Man, 210
Meaney, Michael, 51-52
Metropolitan Museum of Art, 40, 190
Mexico, 209
Mikova, Czechoslovakia, 54, 89, 100, 128
Minnelli, Liza, 163, 181, *196*, 197-198, 202
modernism, 134-138
Monet, Claude, 103, 157
Monroe, Marilyn, 21, *72*, 78-80, *81*, 82-83, 124
Morrissey, Paul, 41, 57, 84, *86*, 115-116, 149, 184
Museum of Modern Art, 21, 140
Neo-Dada, 135, 143
Newman, Barnett, 134-135, 139-141
Newton, Isaac, 193
 Newtonian model, 108, 137

Noguchi, Isamu, 17, 21, 107, 202

obsessive-compulsive disorder (OCD), 53, 56, 79, 82, 105, 189

OCD. *See* obsessive-compulsive disorder (OCD)

Olympic Tower, 181-182, 198

Ondine, 92, 154, 170, 184, 206

Penrose, Roger, 30, 194

 Cycles of Time: An Extraordinary New View of the Universe, 30

 Shadows of the Mind: A Search for the Missing Science of Consciousness, 194

phantom stress, 50-51, 61-62, 64, 66, 70, 143

Phantom Stress: Brain Training to Master Relationship Stress (Romero), 25, 29, 51-52, 112, 152

Picasso, Pablo, 137, 141

Planck, Max, 137, 194

Plato, 30, 155-156, 164, 193-194

 Allegory of the Cave, 155-156, 164

 Platonic values, 97, 138, 179, 191, 200

 Theory of Forms, 155, 193

Pop art, 37, 39, 42-44, 70, 91-92, 101, 134-135, 145-146, 184, 190

 POPism, 21, 37, 43, 44, 63, 83, 109, 116, 135, 141, 145-146, 149, 179, 184, 190-191, 205. *See also* Warhol, Andy: Publications: *POPism: The Warhol Sixties*

posttraumatic stress (PTS), 53-55, 61-63, 70, 80, 88, 93, 127-128, 139, 160, 170

quantum mechanics, 30, 108, 137-138, 194

Presley, Elvis, *72*, 74-75, 79, 83

Raphael, 192-193

 The School of Athens, 192-193

Rauschenberg, Robert, 18, 134-135, 143, 146, 190, 211-212

 Rauschenberg Overseas Culture Interchange (ROCI), 211-212

Ray, Man, 161-162, 200

 Rrose Selavy, 161, 200

Reed, Lou, 41, 93, 170, 184

 Songs for Drella, 93

Renaissance, 24, 41, 100, 108, 141, 191-193, 195

replacement child syndrome, 88

Rockefeller University, 51, 107

Rossi, Giuseppe, 84, 149, 155. *See also* Warhol, Andy: attempted assassination of.

Royer, Chris, 180-182, *183*, 184-185, 199

 Halston and Warhol: Silver and Suede, 180-181, 199

SC. *See* Sydenham Chorea (SC)

Sedgewick, Edie, 84, 93, 174, 184

Sheridan, Gilbert, 150-151

Smith, Rupert Jasen, 41, 84, 153, 171, 197, 219

Solanas, Valerie, 18, 69-70, 125, 146, 167, 174. *See also* Warhol, Andy: attempted assassination of.

St. Vitus Dance. *See* Sydenham Chorea (SC)

Studio 54, 173, 197-199

Superman, 44, 74, 144, 150-151, 171

Surrealism, 137, 161, 191

Sydenham Chorea (SC), 55, 57, 70, 89, 97, 113, 144, 154

Taoism, 30, 137, 194

Taylor, Elizabeth, 11, 45, 145, 181, 198

Temple, Shirley, 61, 73, 90, 115

The Art Imperative: The Secret Power of Art (Romero), 15, 17, 25, 31, 62, 107-108, 126, 152, 200

The James Dean Story, 75-77

Tibet, 209

Tracy, Michael, 19-20

Triple Self-Portrait with Andy Warhol's Shadows (1978) (Romero), *157*

Trump, Donald, 208

 The Art of the Deal, 208

Trump, Mary L., 208

 Too Much and Never Enough: How My Family Created the World's Most Dangerous Man, 208

toxic stress, 24, 49-53, 62, 64, 97, 100

Vanni, Maurizio, 102-104

Velvet Underground, 93, 125, 170. *See also* Reed, Lou *and* Cale, John

Vietnam War, 179, 210

Warhol, Andy

 Artwork

 Altered Image, 113, 123, 161, 200. *See also* Makos, Christopher

 Before and After, 101, 113

 Brillo Boxes, 175, 184

 Camouflage, 104, 163

 Crosses, 103, 171

 Cowboys and Indians, 153, 171, 197, 219

 Cum, 155

 Death and Disaster, 77, 101, 114, 126, 142, 153, 185

 Dollar Signs, 103, 149, 151, 171

 Dr. Scholl's Corns, 101

 Electric Chairs, 114, 142, 185

 Georgia O'Keeffe, 153

Guns, 103, 142, 171
Knives, 103, 171
Ladies and Gentlemen, 125, 216-217
Mao, 142, 149, 216
Marilyn Diptych, 69, 79-80, *81*, 82, 124, 135, 149
Myths, 154, *158*, 171
Nosepicker II, *48*
One Dollar Bill (Silver Certificate), 151
Oxidations, 101, 103, 155
Piss, 155
Race Riot, 151
Red Explosion (or Atom Bomb), *132*, 139
Rorschach, *34*, 104, 163
Self Portrait, *118*
Self-Portrait with Skull, *149*
Shadows, 103, 126, 155-157, 163
Silver Elvis, 42, 87, 149
Skulls, 142, 155
Soup Cans, 40, 43, 113, 115, 126, 133-135, 144-145, 149, 175, 184-185, 215
Superman, 144
Ten Portraits of Jews, 189
The Last Supper, 42, 101, 104-105, 126, 163, *168-169*, 173-174, 211
Time Capsules, 56-58
Tunafish Disaster, 142
Wigs, 101

attempted assassination of, 69-70, 84, 98, 101, 114, 125, 146, 149, 154, 159-160, 167, 174. *See also* Solanas, Valerie

Books and publications

25 Cats Name Sam and One Blue Pussy, 66-67, 135
Interview, 17, 31, 84, 116, 211, 216
POPism: The Warhol Sixties, 40, 134, 143, 146, 189
The Philosophy of Andy Warhol (From A to B and Back Again), 36-38, 63-64

faith, 63-64, 83-85, 104-105, 113-114, 149, 151, 154-155, 167, 170-175, 206

Factory. *See* Factory, the
Film and television

Andy Warhol's Fifteen Minutes, 211
Blue Movie (Fuck), 84

 Chelsea Girls, 84
 Empire, 84
 Lonesome Cowboys, 84
 Outer and Inner Space, 84
 Poor Little Rich Girl, 84
 Screen Tests, 84
 Sleep, 84
 Vinyl, 84
 Foundation. *See* Andy Warhol Foundation
 Museum. *See* Andy Warhol Museum
 Personae
 Drella, 92-93, 154, 170, 206
 Pope of Pop, 85, 116, 125, 173
 Raggedy Andy, 64, *65*, 73-74, 115, 124, 135, 143, 150
 The Warhol, 26, 38, 43, 45, 56, 74-75, 79, 82-83, 88, 115, 124, 135, 144, 150, 154, 207
 sexuality, 66-69, 83, 143, 153, 167, 170, 205-206
Warhola, Andrej, 54-54, 61, 89, 91, 99, 171
Warhola, John, 55, 99
Warhola, Julia, 35, 38, 49-50, 53-55, 61, 64, 74, 84, 88-91, 93, 97-100, 113, 115, 126-128, 133, 160, 171
Warhola, Maria, 54, 88-89, 100, 126, 128, 160
Warhola, Paul, 55, 99, 124
WarholStars.org, 67
Wilson, E.O., 107-108
 Consilience: The Unity of Knowledge, 107
Winnicott, D.W., 52-53, 90, 127-128
Wise, Peter, 161, 163

"I never understood why when you died, you didn't just vanish, and everything could just keep going on the way it was only you just wouldn't be there. I always thought I'd like my own tombstone to be blank. No epitaph and no name. Well, actually, I'd like it to say 'figment.'"

Andy Warhol